ELI REED

BLACK IN
AMERICA

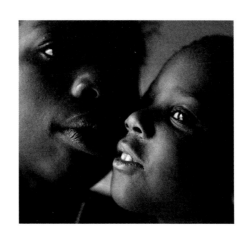

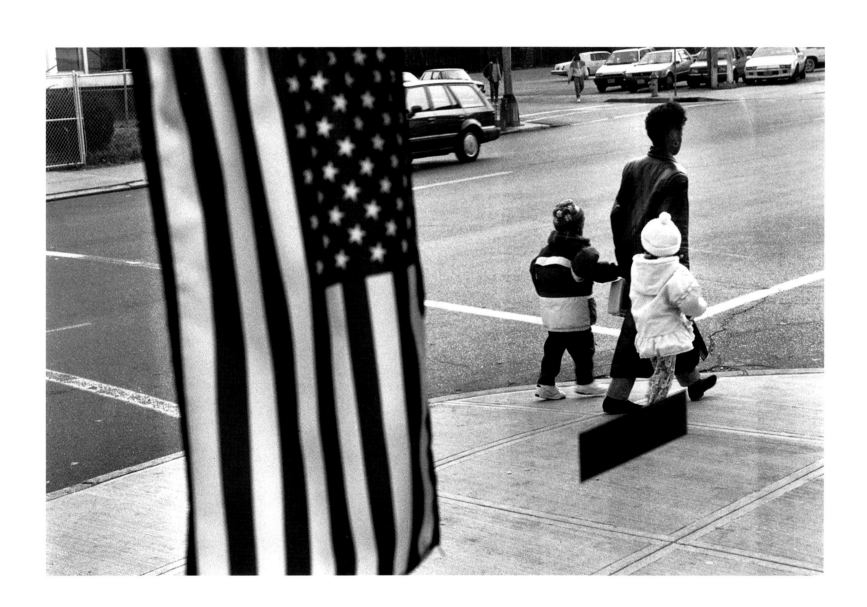

ELI REED
BLACK IN AMERICA

FOREWORD BY GORDON PARKS

W.W. NORTON & COMPANY, INC.
NEW YORK AND LONDON

The text of this book is composed in Gill Sans
with the display set in Gill Sans Extra Bold
Composition by Debra Morton Hoyt
Manufacturing by Arnoldo Mondadori Editore, Verona

BOOK DESIGN BY DEBRA MORTON HOYT

Cover photograph: Mother and son, Bedford Stuyvesant, Brooklyn, New York, 1985
False title page photograph: Mother and son, Beford Stuyvesant, Brooklyn, New York, 1985
Title page photograph: Central ward, Newark, New Jersey, 1993

ISBN 0-393-03995-1

W. W. Norton & Company, Inc. 500 Fifth Avenue, New York, N.Y. 110110
http://www.wwnorton.com
W. W. Norton & Company Ltd., 10 Coptic Street, London WC1A 1PU

1 2 3 4 5 6 7 8 9 0

FOREWORD

FOR A LONG TIME I HAVE HELD THE BELIEF THAT, usually, a truly fine photojournalist is a fine human being. Eli Reed's outstanding work, and his concern for humanity, strengthens that belief. Sensitivity, perceptiveness, and a discerning eye are his hallmarks, and with these attributes he keeps chipping away at the evils of hunger, bigotry, homelessness, and other problems that plague the African-American existence in this country. Not one to move into these situations just for the sake of an assignment then duck out, his concerns—deepening, lingering—stay on to knit together the overall pattern of injustice. His soul, firmly locked into black problems, fuels his indignation, compels his eye to listen to his heart—and his camera becomes a weapon against hardships black people war against every day. That weapon, constantly firing, usually hits the mark.

Obviously the sensitivity that propels him is lacking in many of his compatriots—those who fire away without sufficient reason or thought while hoping for the hand of luck. A majority of the exposures Eli Reed makes seem to be thought out and wedded to moments that are meaningful. With that discerning eye shifting from course to course, he keeps us seeing things we never expected to see; keeps us remembering things that are important to remember. For those of us whose mothering earth is dark, his photographs tend to lighten the shadows we swim through each day. A black teenager is murdered by a white gang in Brooklyn. Reed arrives quickly, quietly, and starts working. Racism in Los Angeles fires the city into an explosive riot. He moves in cautiously, his camera recording the rioters, cops, smoke, and flame. With the Million Man March showing up on his calendar, he hurriedly takes a plane for Washington. All of these events are bound to the ways of urban unrest, bigotry, poverty, and racism—and all are a part of Eli Reed's daily grind.

But a deeper glance into the book clearly reveals that the emotional pull of his experience has not limited the scope of his work. He roams the silk bars as well as the markets of misery, becoming preoccupied with anyone of interest who wanders into his universe—activists, actors, politicians, cops, comedians, cowboys, hopeful young boxers, young lovers, old lovers, blues singers, rappers, and teenagers, all caught up in the weighty perplexities of survival. With camera in hand and saturated with enthusiasm he moves unobtrusively into their lives, melts gently into their presence, then begins shooting. And after taking a penetrating look into these faces he photographs, I somehow feel a lot wiser. With intruding eyes, curious ears, and an inquisitive heart, he seems to have roamed the entire length and breadth of the African-American experience. Eventually, with the clock moving on relentlessly, these people and events taken out of his time will grow faded, but not their images. Those will survive even after death turns up in their diaries. Then what an exotic moment it would be if, with Eli, we could sit on a curbstone a century from now, and watch all those people and events come together in one sudden strangeness.

In a sense, this book is a mirror of the black man's past and future. Certainly it is a strong document of his people living in downtrodden areas of America's backyards—a condition that threatens to hang around for a long time. The same tired tenements of imprisonment are still there, holding young and old alike for sentence without trial. The older folks still go to church on the Sabbath; still manage through gospels and prayers to keep the faith. But glimpses through the book warn us that the younger folks are giving into the streets and junky pads—winding up in jails or on slabs in morgues. Joy, sorrow, happiness, and despair are hanging out together. And we are not allowed to escape the hungry eyes of

the homeless standing on corners.

On several occasions I have read about "Eli Reed's good fortune for having been taken on as a member of Magnum," the prestigious photojournalists' cooperative. Well, I've given that serious thought. Magnum, I feel, should be granted a salaam. Yet I also feel that by signing him on, the agency granted loftiness to its own existence. So, both parties can share the pleasure of wearing neutral robes. This gentle, compassionate hulk of a man is meant for all seasons. Having crossed the world several times, very few countries would seem foreign to him. Here, at home, he allows nothing to alter the color of his skin, its thickness, nor his passion for conveying truth. Count on him to keep on doing the same—emotionally and with power.

—GORDON PARKS

BLACK IN AMERICA

LENELL GETER WAS WAITING IN THE ALCOVE of his church for his wedding to begin and he had a number of reasons to be sad which perhaps made the occasion bittersweet. He had recently been arrested, charged with robbing a fast food restaurant in Texas. Geter was an engineer at that time and according to reports, was attending a meeting during the robbery. Even though he had witnesses, it apparently didn't matter to police authorities there. They were determined to put him away in prison regardless of his innocence. All during his ordeal, Geter conducted himself with honor in the face of the indignities that were piled on him. Geter was rescued from his fate because a number of news organizations helped force the truth to be known. Lenell Geter, an innocent man, was to be freed.

As I stood there with Geter on his wedding day, I watched the little ring boy looking up at him with unabashed admiration. It was as if the boy was gently being given lessons from life directly to his little heart.

I looked into the faces of young lovers on concrete sidewalks of Richmond, California. I saw innocence, hope, possibilities, and a certain amount of foreboding on their faces and in their eyes.

I rode through Hollywood's main drag in a friend's car. We pulled up to a traffic light in front of the wax museum and watched the ebb and flow of sidewalk and vehicular traffic. I glanced over to the next lane, giving an attractive sports car the once over while at the same time taking in the Wax Museum with the American flag suspended high over it. A young black man sat in the driver's seat with his female companion and glanced into his rear view mirror. He watched the flashing lights from an approaching police patrol car as it came up to detain him. I raised my camera, squeezed the shutter release and made a few frames. The light changed and we neatly and slowly drove away.

Sixteen years ago, I began working in earnest to photograph black people, my people. It seemed like a simple way of honoring my parents and acknowledging what they had experienced during their lives. I was borne the son of the former Sally Mae Holland, in 1946. My father, Ellis Reed, was born in 1900 and my mother was his second wife. They were both born in the state of Georgia and reached adulthood without much education. They were "poor but rich in spirit" and they have both passed on.

My friend Paul Theroux once made an interesting observation about my father's life. (At the time, we were working together on a *National Geographic* story in Malawi.) He said that although my father had been too young to be in World War I and too old to fight in World War II, he lived through one of the most traumatic times for black people, struggling for their rights as human beings in the United States.

At that time I began this project, I had hoped my photographs would form an inspiring overview of one chapter in our struggle for equality in America. But that hope dimmed over the years as I photographed life in low-income housing projects, the struggle against the Ku Klux Klan in Forsyth County, Georgia, and riots between black citizens and police in the Liberty City district of Miami. The struggle's end that I had longed for was nowhere in sight.

Almost everywhere I traveled in America, I saw the wasted potential of black children and the grim future that they face. In April 1992 in Los Angeles, the day of the Rodney King verdict, I was working on a film project, stuck in Simi Valley. I sat on my hotel bed with head down and a cold feeling in my stom-

ach. I remembered dangerous nights in the streets of Miami twleve years before—the burning homes, the National Guard troops, the indiscriminate beatings—and I knew what was coming.

The moral conflicts of history continue. In the past, we had the righteous visage of Martin Luther King on one hand and the fiery inspiration of Malcolm X on the other. Today the symbol X has come to mean that Malcolm X lives in a cultural movement of those who can read the truth in what they see, not what they're told. At times, our black political leaders are lightening rods for implied transgressions immediately upon taking office. Many have been dismissed in one way or another. Much has happened to all of us both black and white dating from school desegregation and busing to the Clarence Thomas Supreme Court nomination hearings and the beating of Rodney King. It has come to the point that when during the Los Angeles riots, an emotionally upset Rodney King asked, "Can't we get along?", he was accused of selling out by a part of the black community.

There were bright moments. I witnessed the exhilaration of hundreds of black men coming together at the Million Man March in Washington, D.C. in 1995. I photographed the enduring ritual of parents and children loving each other, images that can be found among people of every race, every color, in both the city and the country. At those times, I felt like a witness to the revival of delivery of the earth's beauty and promise. But invariably, the road would take a hauntingly familiar turn: the funeral of Yusef Hawkins, a young black killed by a white mob in Brooklyn; the violent clash among Hasidic Jews, blacks, and police in the Crown Heights section of Brooklyn; the shootout between black children in Brooklyn's Thomas Jefferson High School.

Recently, a white participant of the Civil Rights Movement described that earlier time. He said that few people understood the importance of what they were doing and how the movement would be viewed historically. People died during the American civil rights movement. They died for voting rights, the right to an education, and true integration into American society, a society at that time that was often totally segregated, violent, and hateful.

Although I went on assignment for newspapers and magazines in some of the world's hot spots—Beirut, El Salvador, Haiti, Zaire, and Panama during the military action taken by the United States, I could not avoid the disquieting truth back home; my people were being torn apart by the systematic denial of a decent education, equal opportunity in employment, housing, and a fair shake in the courts of law. African-Americans were still treated with the grudging tolerance that a master reserves for his servant. Andrew Hacker wrote about this in his book, "Black and White; Separate, Hostile, Unequal."

Cultural and social bias ingrained in society often obscured the pressures of daily life for minorities. The more I worked on this self-assigned project, the more frustrating it became to obtain magazine assignments that dealt with what I was seeing. For example, there was much talk, particularly on radio and television, about how important it was to document for example the black middle class but very little will to actually have someone (particularly a black someone) photograph them. The most common response I received was, "You're too close to the subject."

In Africa, I had felt the earth's fertility. I could feel the honest connection of humans to the earth's surface. I needed to walk on African soil to try to understand the collective fate of black Americans. And I, being one of many black Americans living in the United States, felt the pull of eternity and the looking for of understanding in a place not yet there. A place trying but not becoming yet a place of rest. A place that told of my inheriting the weariness of my father and mother and the fact that I must not expect easement in my lifetime. That is perhaps for the offspring of the next generation of children to enjoy. We are still in process.

The fortunes of black folk rise and fall in the quiet, for the most part, daily struggle of existence. Note is taken and held in memory of when the black churches burn and the authorities have difficulty believing that the burnings may have been organized or indeed even based in racial bias.

We are now approaching the year two thousand and it is a time of reflection. Society is given a

portal from which to view the coming century. Often enough, history repeats itself but this a particularly special time. The world has changed so quickly in the last decade that evasion of reality is no longer possible or desirable. The past has become the present and perhaps the future. Racism is claiming another generation. The United States must wake up before it's too late, too late for everyone.

This book deals with life for black Americans now and reaching into the next century. It is, in a larger sense, about spirit and substance, about successes and failures, and social intercourse between the races, particularly blacks and whites. This project has not been easy for me. At times I wanted to turn away in disgust. But there were moments of joy and encouragement. The situation in the United States isn't good but I'm still an optimist.

—ELI REED NOVEMBER 1996

DEDICATION

This book is dedicated to a trio. First to my wonderful parents, Ellis and Sally Mae Reed who have both passed on, and who brought me into this world with all the love they had to give. Then to my friend Maggie Hallahan, who adopted me as family from the very first moments of our friendship fourteen years ago and gave me unceasing support without hesitation or judgment during some very dark days. And finally to the students and staff of Thomas Jefferson High School in East New York, Brooklyn where I spent a little time. They take a stand every day in a difficult place and carry themselves in the best way they know.

SIXTEEN YEARS OF ACKNOWLEDGMENTS

There are numerous people who gave me unselfish support over the long years I spent working on *Black in America*. The first name on the long list must be Jim Mairs, my editor, who waited very patiently for the birth while exhibiting the patience of Job. I marveled as Jim's colleague, Tabitha Griffin, went to the barricades and beyond, holding my hand with aplomb as she helped walk me through the long difficult process of finally putting this book to bed. I had already admired designer Debra Morton Hoyt's work and she didn't disappoint, making brilliant sense of this work with her design. Beni Ortiz believed in me with the fire of a mother for her cub. Misha Erwitt and Budd Williams were there for me always and many times, supporting without judging. Donald McCullin, Philip Jones-Griffith, Rosemary Wheeler, Sebastio Salgado, Nick Nichols, Eugene Richards, Henri Cartier Bresson, George Rodgers, Gordon Parks, Toni Parks, and my Magnum brother and sister photographers who have supported and given me good advice over the years, as have a host of others including Cheryl Mendez, Jimmy Fox, Robert Pledge, Chrissy Salvador, Wendy Tiefenbacher, Dr. Kevin Cahill, Dr. James Wales, Marlene Burke C.S.W., Utrice Leid, Shahn Kermani, George Waldman, Jay and Rose Deutsch, Lois Fiore, Frank Bell, Joe and Julie Wrinn, Laura Tavoramina, Robin Boyce, John Gulish, Larry Rice, Chandra Carr, Bob Dannin, Maria Stenzel, Paul Theroux, Sheila Donnelly, Bruce Talamon, Karen Grigsby Bates, Arlene Muzyka, Donald Greenhaus, Scott Fraser, Lola Garrido, Mary Dunn, M.C. Marden, Eric Meskauskas, Kim Komenich, Maddy Miller, John Shearer, David Markus, Kathy Ryan, David Friend, Stella Johnson, John Singleton, Sherry Krauter, Ernest Carl Lofblad, Michelle Agins, Allen Brown, Paul Gauci, Carol Collins, Susan Vermazen, Lois Raimondo, Carol Oditz, and Nancy Hall Duncan and The Bruce Museum staff. Thanks also to the *Detroit News*, the *San Francisco Examiner*, the W. Eugene Smith Grant for Documentary Photography, and the Kodak World Image Awards who supplied much needed film and financial support. And finally I must mention two little boys named Jordan Talamon and Nicholas Lindenlaub, for making me feel grateful that they're alive.

I used a variety of cameras over the years from 35mm to medium format cameras. I have used Leica rangefinder cameras consistently through the years. I now use Canon EOS cameras and the Mamiya RZ67 format along with the Leicas.

NOVEMBER, 1996

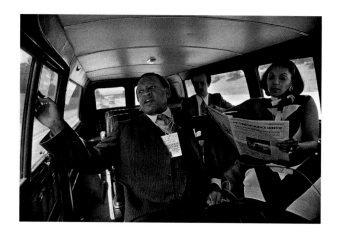

Vibes player Lionel Hampton,
Michigan, 1980

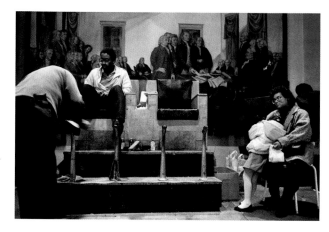

Philadelphia, Pennsylvania, 1989

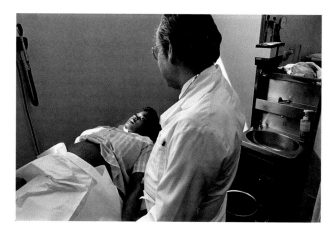

Single mother of two, St. Louis,
Missouri, 1986

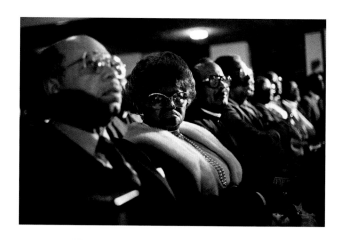

Meeting in Georgia, 1990

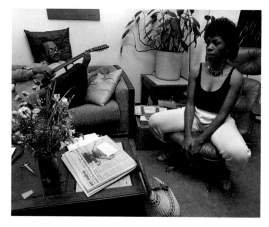

St. Louis, Missouri, 1985

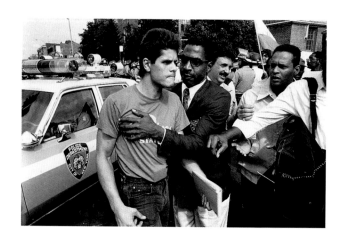

Brooklyn, New York, 1991

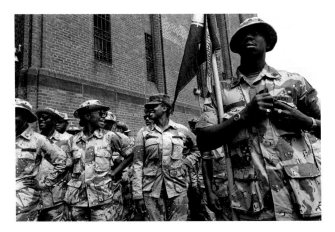

Persian Gulf War veterans, New York City, 1991

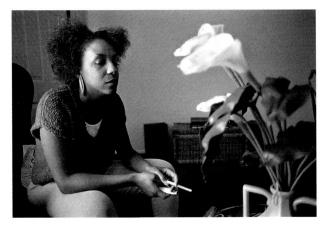

Single mother of two, St. Louis, Missouri, 1986

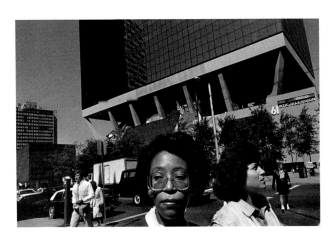

Hartford, Connecticut, 1988

WALKER

Time again,
For the walking of the road.
Exposed and upright in time.

A friendly foe,
They,
The three.

Moving as precise equals in the main.

In spite of the simple pain,
They remain in bonded bliss,
The same.

FAVORED POSITION

I walked on the smooth stones of a golden path
Learning the ways of least resistance.
Feeling inside the way of warmth,
I slid into a position of favor,
For a long sweet flavored benign moment of delight in singing presence.
Wearing the good wine as befitting the nervous neophyte,
In supple tuning of my partner's soul,
I watch the beating of life in its circular windows.
Gazing to my own distraction
As I lay quiet quivering in silky defiance,
I long in good time for the ineptness of reversed logic.
To make sense of my limitless landscape,
I sing for my midday meal.
Finding and caring for the lost envelopes of the little sleep
Thereby preventing my own disarray,
I sing for my supper.
While enjoying the revealing of self
Within my own best cause without false nobility,
I find simply the enjoyment of bewilderment comes less.
In ample supply,
In midarrival at my back
Time bids joyful life's easing of temptation.
For what it's worth,
I say goodbye to all of that
Yet staying the distant running speech,
And laying this body down to sleep.
Versed in finding hidden valleys of free joy,
I sing still of pure pleasure.
And I welcome the sleep,
Without the dreams.

TURN AROUND

 I wake up crying,
Inside a center of dark hooded flame,
I look for the cold metal of squared logic,
Discovering instead simple passion made fragile.
My place in the sun is empty for a moment
As is my aged vessel.

I find requited love after searching for true answers,
Not for vanity or the untimely pain of being.
I can hear the change in the shifting gear
Of time's passage.
It speaks to me in soothing tones and—

 I wake up crying.
Thinking in my feverish mind that—
My mother didn't raise me this way.
Discovering the passion of life inside a small room

Brought to an end engraved invitational pity.

I pass through sleep and her bit of heaven,
Looking forward to the joy.
I relinquished to her my good wishes,
I bade her good thanks,
Remembering all of that.
 And then I woke up crying.

SUNSET ON ME

Going down with the African sunset,
Gone to ground before the sun sets.
I seat myself near the quiet water and a riotous sky,
At a place set on ageless rock.
Through the bush I pass slowly,
Resting with the sun during the night at a dusty place,
A dramatic day half risen again,
With quiet stealth in restless phase.
Enjoying the day in unforced bliss,
I leave bravely my place of shelter,
As the set sun caresses my skin.
Finding joy all the days of my life,
While not seeking to retrieve—
Or admire the contour or reason of good fortune.
The cost of loving and living,
Is much too dear for the old before their time.
The plain and the simple loving—
Is all that one desires
Without the fear.
And without the tears.

MID LIFE MORTAL

On mortal thoughts,
I whimpered once,
Closed my eyes,
Went to sleep with all the lies.
And where in the morning did the lies go?
Regard time's passing—
Life's light in the evening brings still some pleasure,
While still I ask.
Once more for the record,
Where are the lies?

AND STILL

While still regarding proper life in its place,
Willed the esteemed self,
In observance of what survives.
Round and rounding the corners of life
Begetting another year of lost time.
Staged without the glossy finery,
We slip and slide carelessly away.
Then—are saved,
As carelessly inside the rhythm,
Finding the quiet and the grace—
And the amen.
We accept the timing,
We accept the grace.

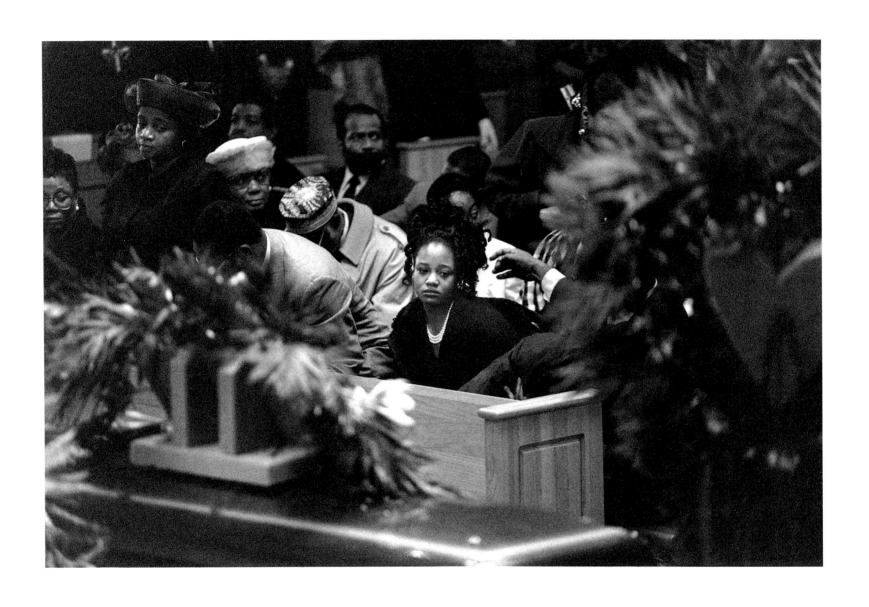

Mother at the funeral of her son shot by a classmate, Brooklyn, New York, 1992

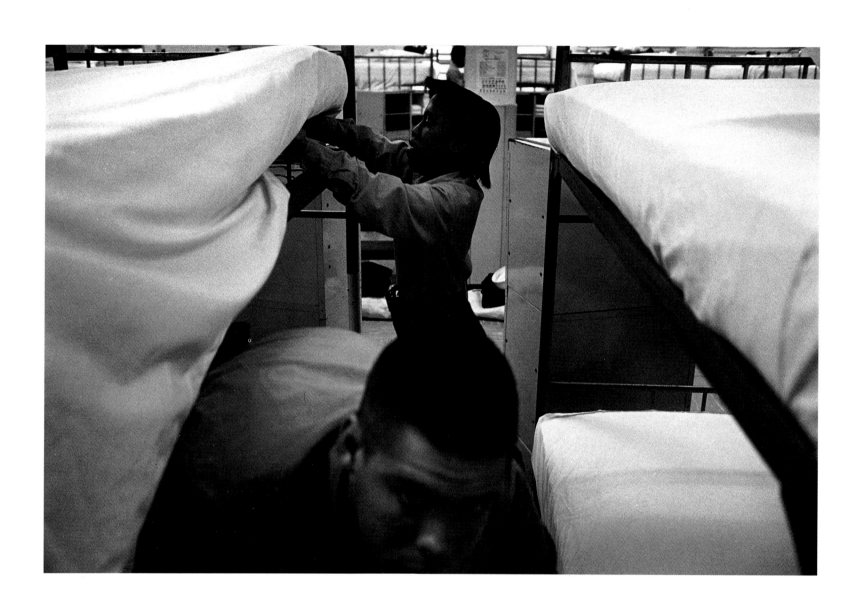

Coed basic training camp, Orlando, Florida, 1993

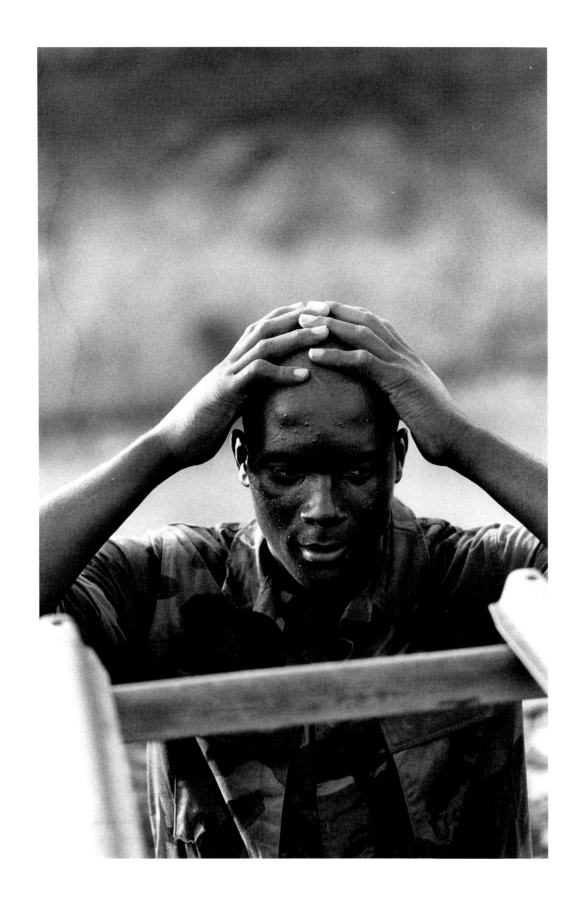

Marine on front lines, Beirut, Lebanon, 1983

15

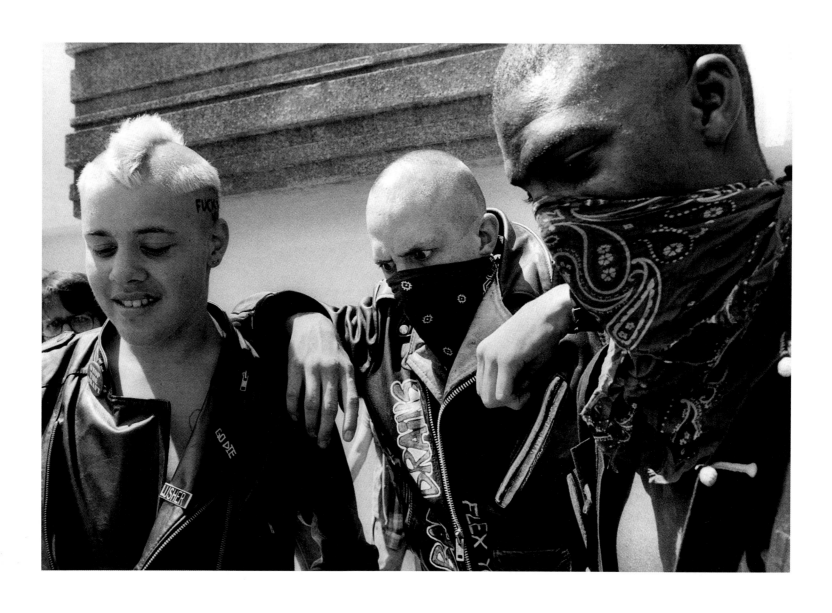

Street rally during the National Democratic Convention,
San Francisco, California, 1984

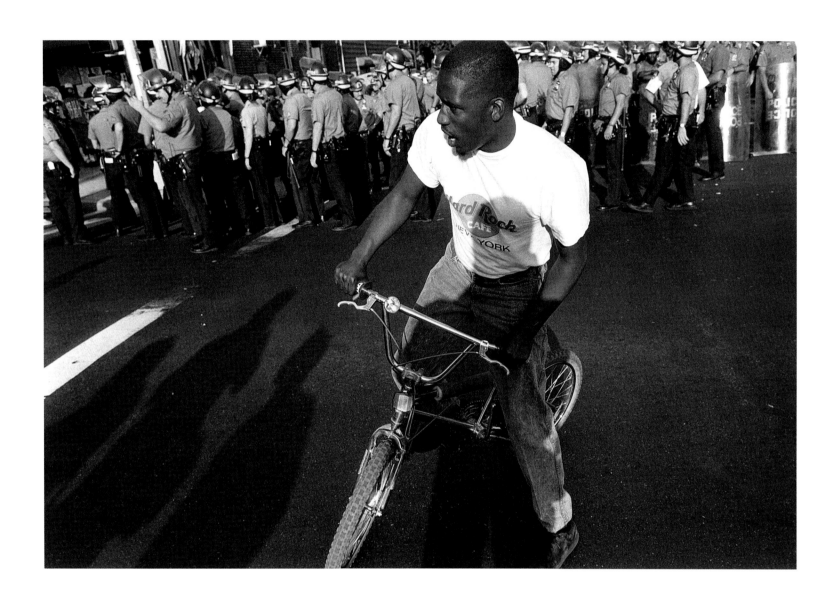

Crown Heights riot, Brooklyn, New York, 1991

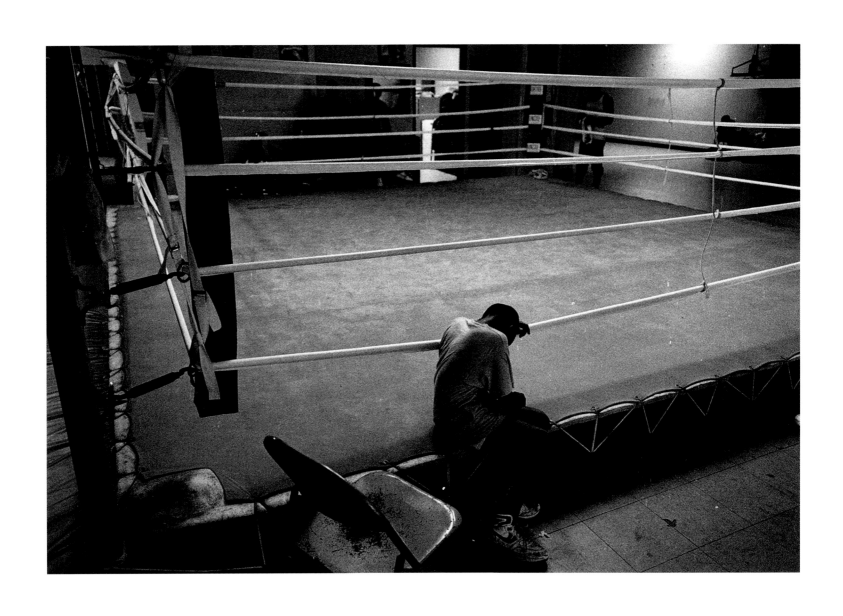

Bedford Stuyvesant Boxing Center, Brooklyn, New York, 1990

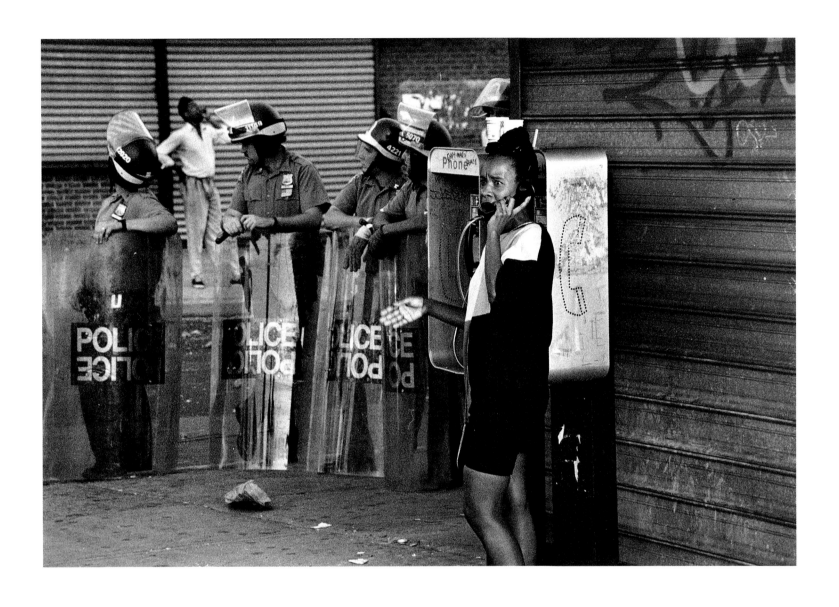

Crown Heights riot, Brooklyn, New York, 1991

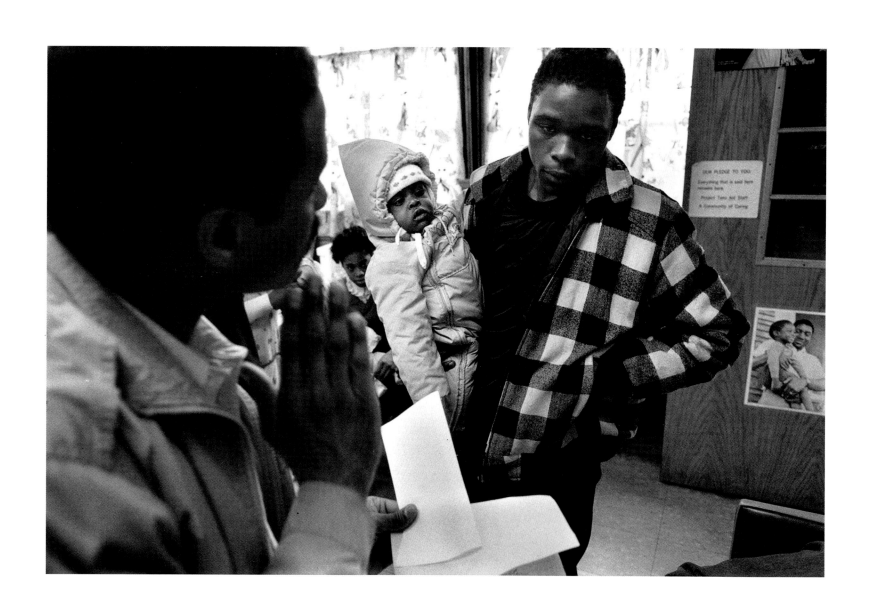

Brooklyn, New York, 1986

20

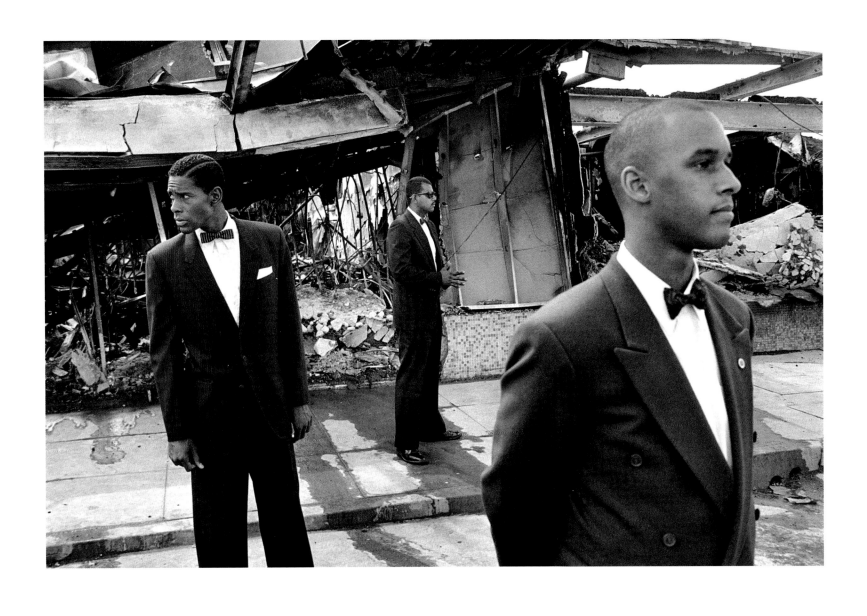

Black Muslim security stand guard for John Singleton during the LA riots,
South Central Los Angeles, California, 1992

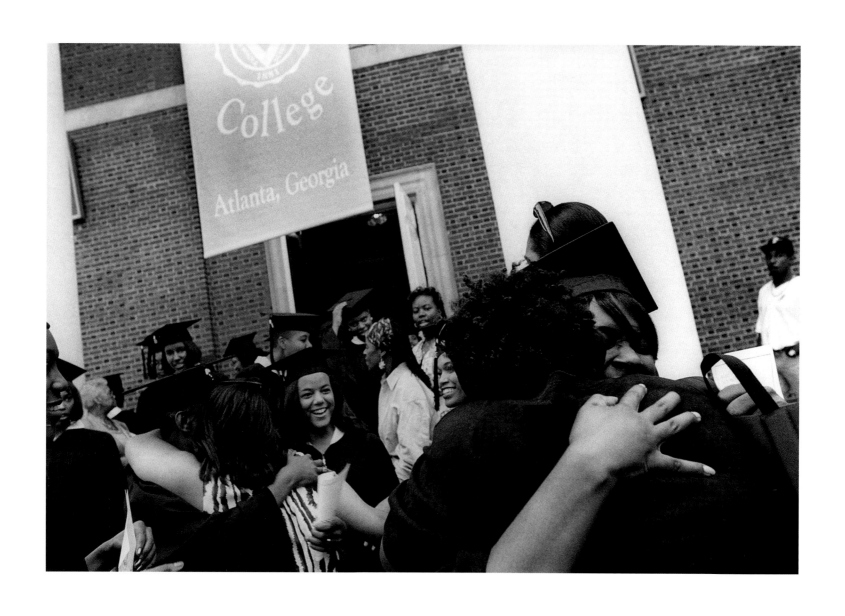

Spellman College for Women graduation, Atlanta, Georgia, 1995

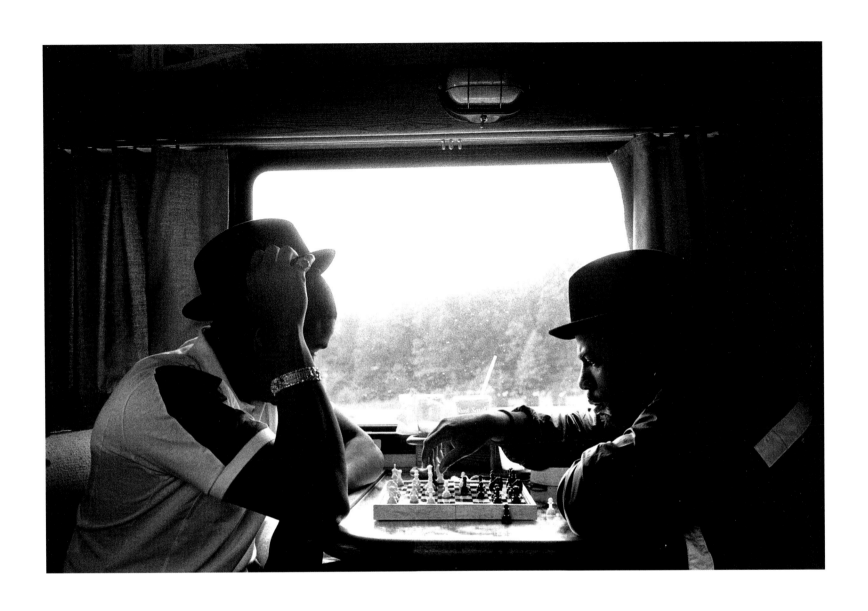

Members of rap group **RunDMC** on the road between Virginia and New York, 1989

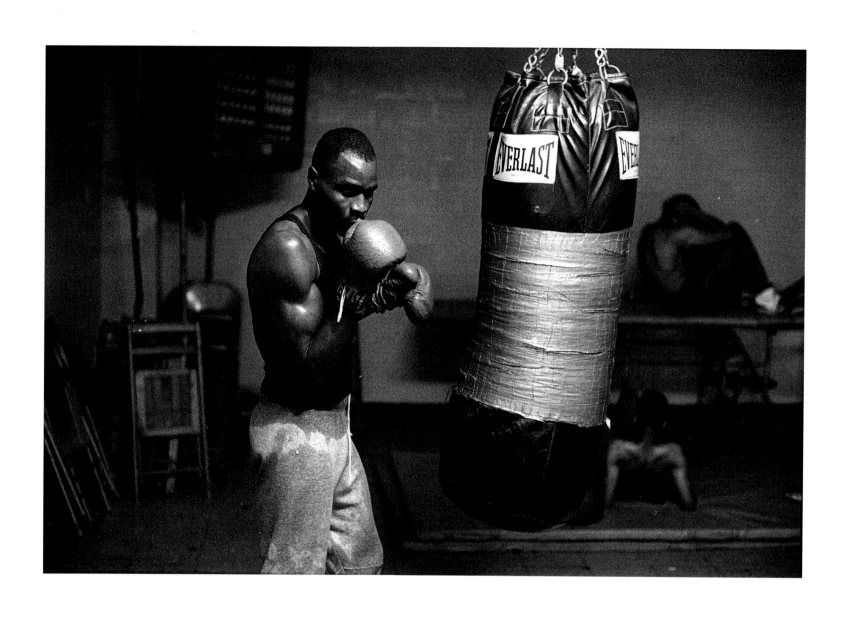

Bedford Stuyvesant Boxing Center, Brooklyn, New York, 1990

24

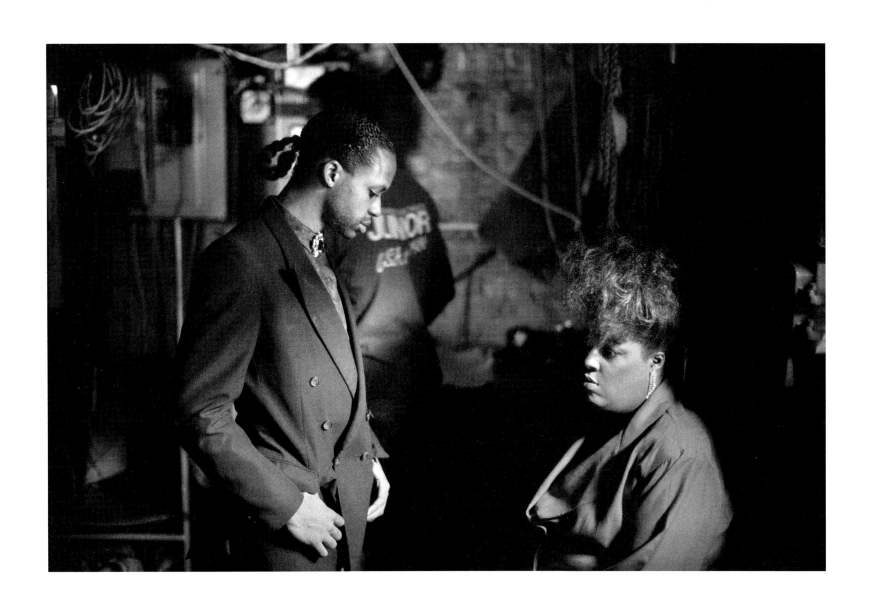

Amateur Night at the Apollo Theater, Harlem, New York City, 1987

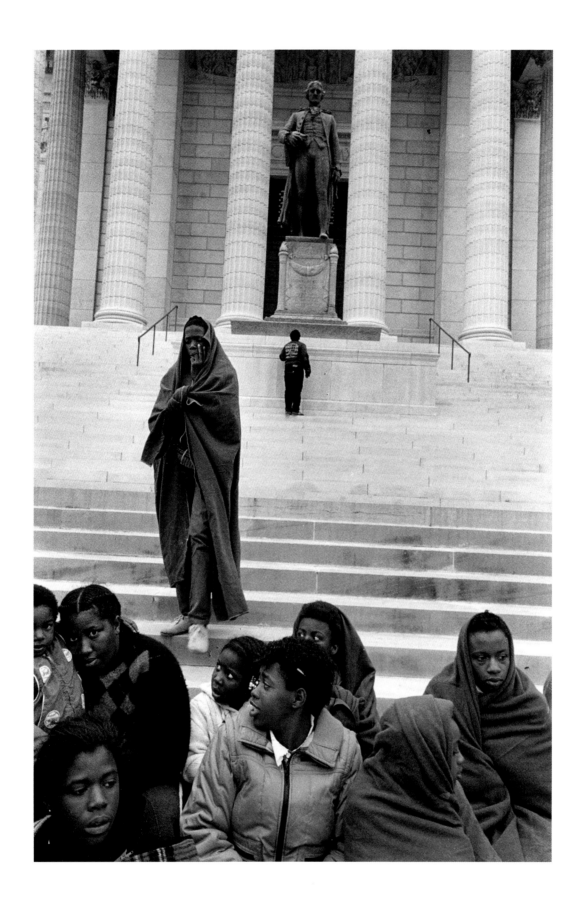

Homeless people at the end of their 135-mile March for Shelter,
Jefferson City, Missouri, 1986

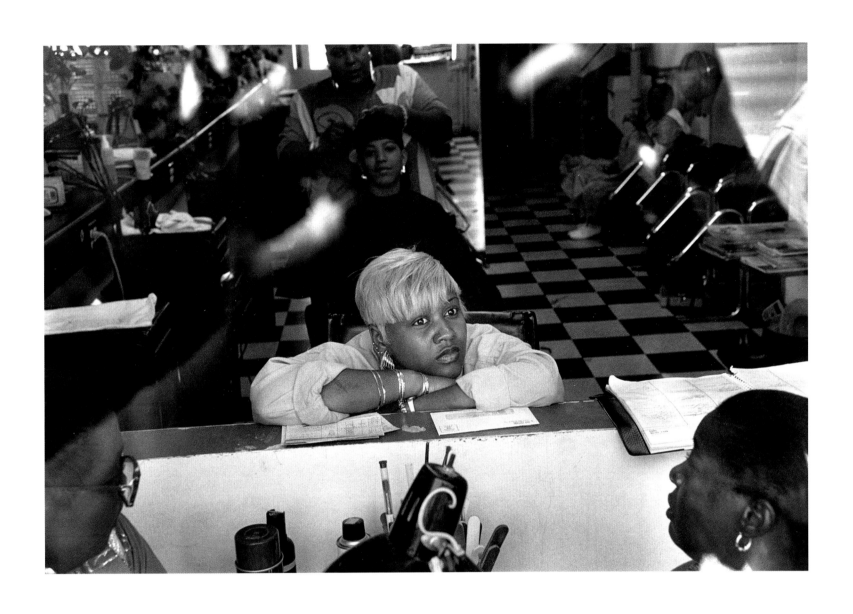

Beauty salon, Atlanta, Georgia, 1995

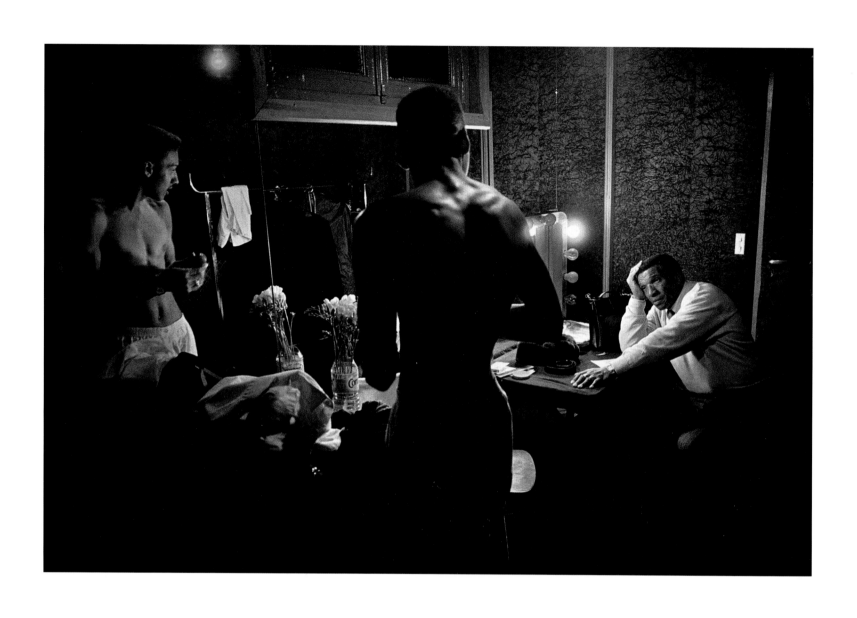

Gospel singers The Golden Gate Quartet in their dressing room, Paris, France, 1991

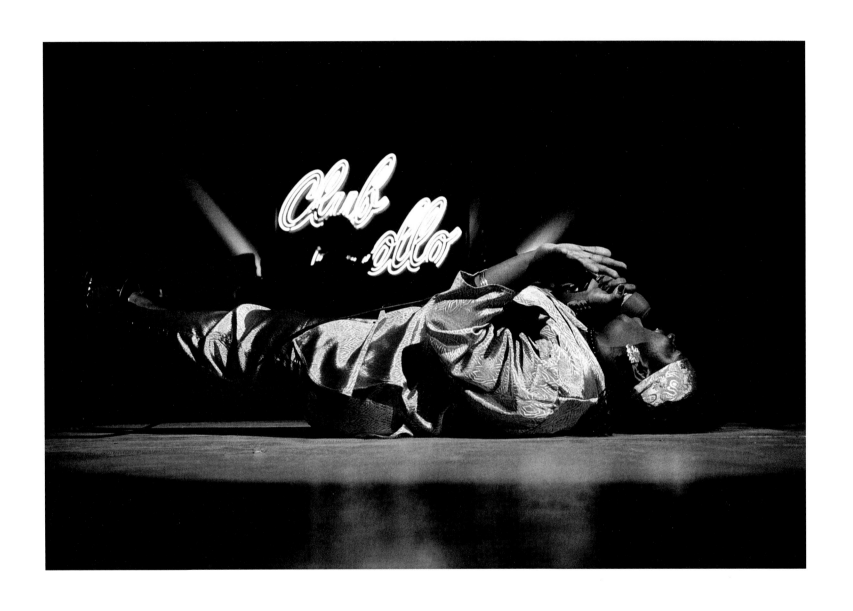

Amateur Night in the Apollo Theater, Harlem, New York City, 1987

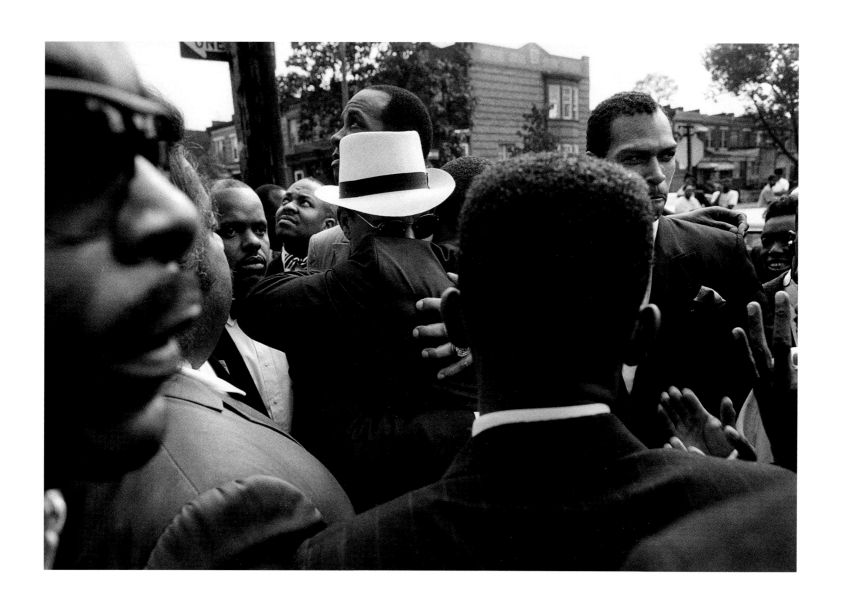

Black Muslim leader Louis Farrakhan embracing the father of Yusef Hawkins,
Brooklyn, New York, 1989

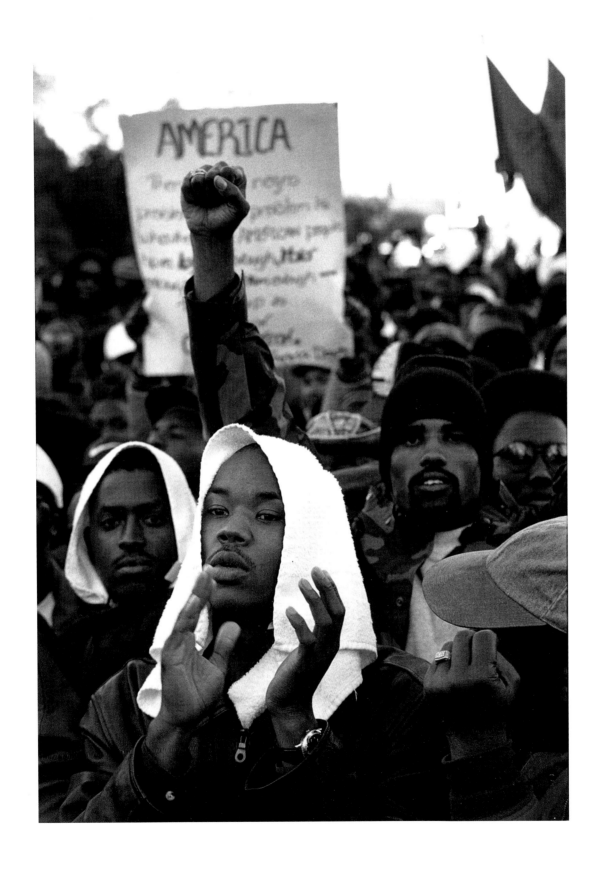

Million Man March, Washington, D.C., 1995

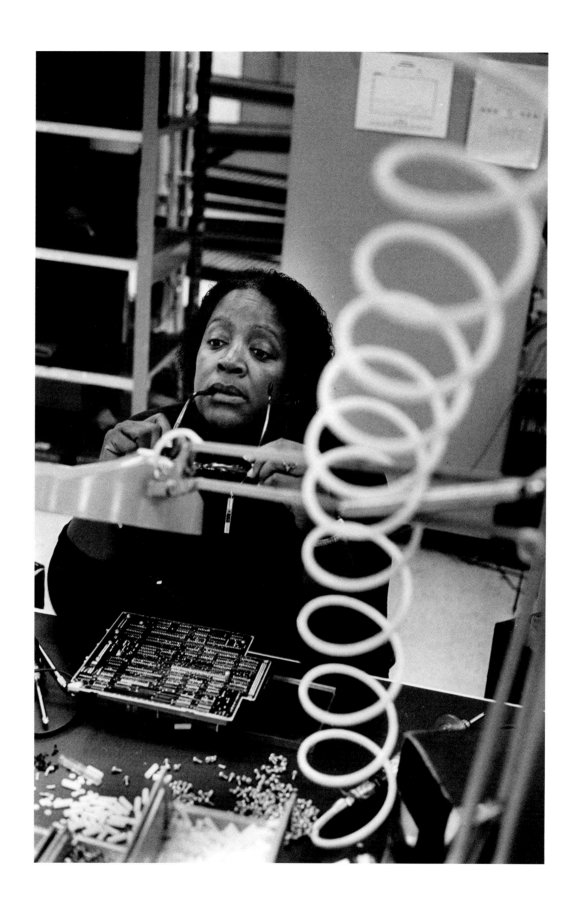

Hewlett Packard factory, San Jose, California, 1985

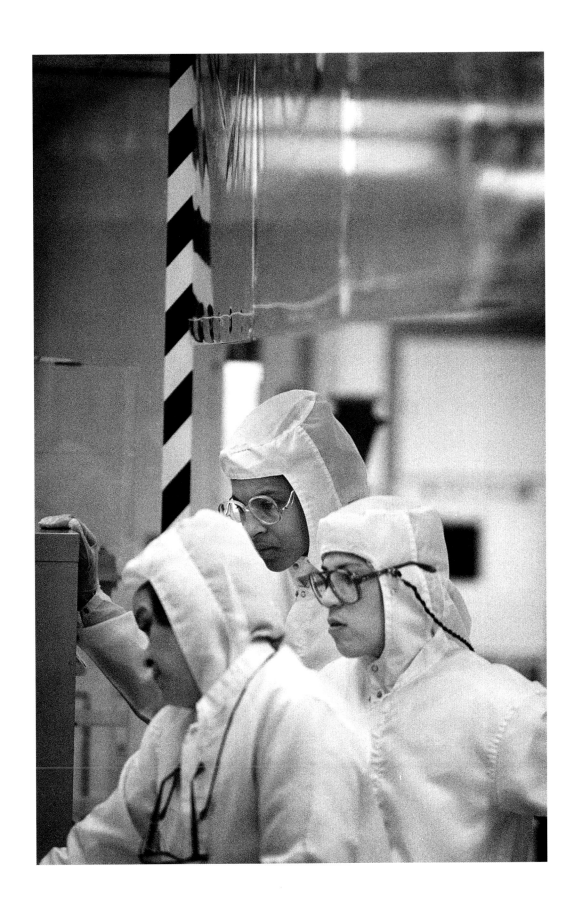

Hewlett Packard "clean room," San Jose, California, 1985

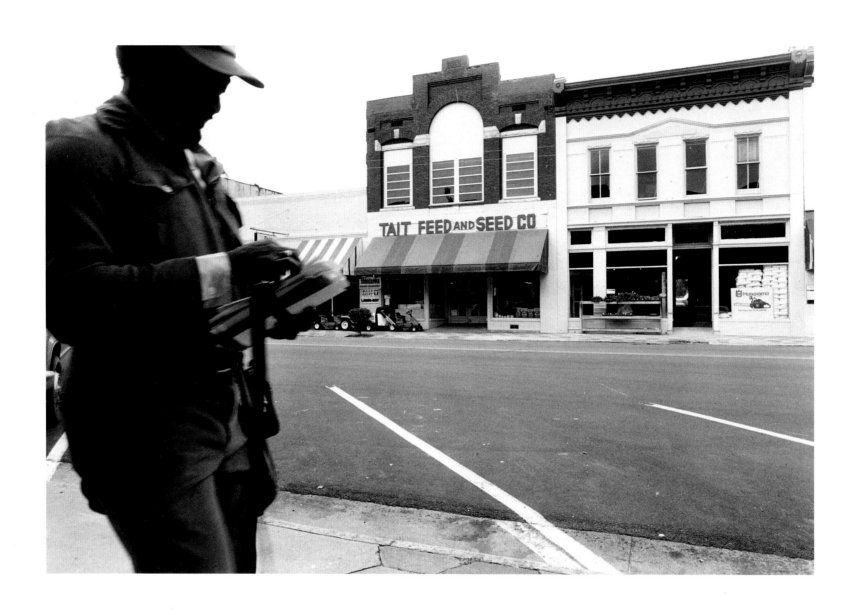

Brunswick, Georgia, 1987

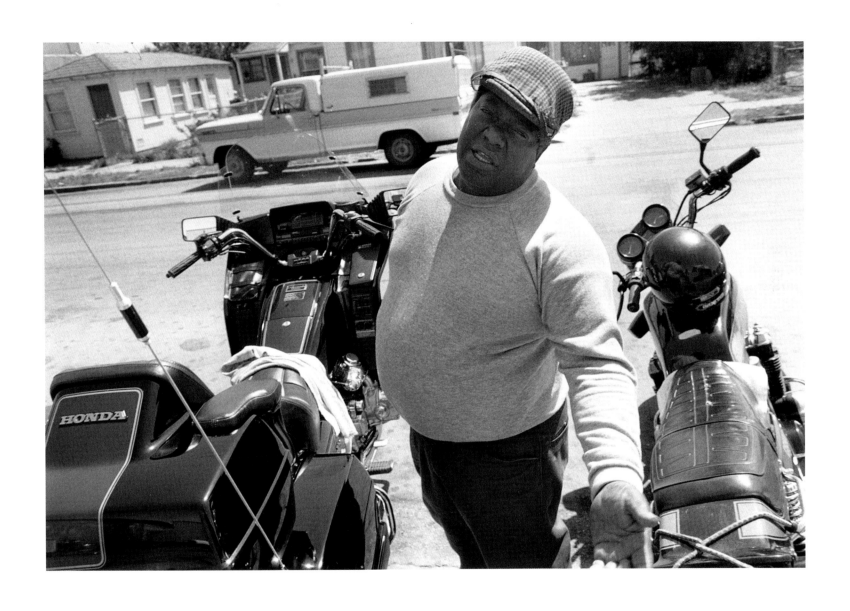

Richmond, California, 1980

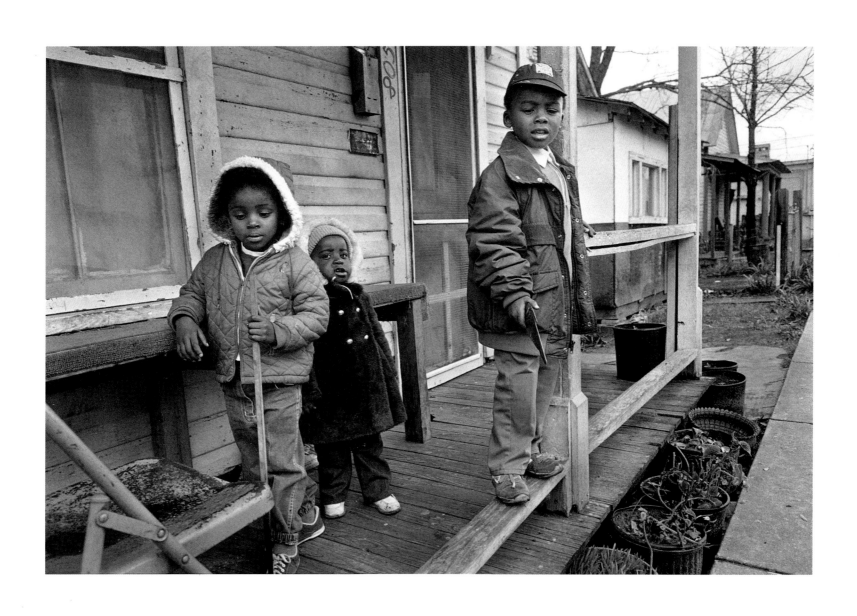

Brunswick, Georgia, 1986

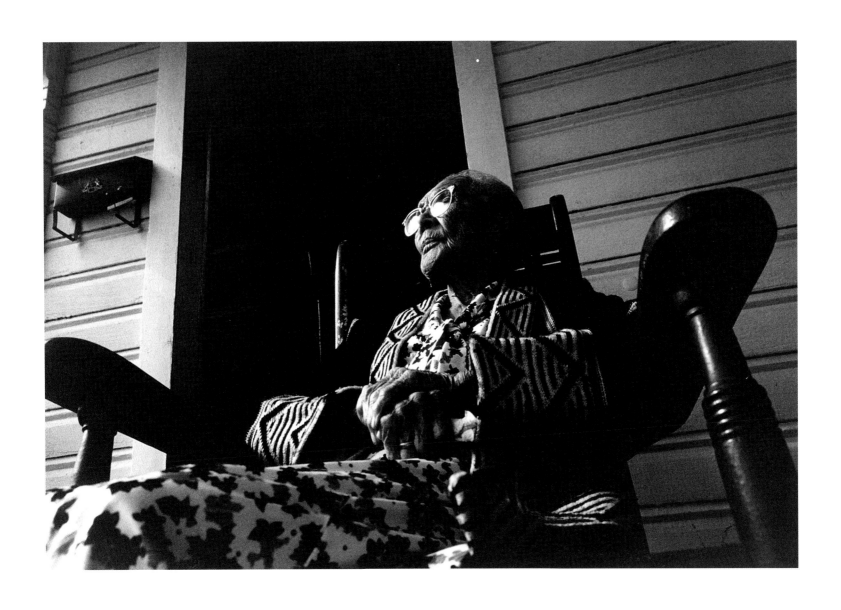

104-year-old woman, Chilicothe, Ohio, 1993

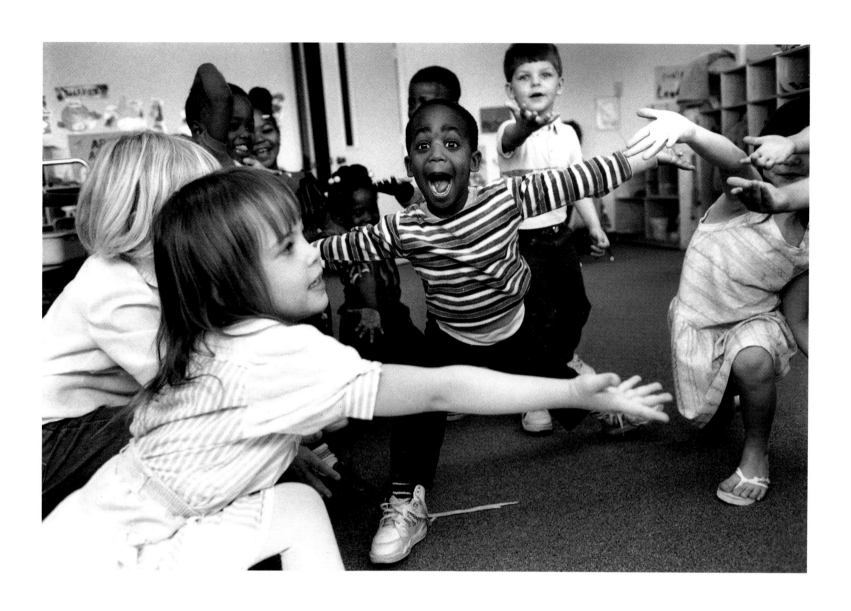

Day care center, Texas, 1990

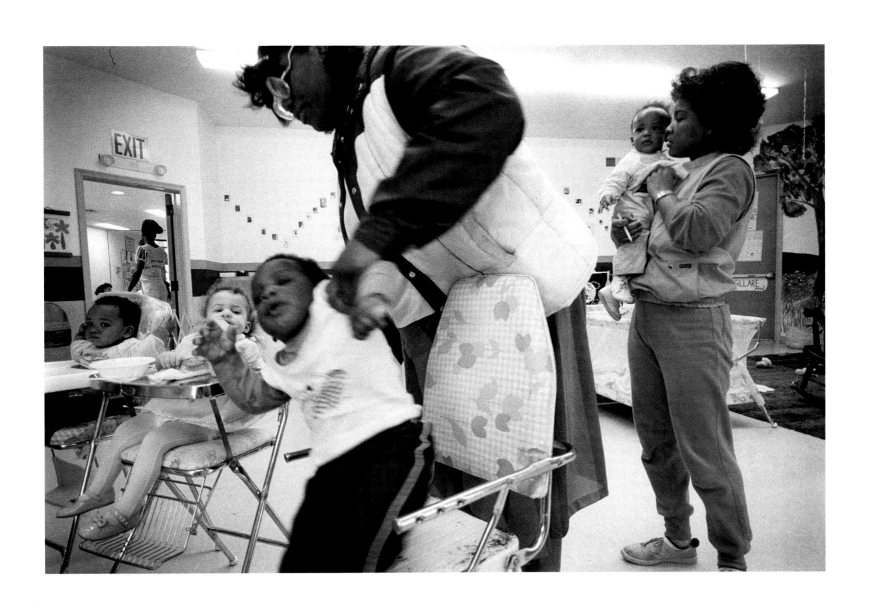

Day care center, Detroit, Michigan, 1985

39

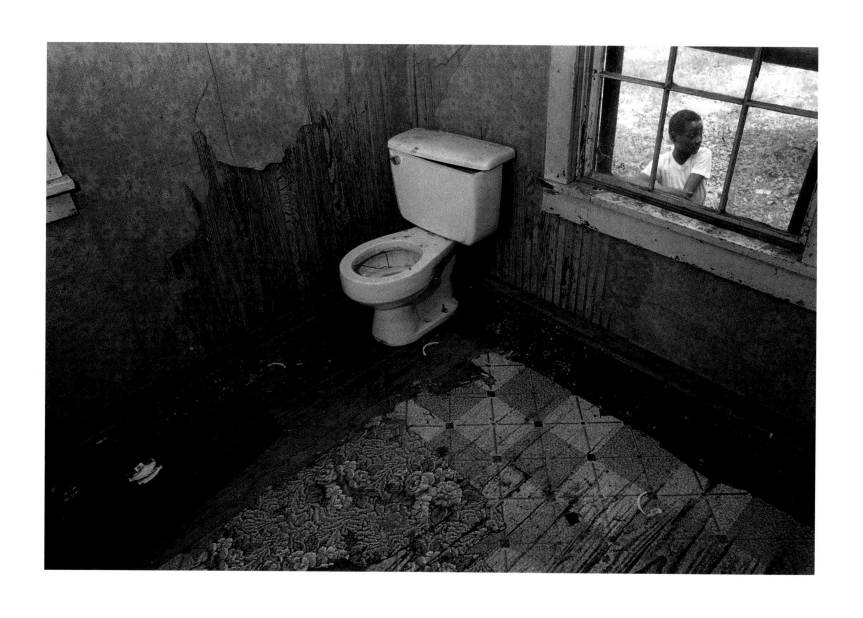

Sugar Ditch region, Tunica, Mississippi, 1986

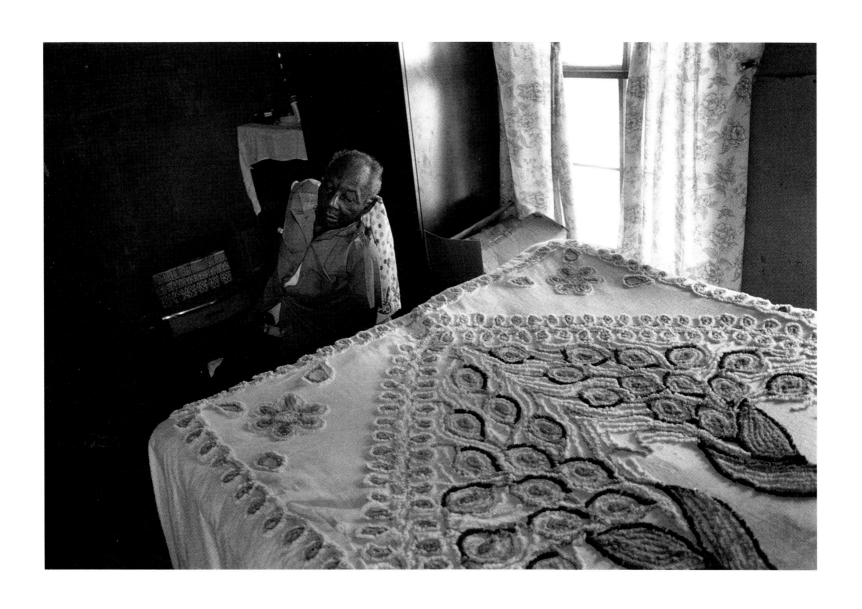

Tunica, Mississippi, 1986

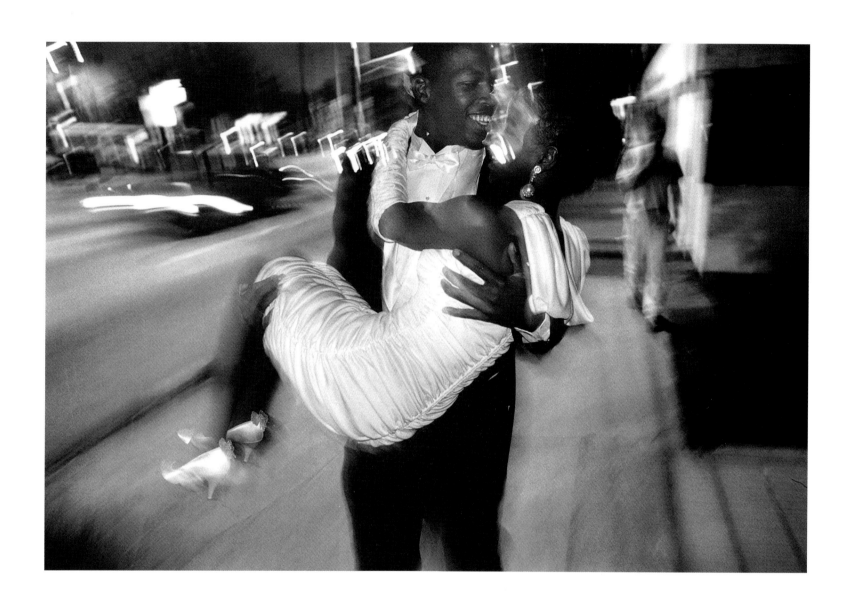

Prom night, Atlanta, Georgia, 1995

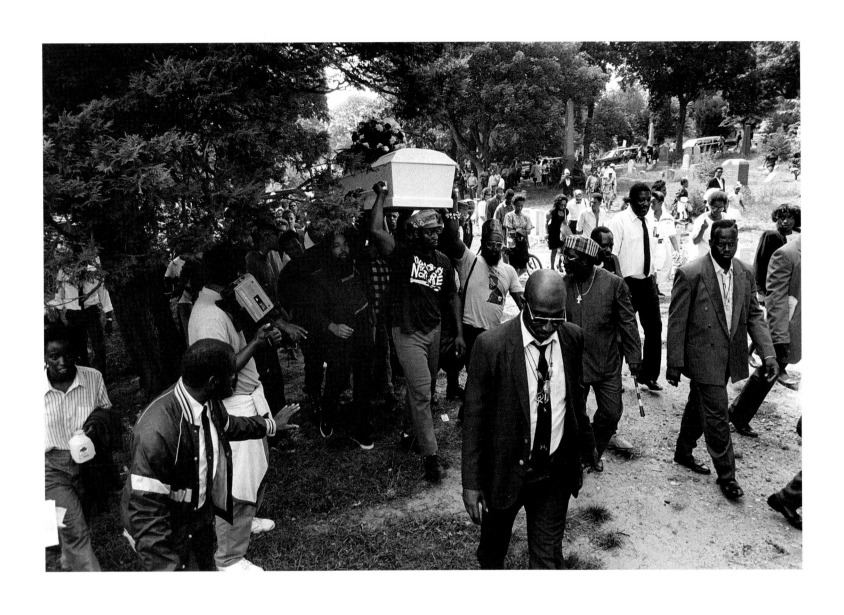

Funeral of child killed by a Hasidic driver that sparked the Crown Heights riot,
Brooklyn, New York, 1991

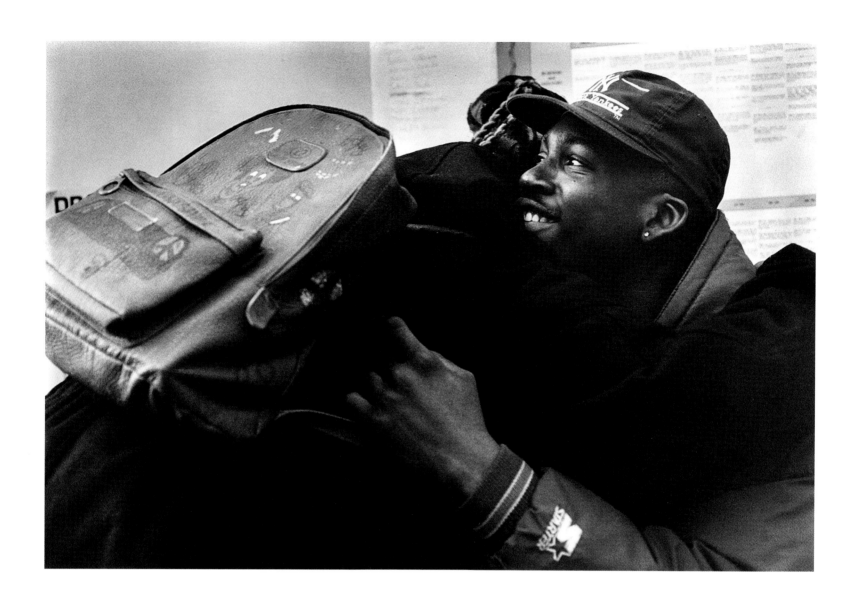

Thomas Jefferson High School, East New York, Brooklyn, 1992

44

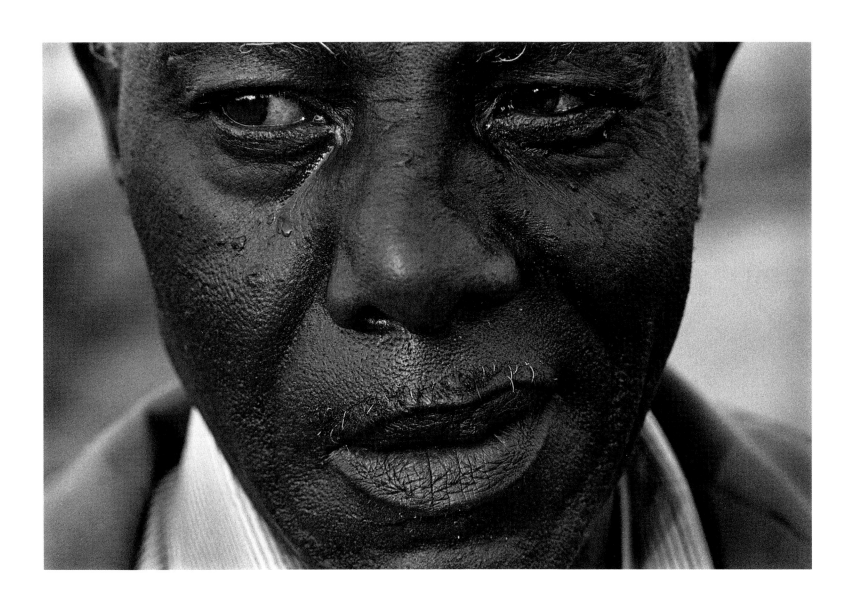

Tunica, Mississippi, 1985

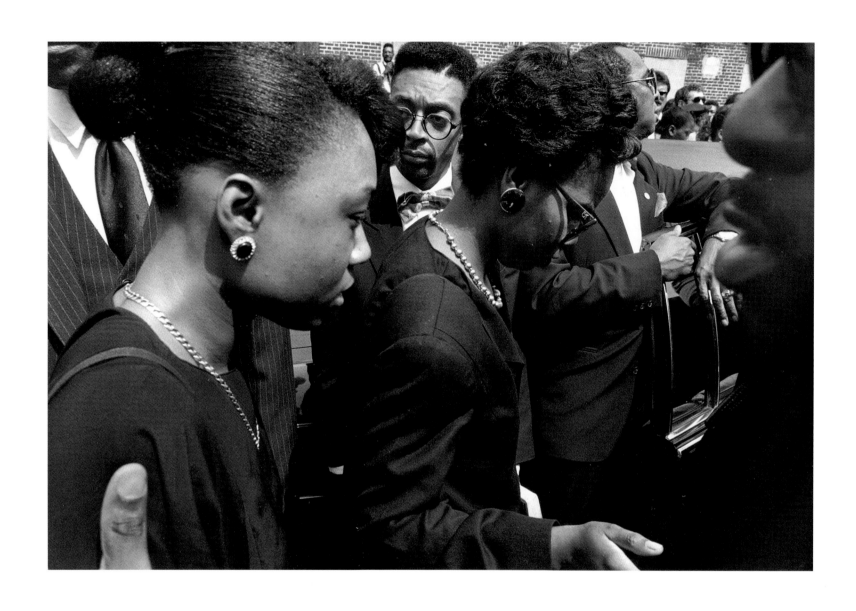

Spike Lee at the funeral of Yusef Hawkins, Brooklyn, New York, 1989

46

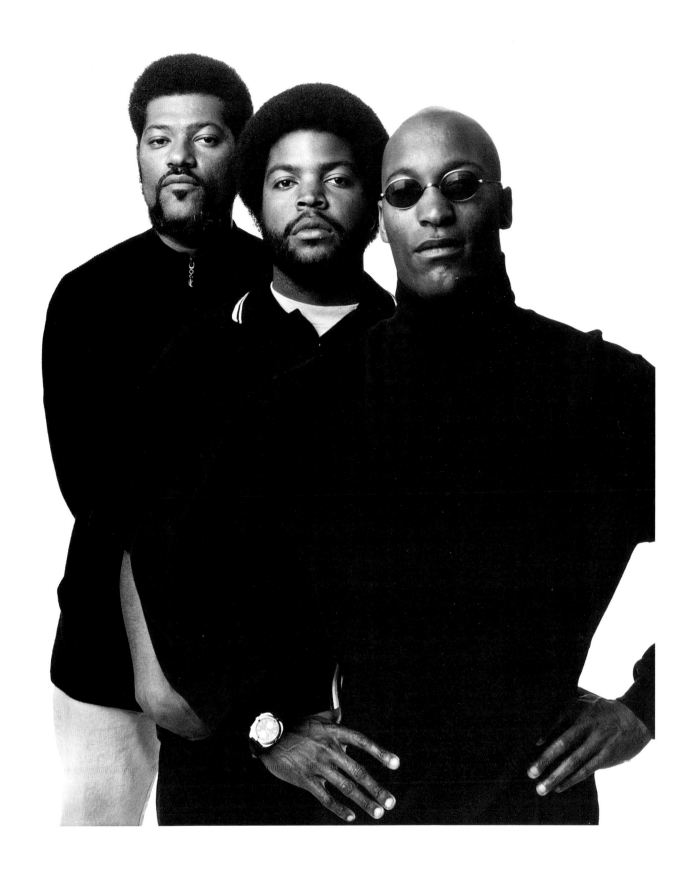

Film director John Singelton, Rap artist Ice Cube, and actor Lawrence Fishburne,
Los Angeles, California, 1994

47

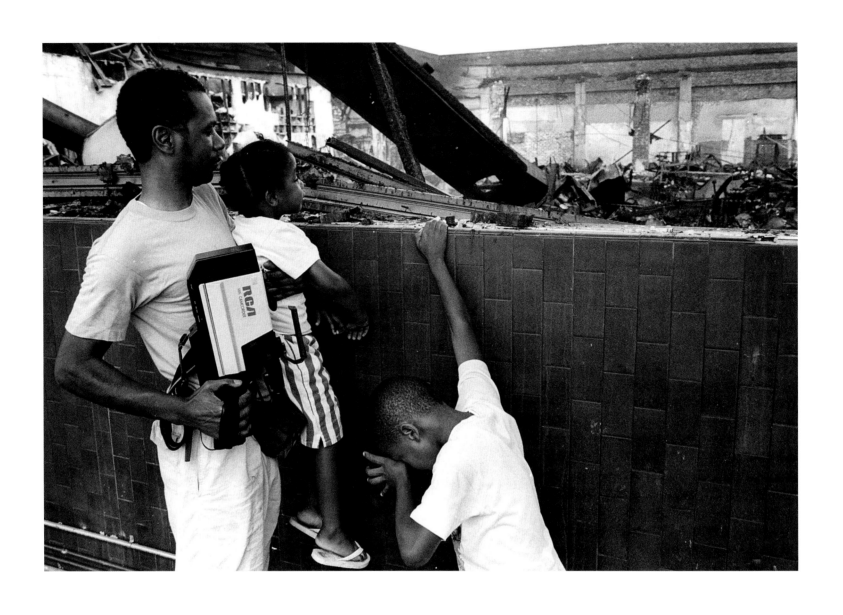

Damage from the LA riots, Baldwin Hills, California, 1992

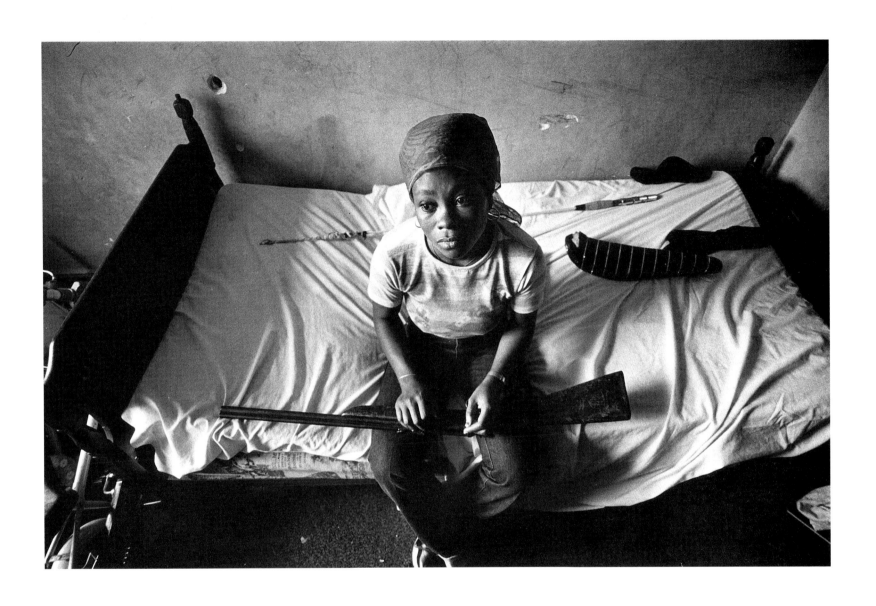

Housing project, San Francisco, California, 1984

49

Actor Glenn Turman at his horse ranch, Los Angeles, California, 1994

Photographer Mike Jones, near Los Angeles, California, 1994

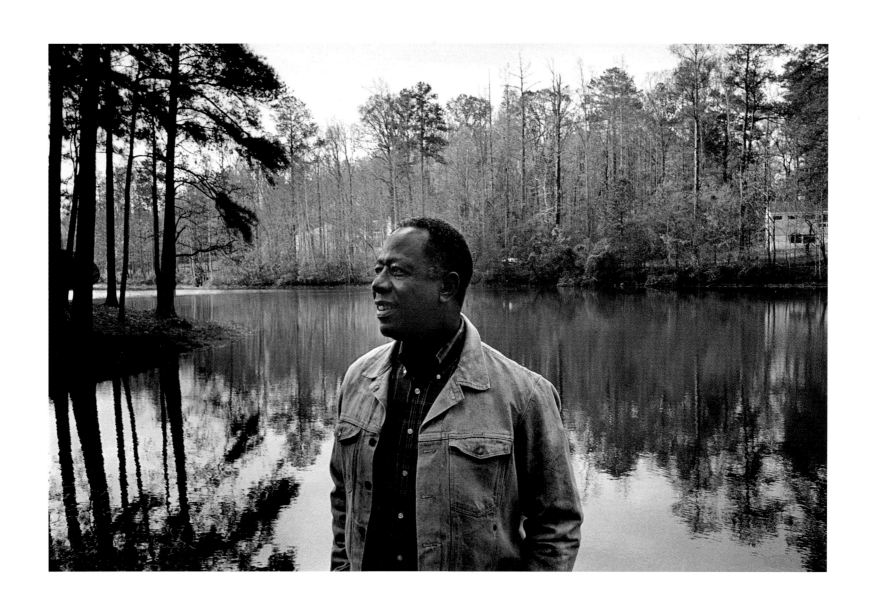

Baseball great Hank Aaron, Atlanta, Georgia, 1994

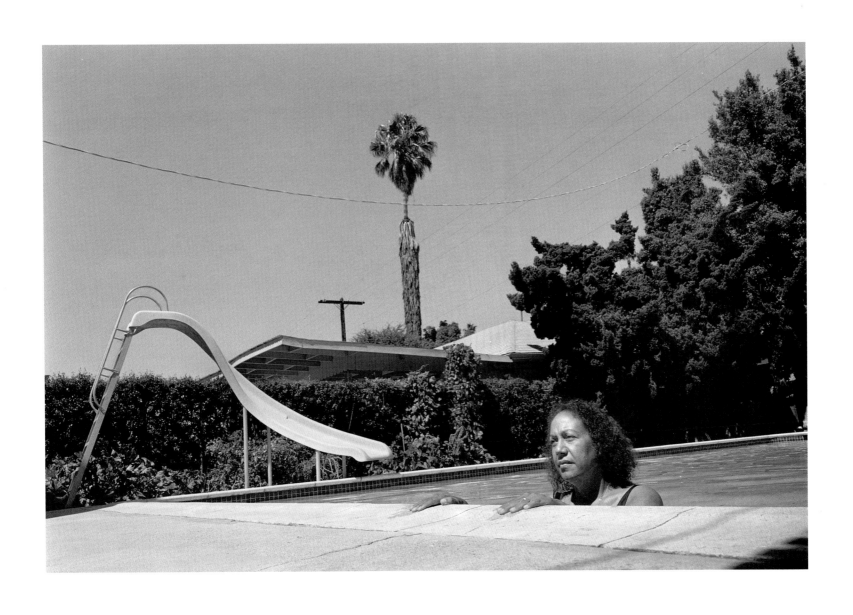

Los Angeles, California, 1990

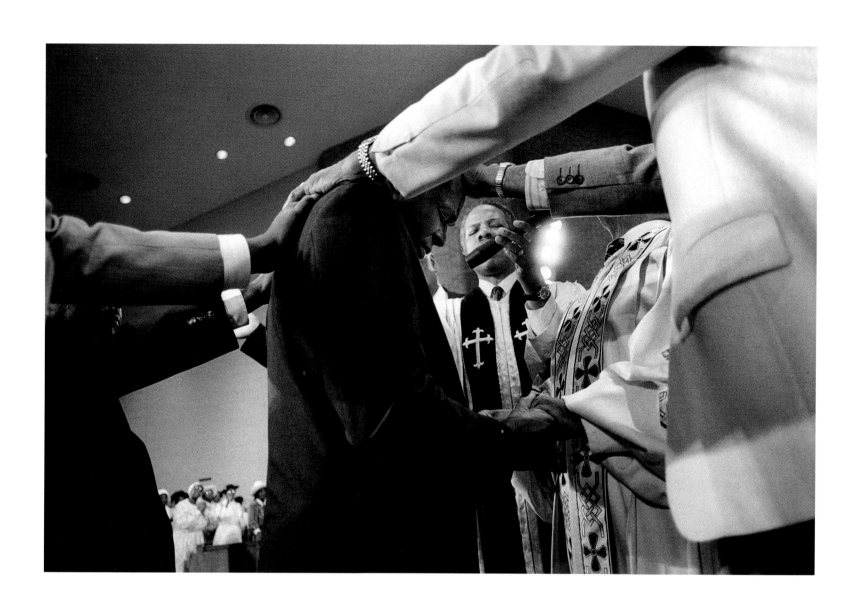

Mayor Marion Barry, Washington, D.C., 1990

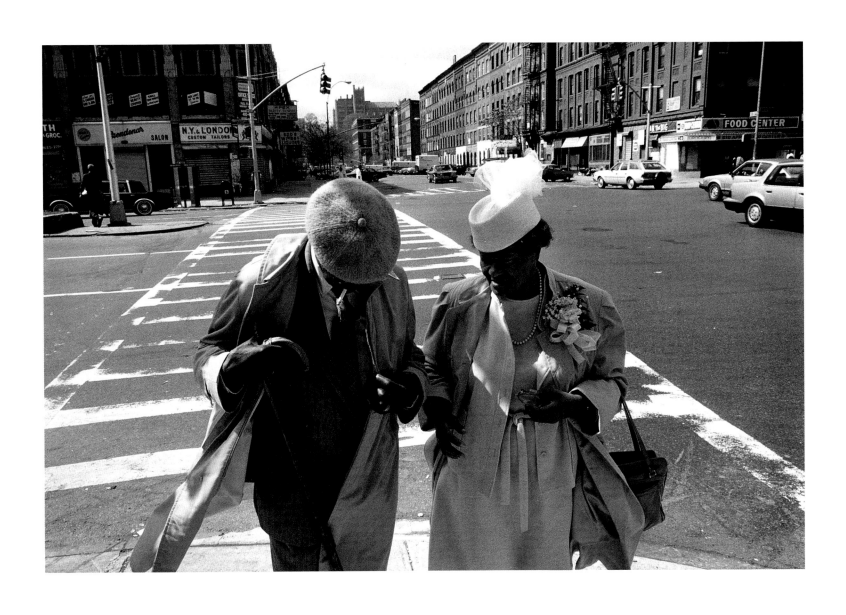

Harlem, New York City, 1991

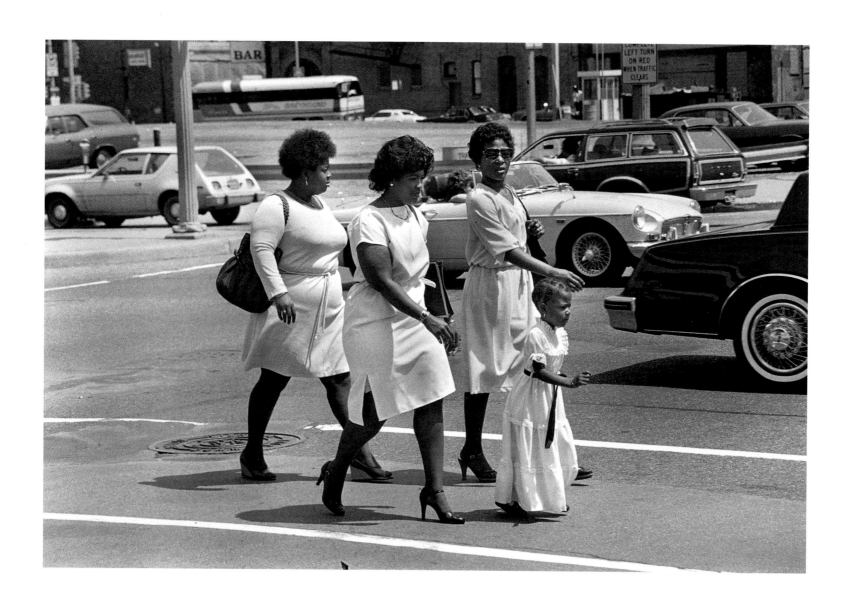

Detroit, Michigan, 1978

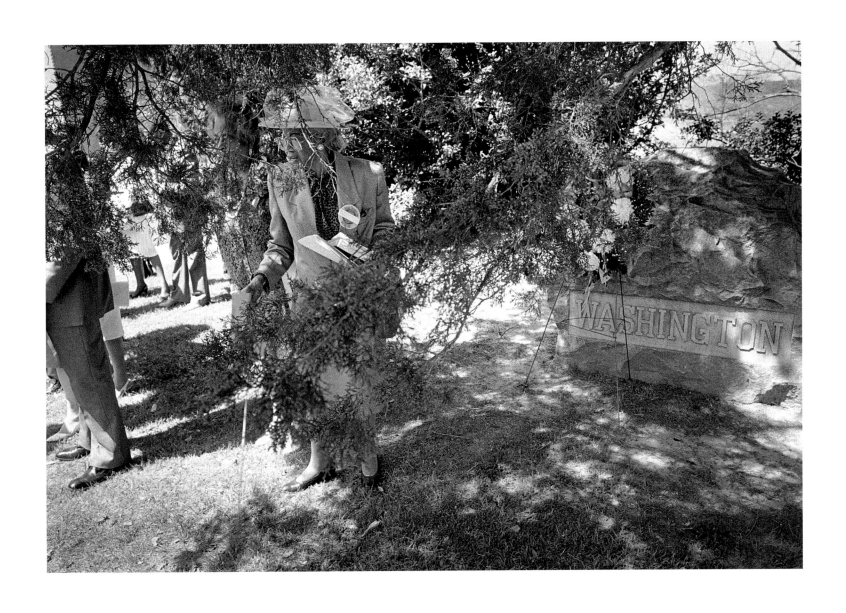

Tuskegee Institute, Tuskegee, Alabama, 1994

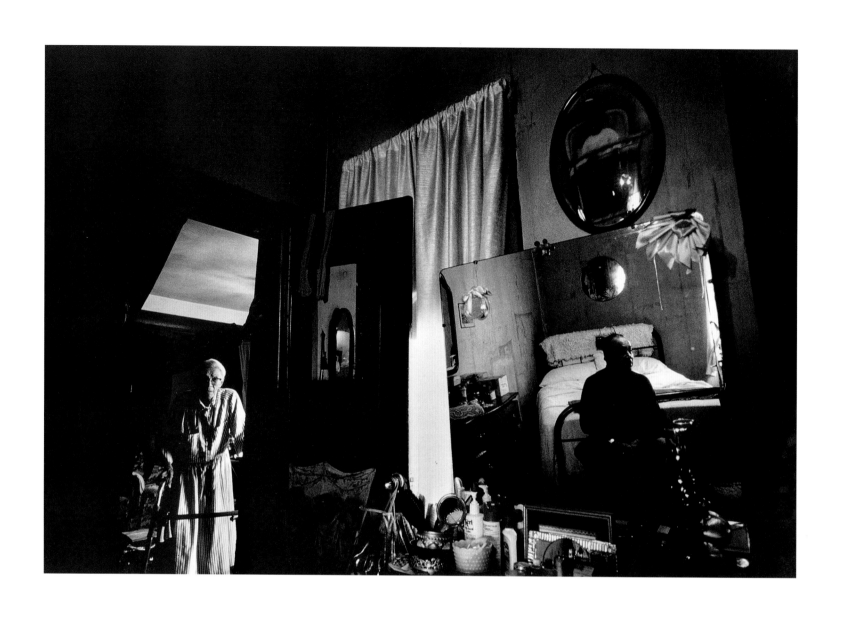

104-year-old woman, Chilicothe, Ohio, 1993

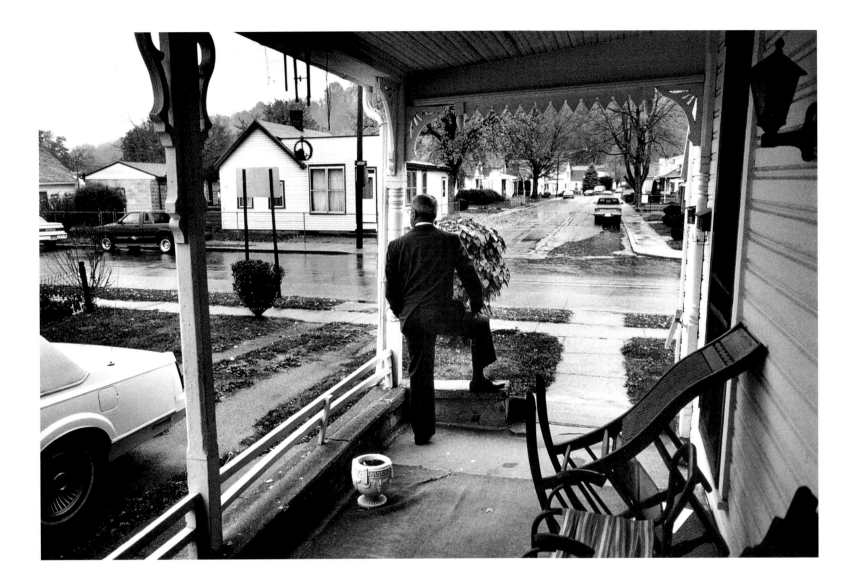

Chilicothe, Ohio, 1993

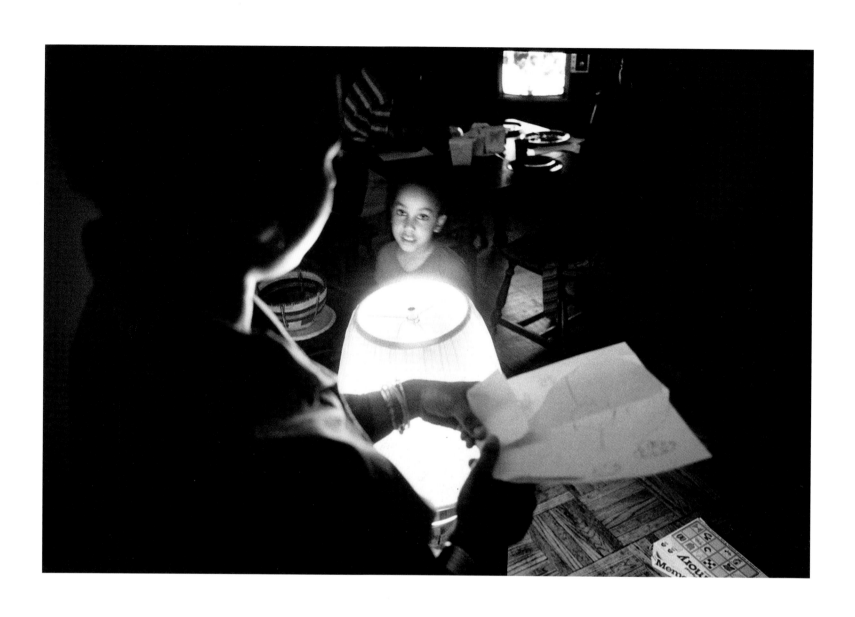

Brooklyn, New York, 1985

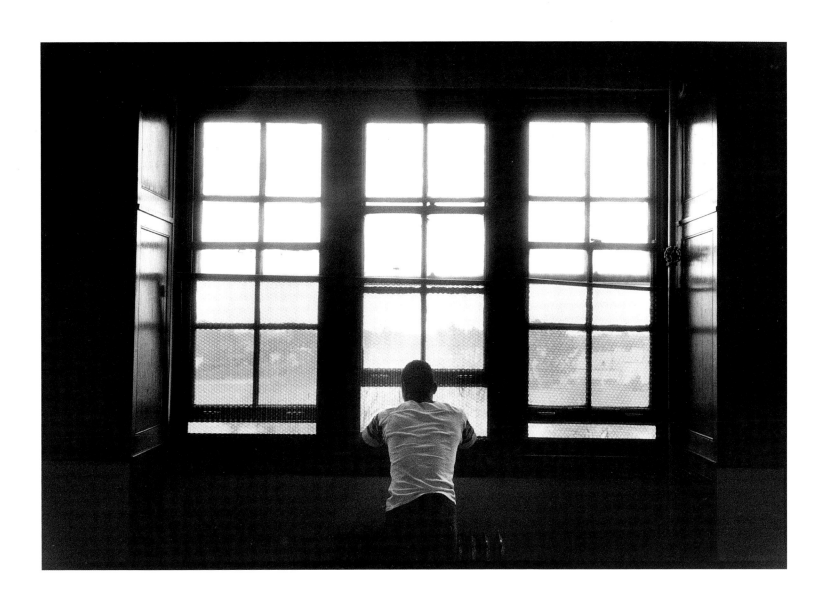

State school for orphans, Detroit, Michigan, 1988

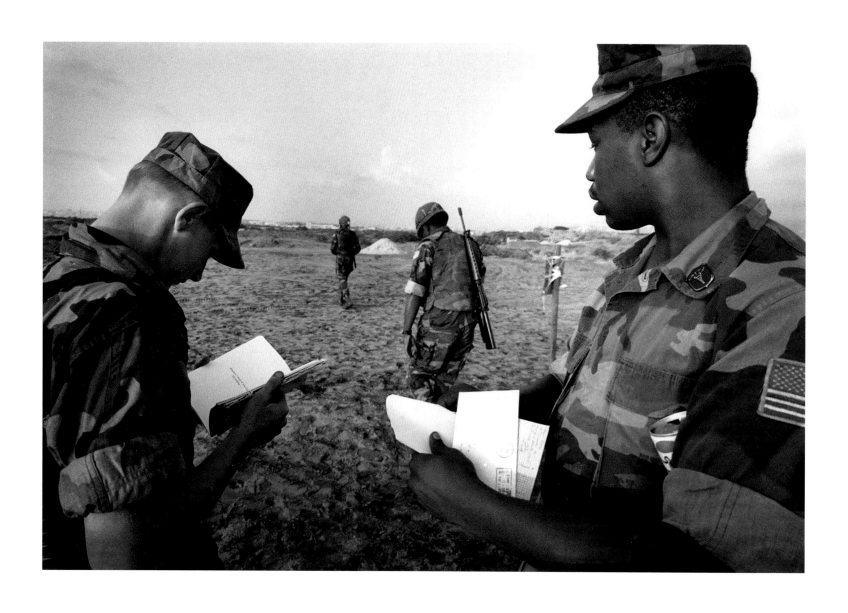

MARINES, BEIRUT, LEBANON, 1983

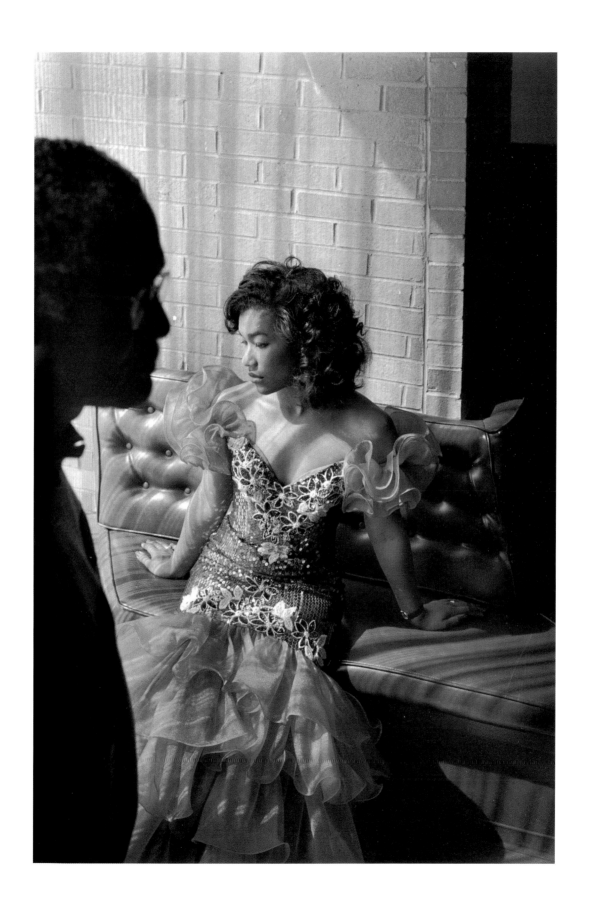

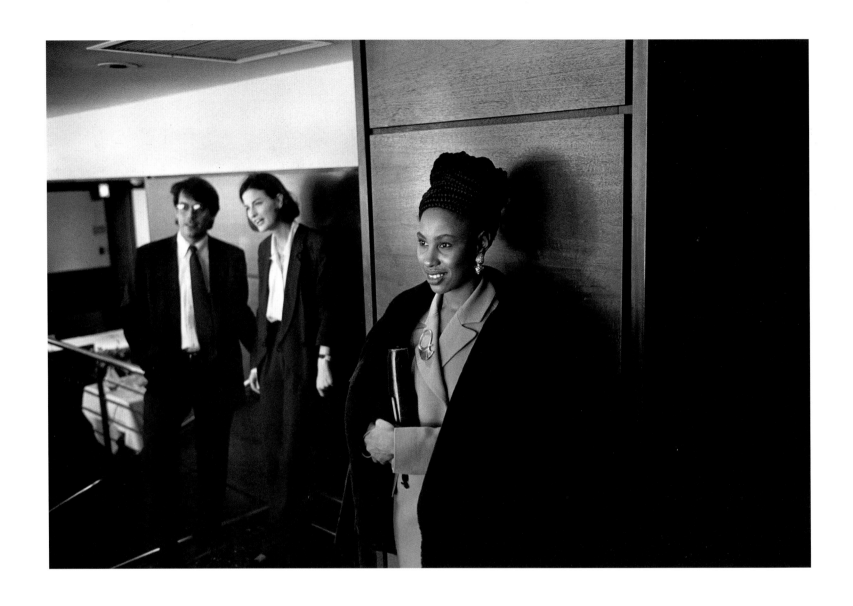

INAUGURAL RECEPTION FOR PRESIDENT CLINTON, WASHINGTON, D.C., 1992

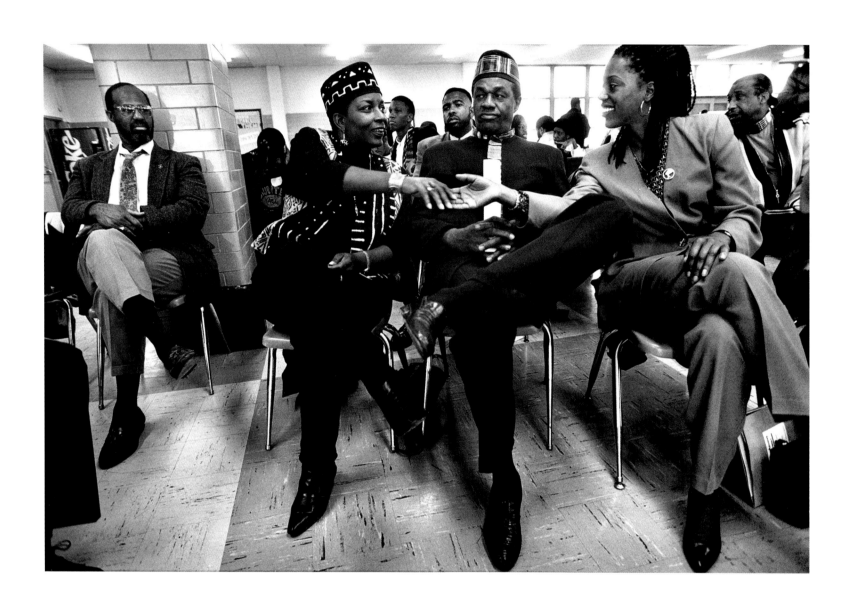

MAYOR MARION BARRY WITH HIS FIANCÉE (RIGHT) AT AN ANTIVIOLENCE RALLY, WASHINGTON, D.C., 1993

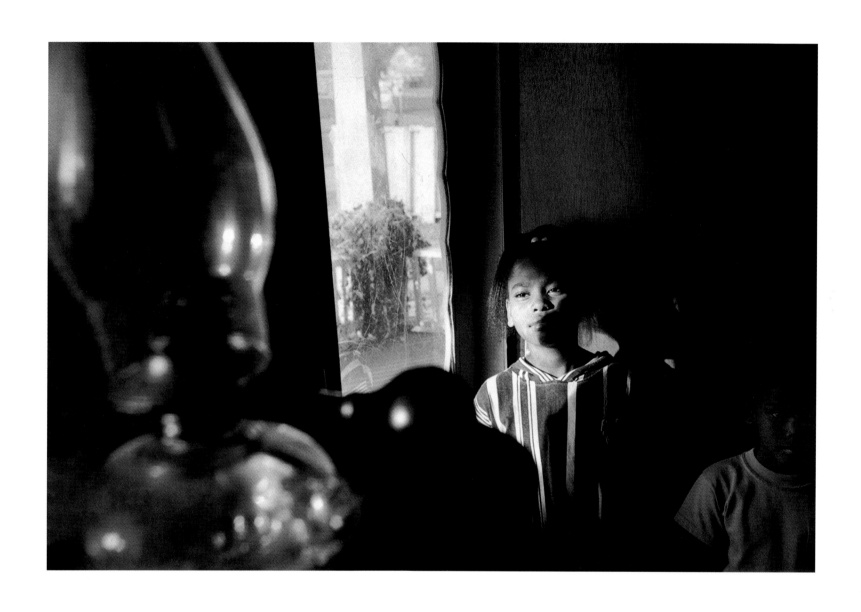

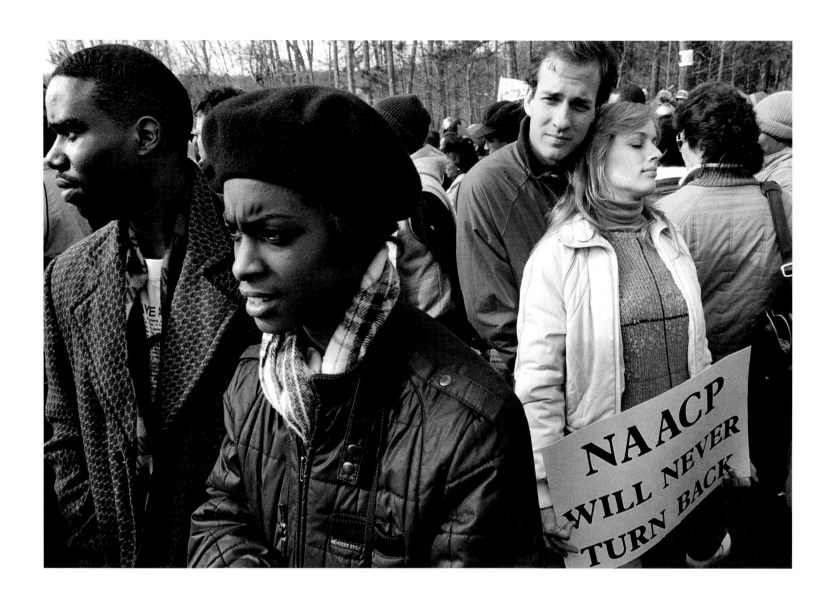

ANTIRACISM MARCH, FORSYTH COUNTY, GEORGIA, 1987

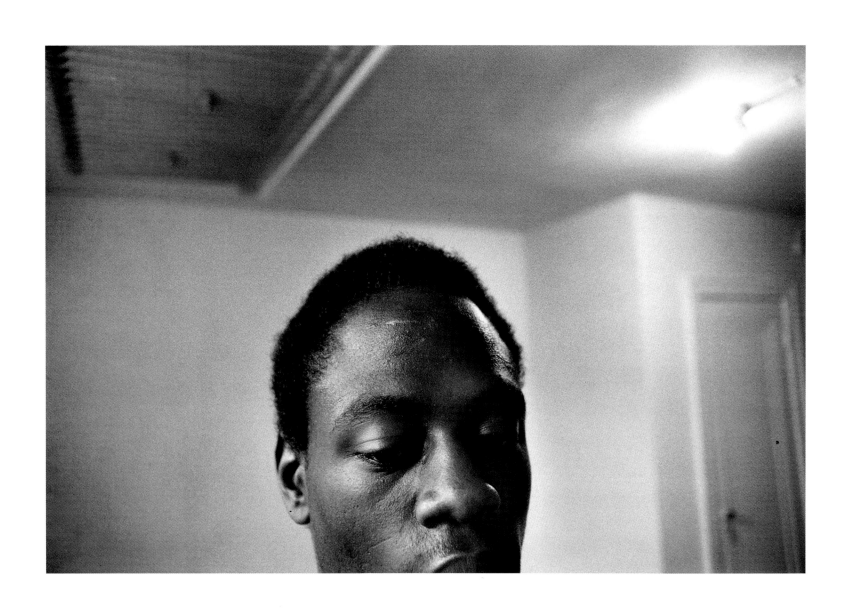

DETROIT, MICHIGAN, 1985

68

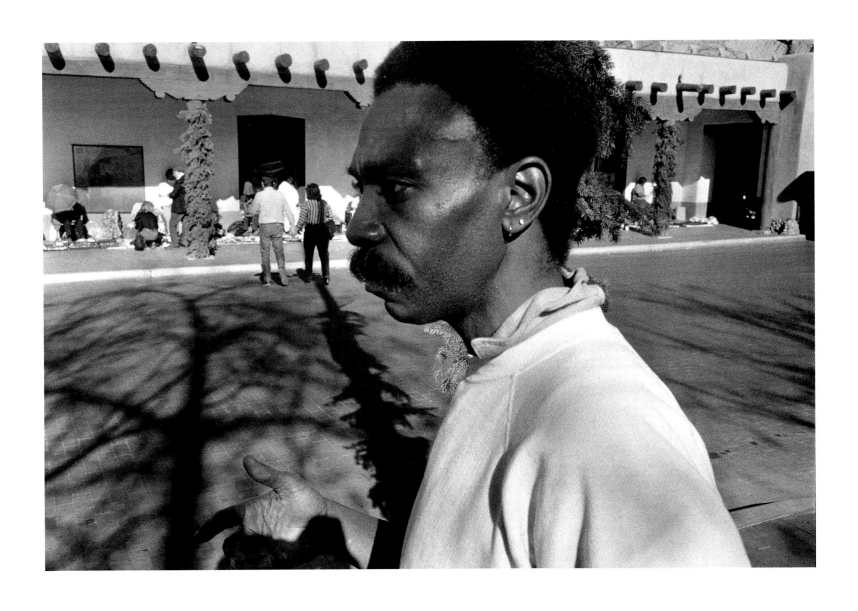

S A N T A F E , N E W M E X I C O , 1 9 9 1

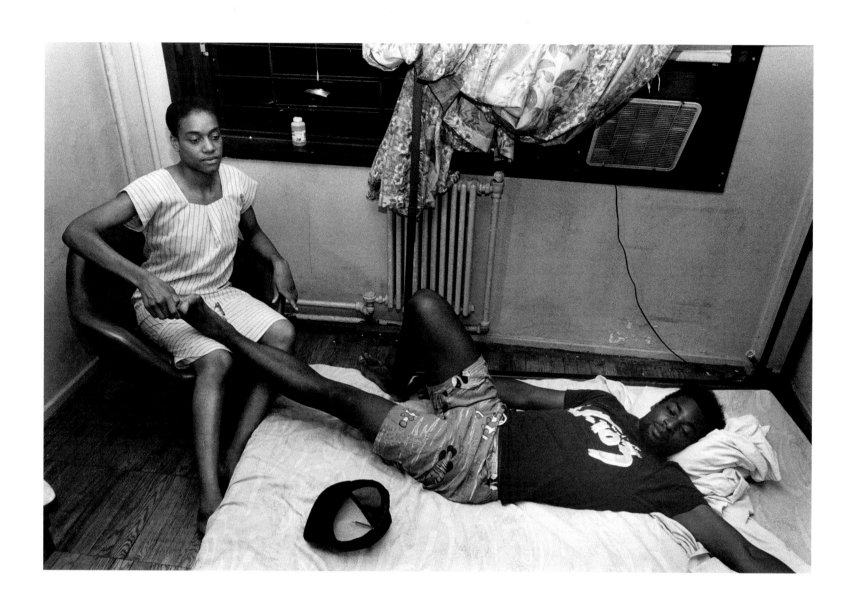

RAP ARTIST JUSTICE WITH HIS GIRLFRIEND, NEW YORK CITY, 1986

70

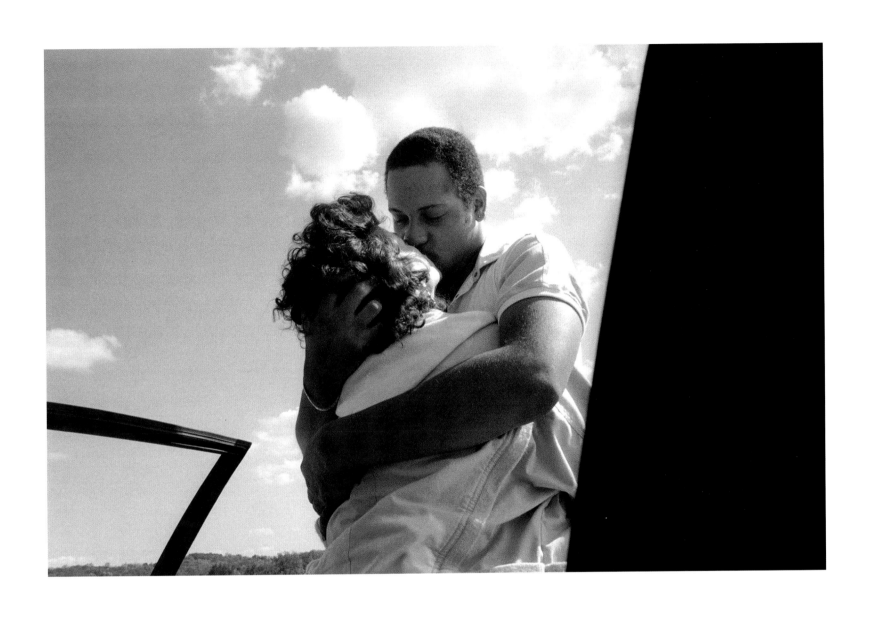

ANN ARBOR, MICHIGAN, 1988

71

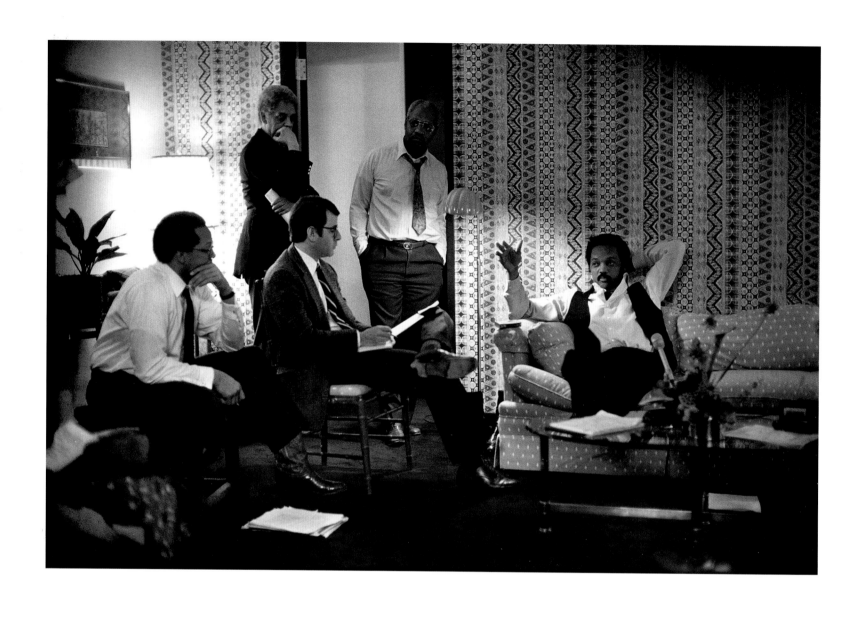

JESSE JACKSON ON THE PRESIDENTIAL CAMPAIGN TRAIL, HARTFORD, CONNECTICUT, 1984

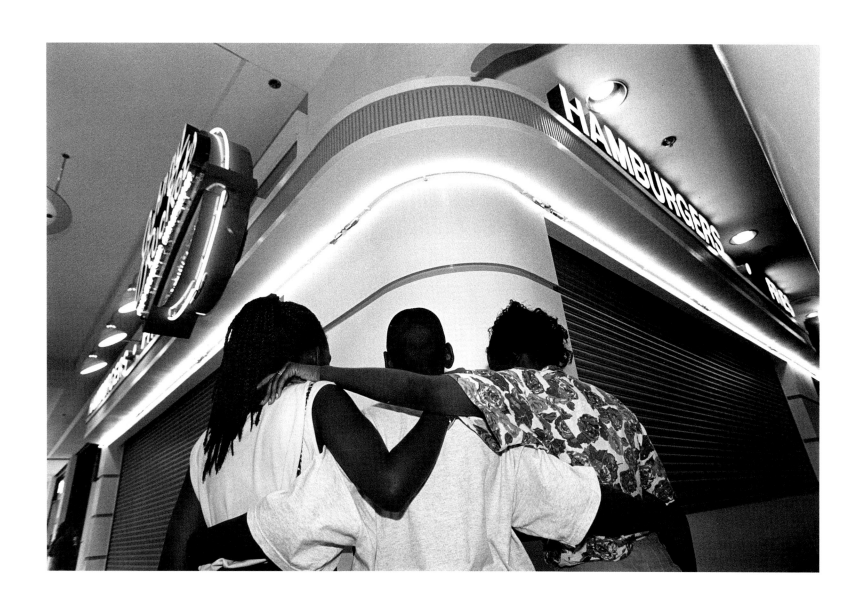

SILVER CITY, VIRGINIA, 1995

OVERLEAF: FUNERAL OF YUSEF HAWKINS, BROOKLYN, NEW YORK, 1989

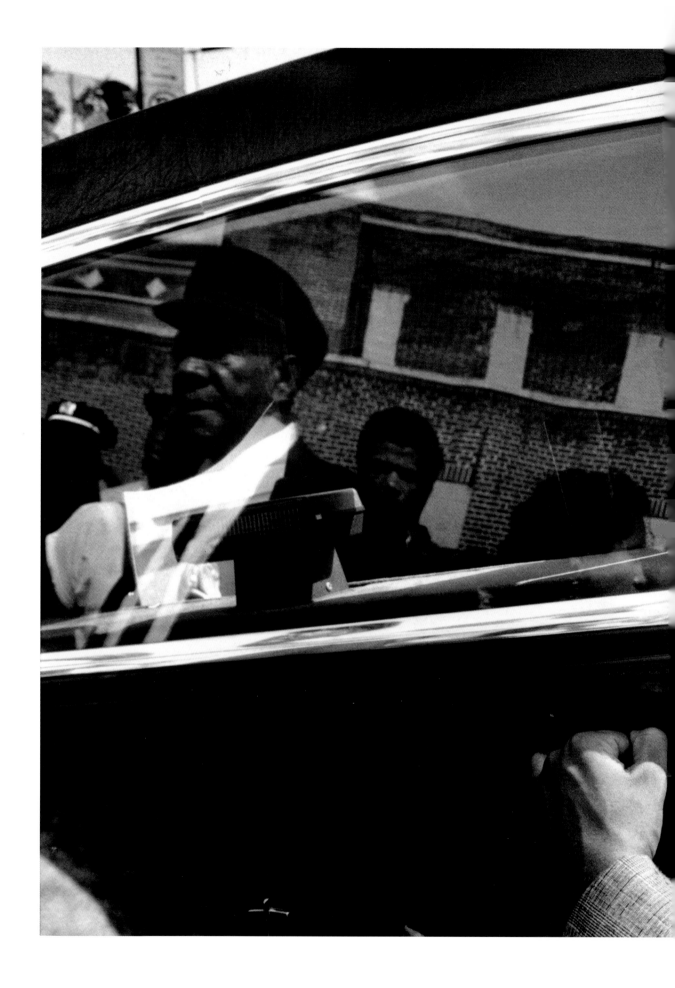

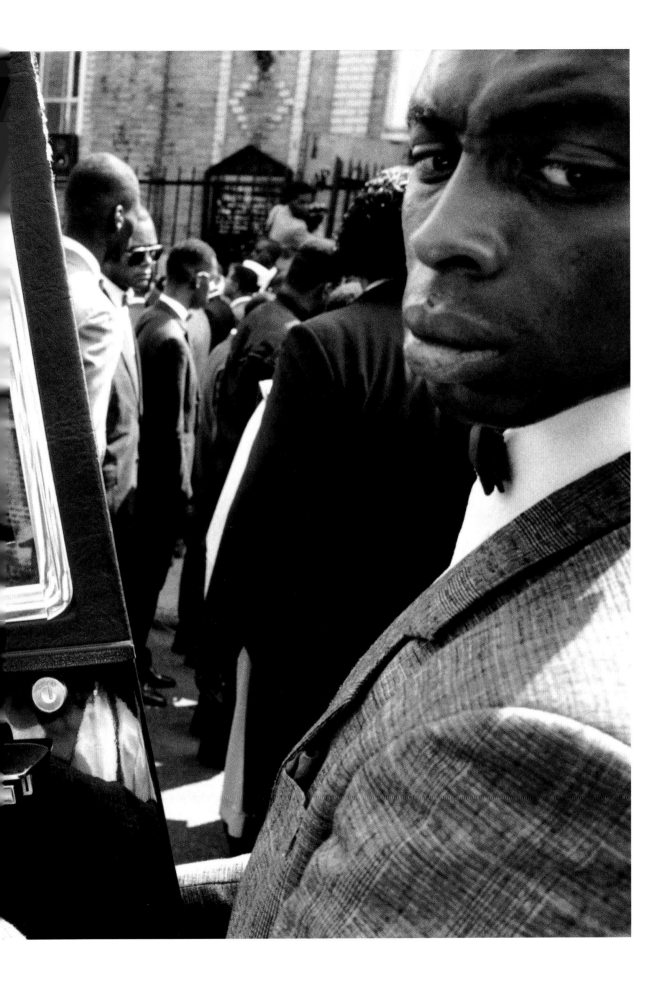

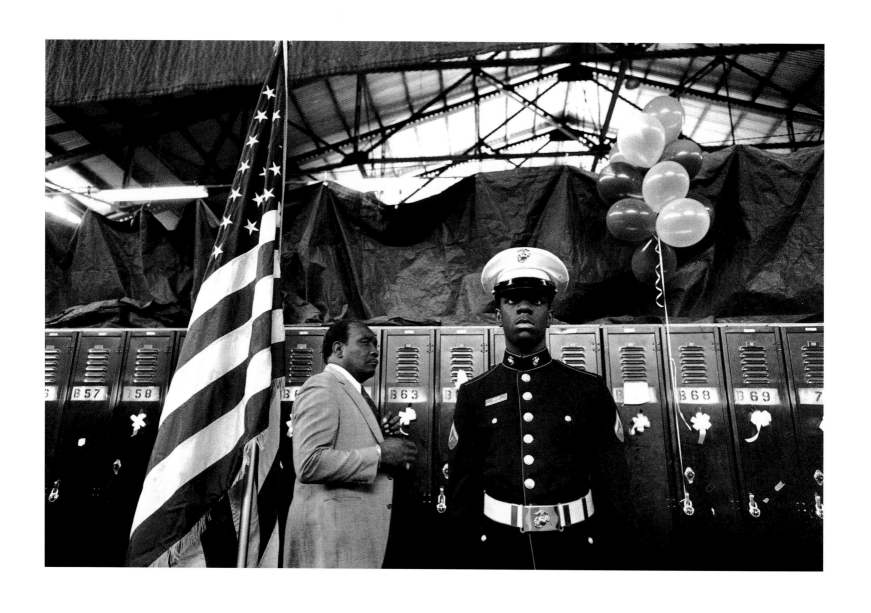

168TH STREET NATIONAL ARMORY, NEW YORK CITY, 1991

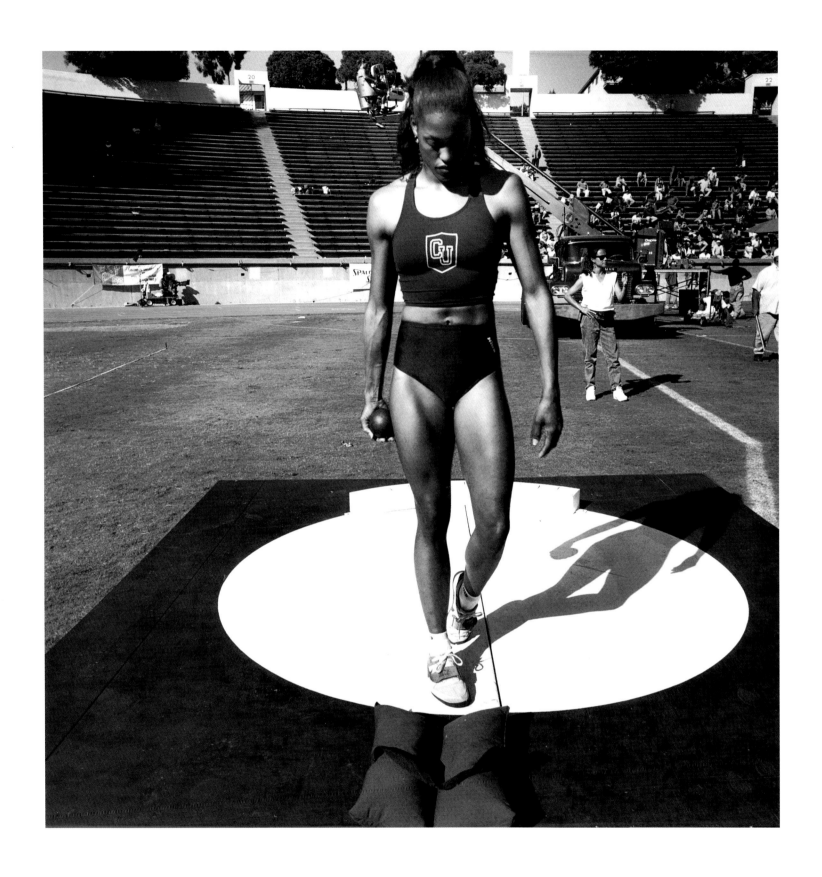

LOS ANGELES, CALIFORNIA, 1994

77

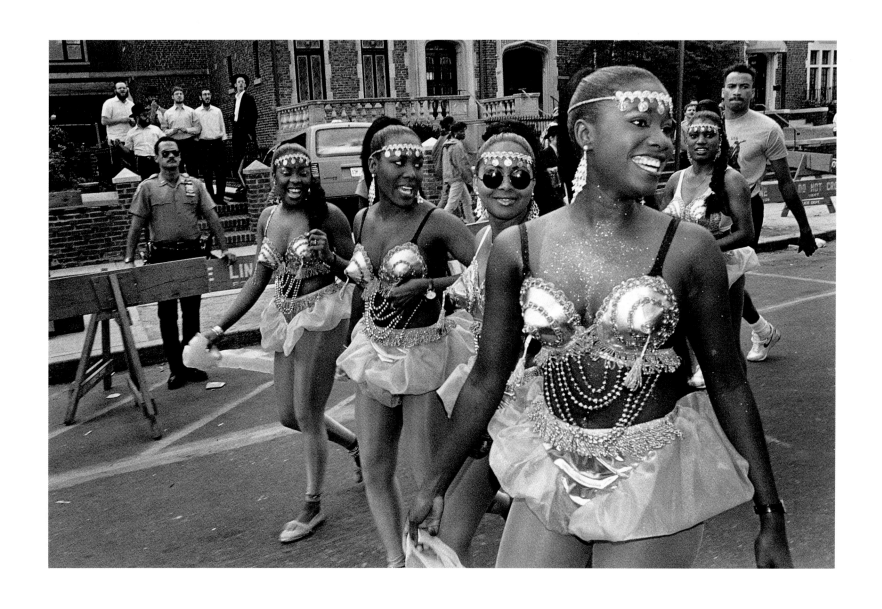

WEST INDIAN LABOR DAY PARADE, BROOKLYN, NEW YORK, 1991

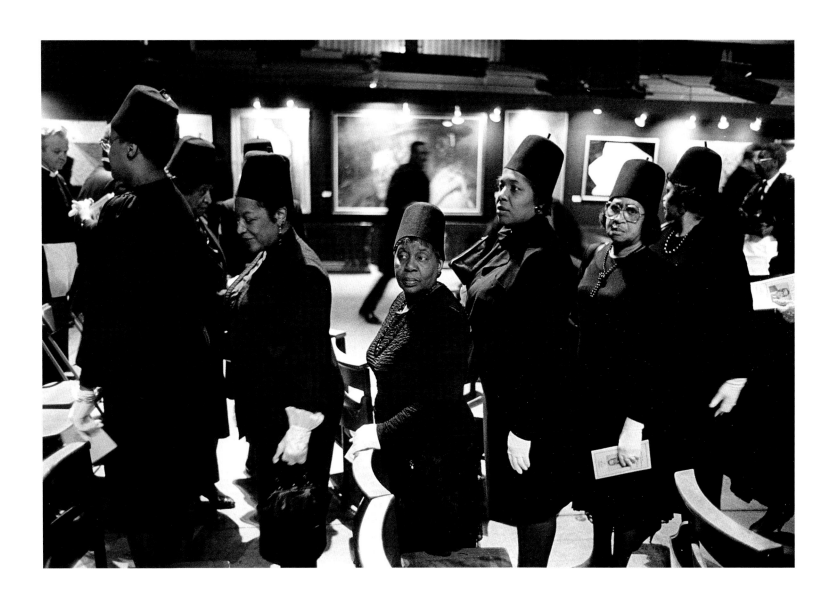

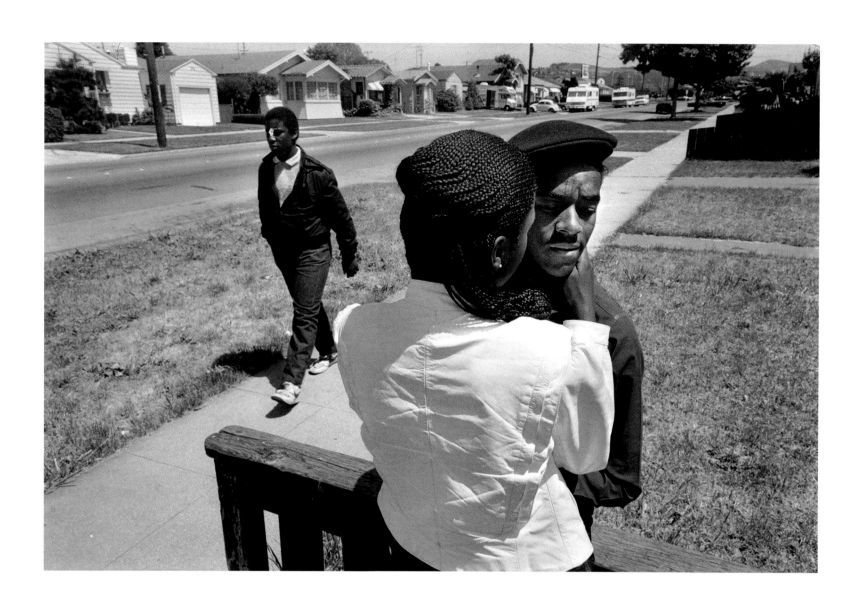

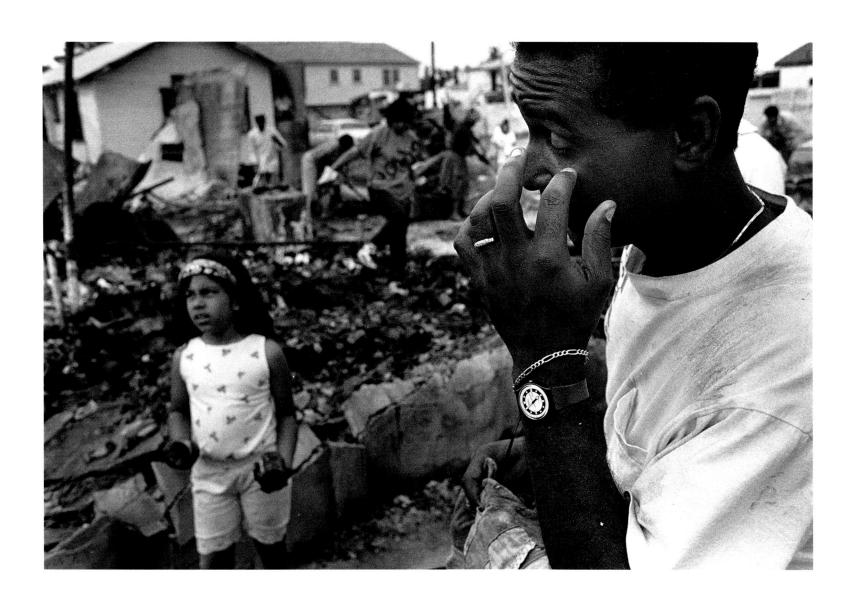

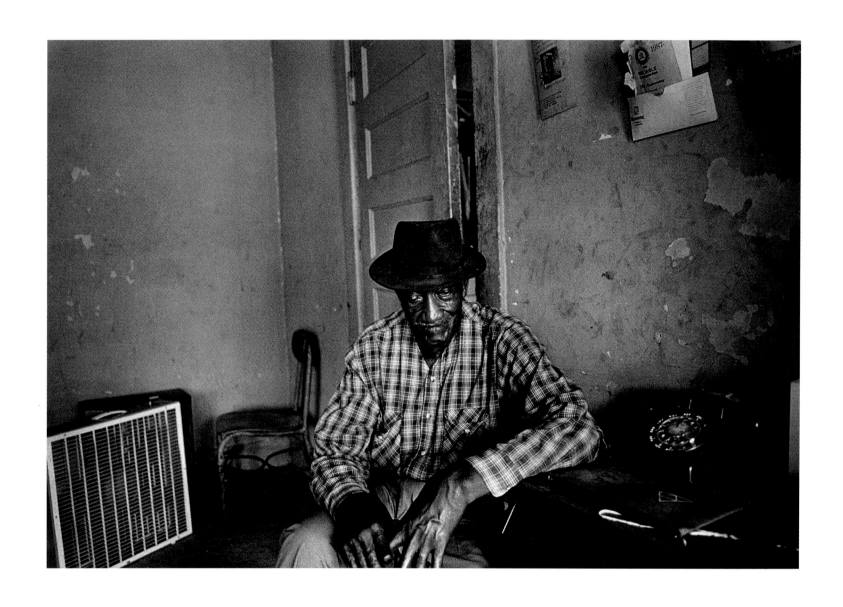

WEST DALLAS, TEXAS, 1993

82

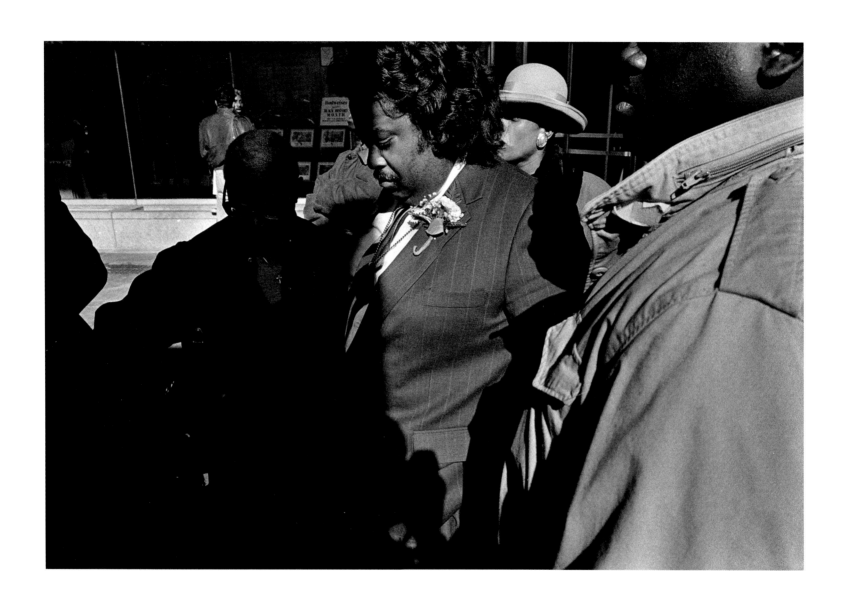

REVEREND AL SHARPTON, HARLEM, NEW YORK CITY, 1988

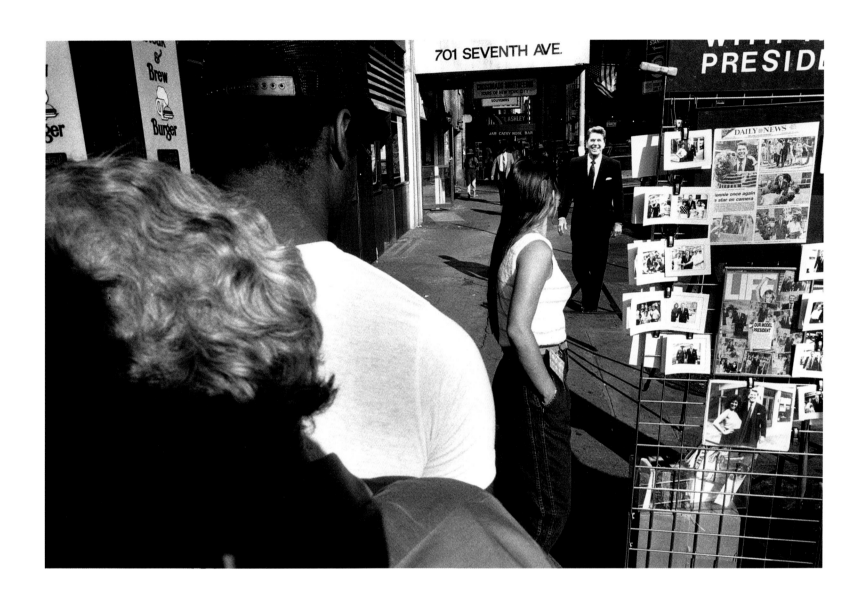

RAP ARTIST JUSTICE, NEW YORK CITY, 1986

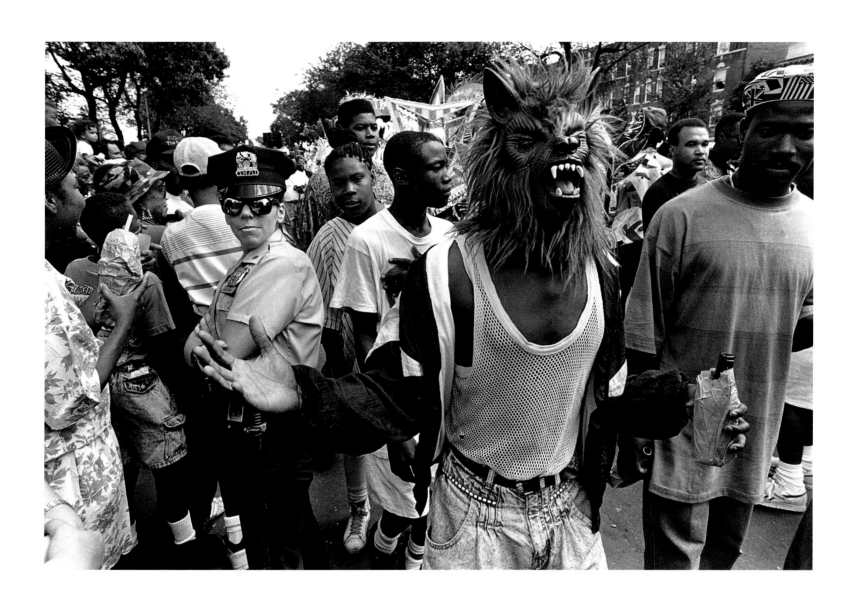

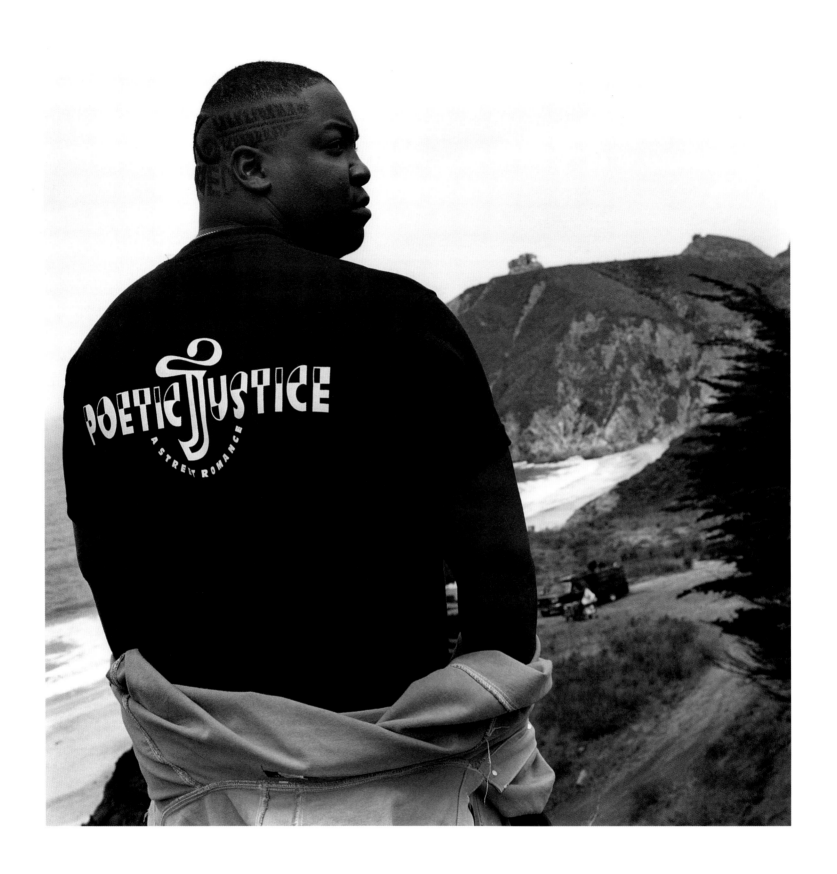

POETIC JUSTICE MOVIE CREW MEMBER IN CALIFORNIA, 1992

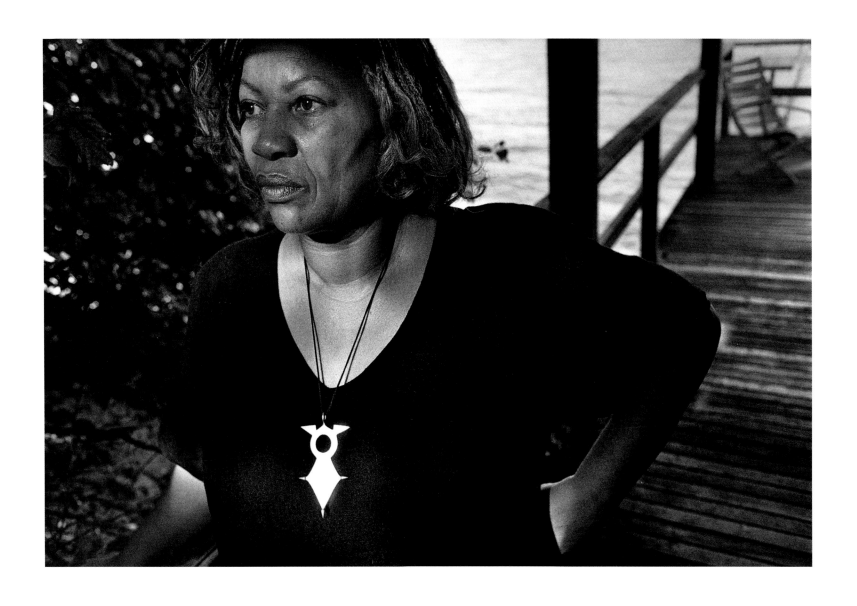

TONI MORRISON, TARRYTOWN, NEW YORK, 1993

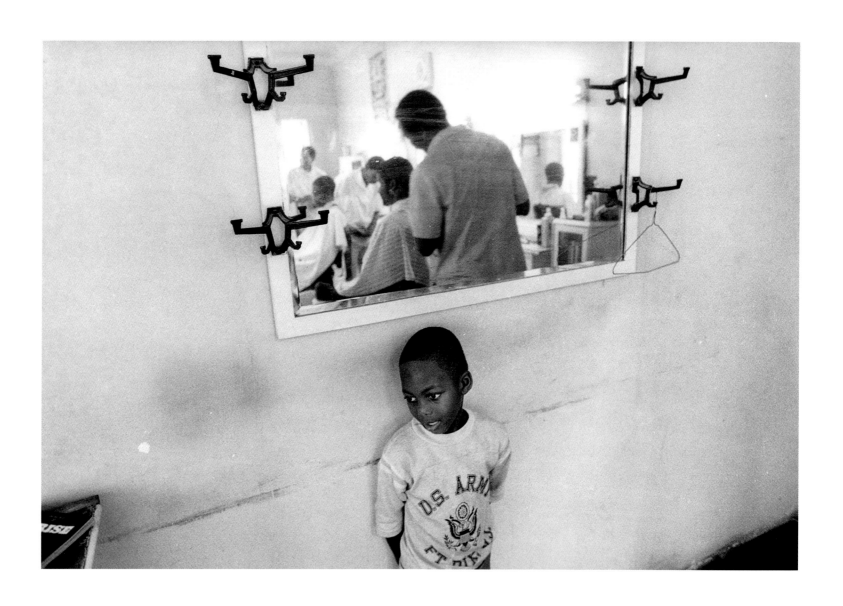

BARBERSHOP, BEAUFORT, SOUTH CAROLINA, 1984

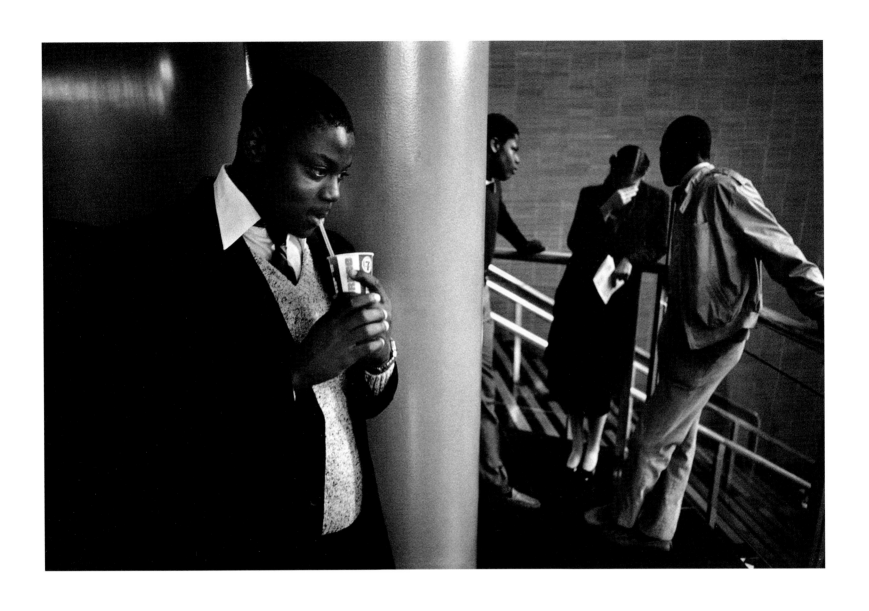

RELIGIOUS REVIVAL, RICHMOND, CALIFORNIA, 1980

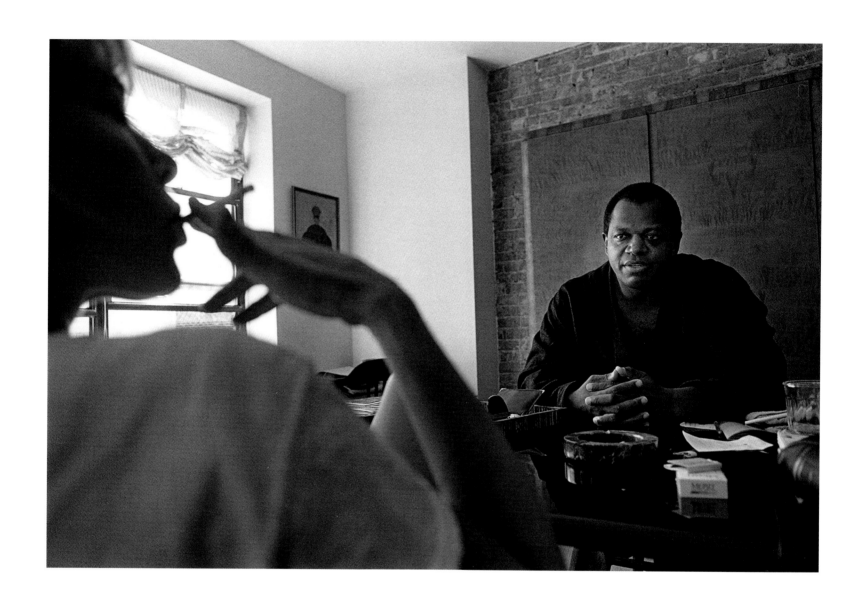

ACTOR CHARLES DUTTON AND AGENT, NEW YORK CITY, 1993

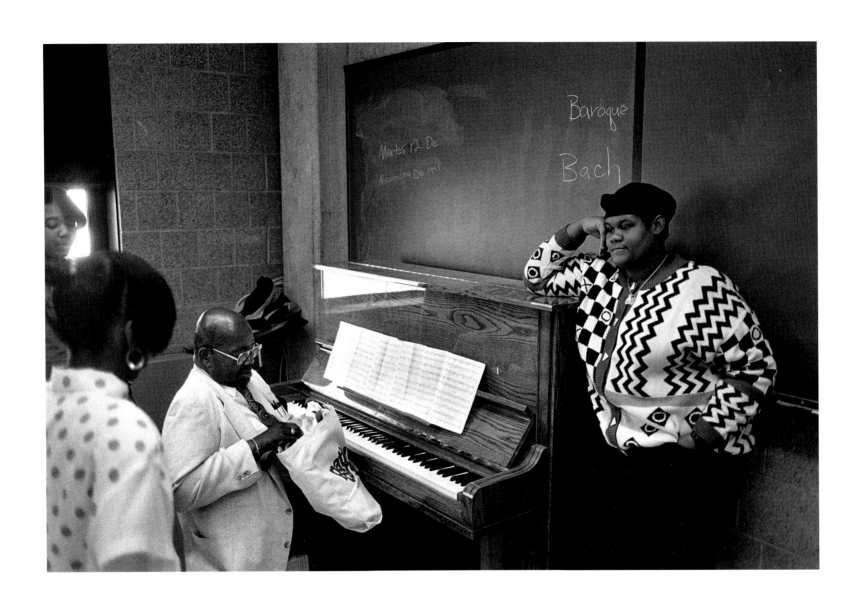

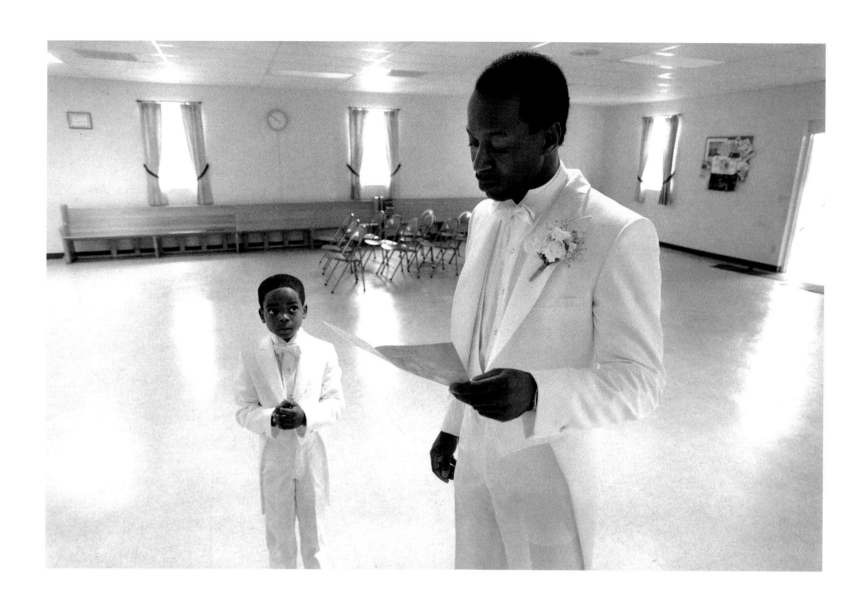

GROOM WITH RING BEARER, BEAUFORT, SOUTH CAROLINA, 1984

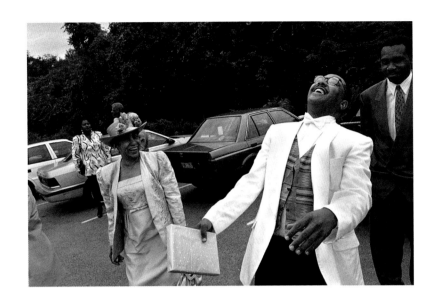

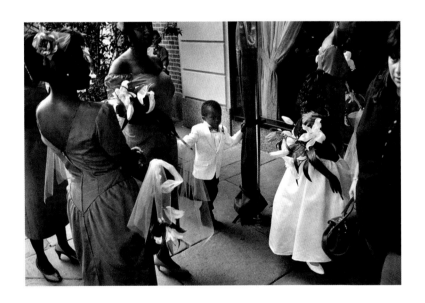

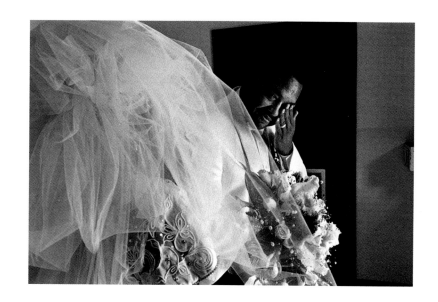

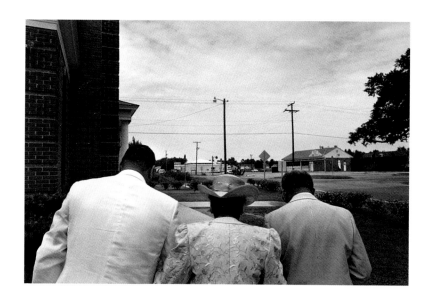

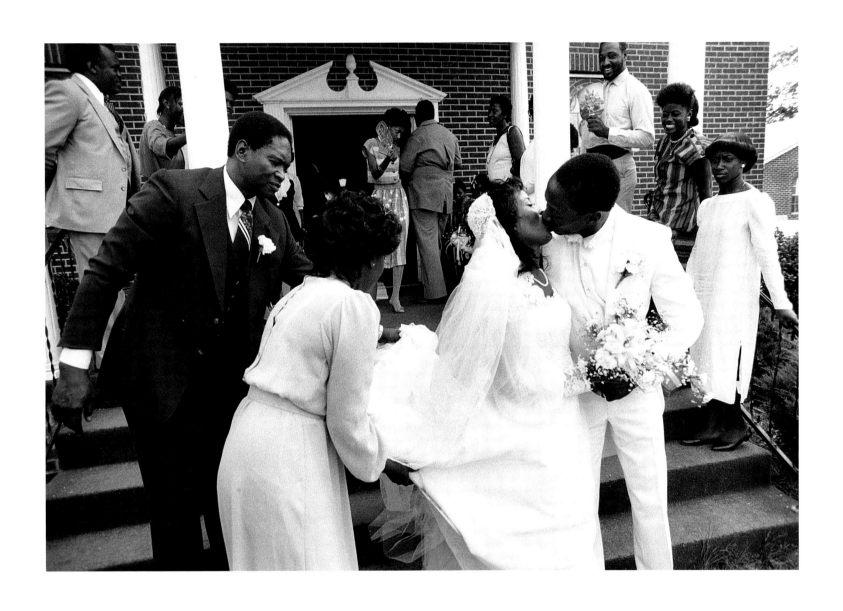

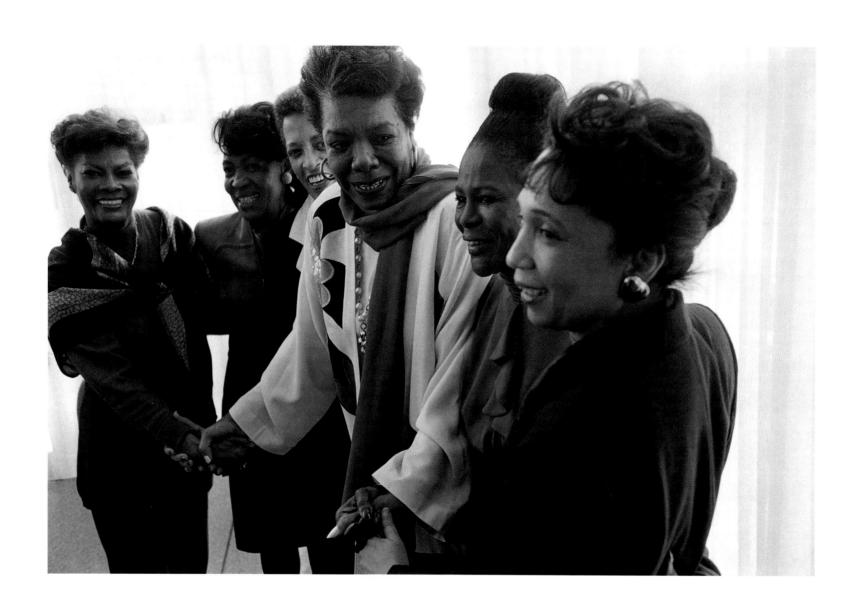

RECEPTION FOR POET MAYA ANGELOU (FOURTH FROM LEFT), WASHINGTON, D.C., 1993

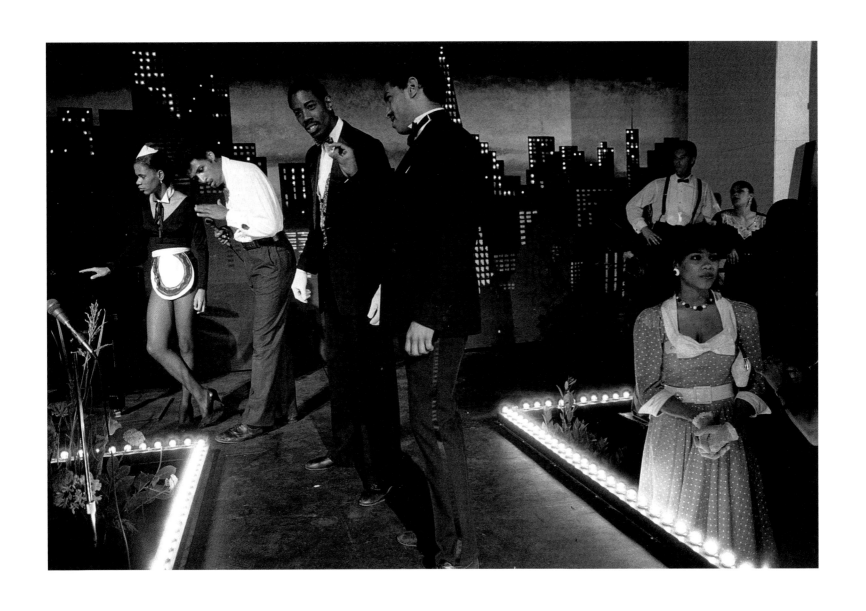

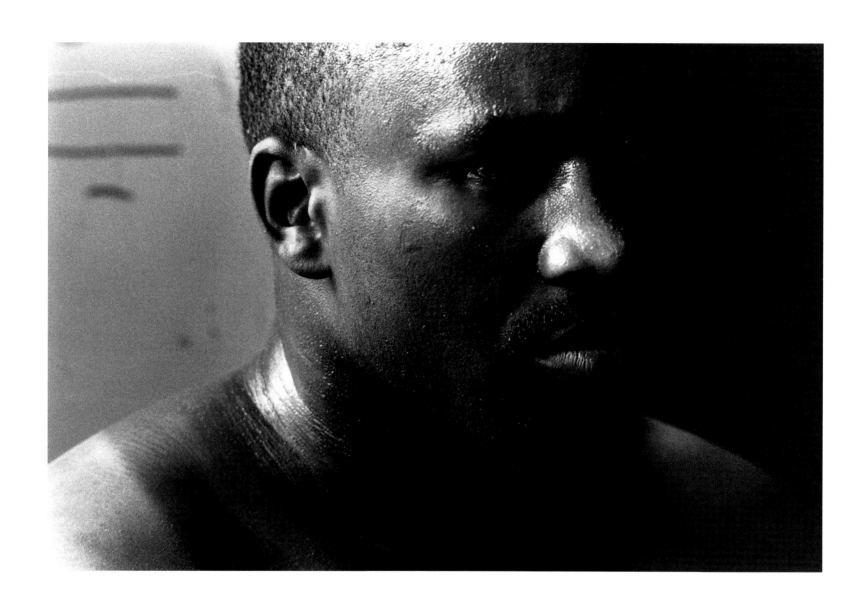

BOXER TIM WITHERSPOON, PHILADELPHIA, PENNSYLVANIA, 1990

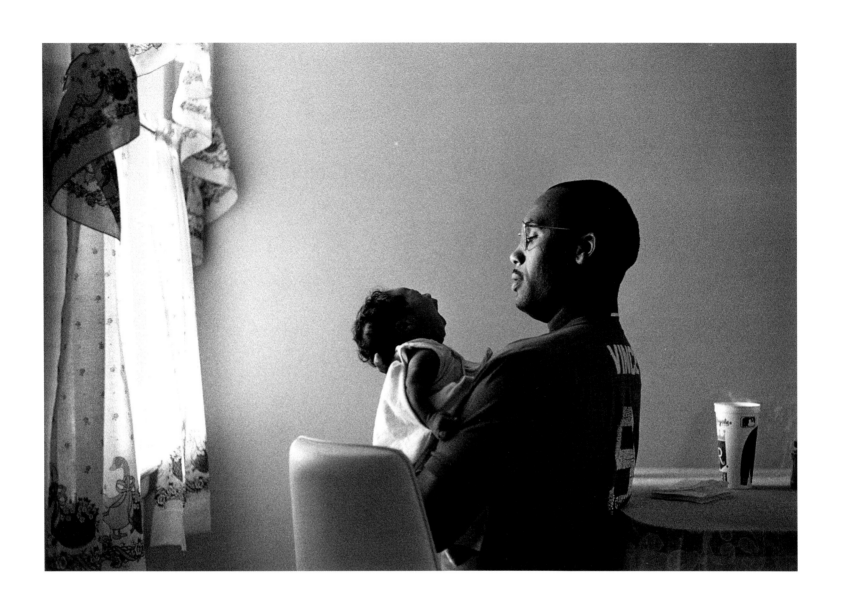

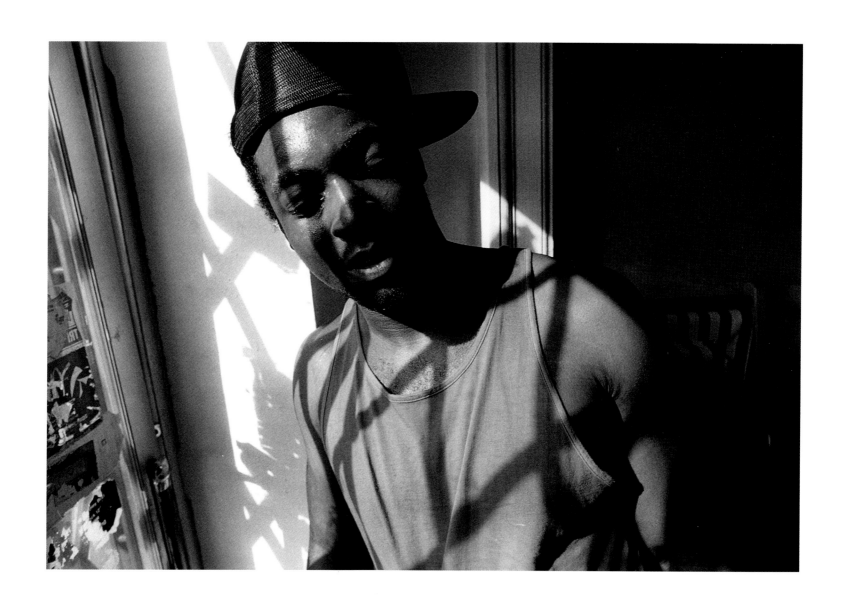

RAP ARTIST JUSTICE, NEW YORK CITY, 1986

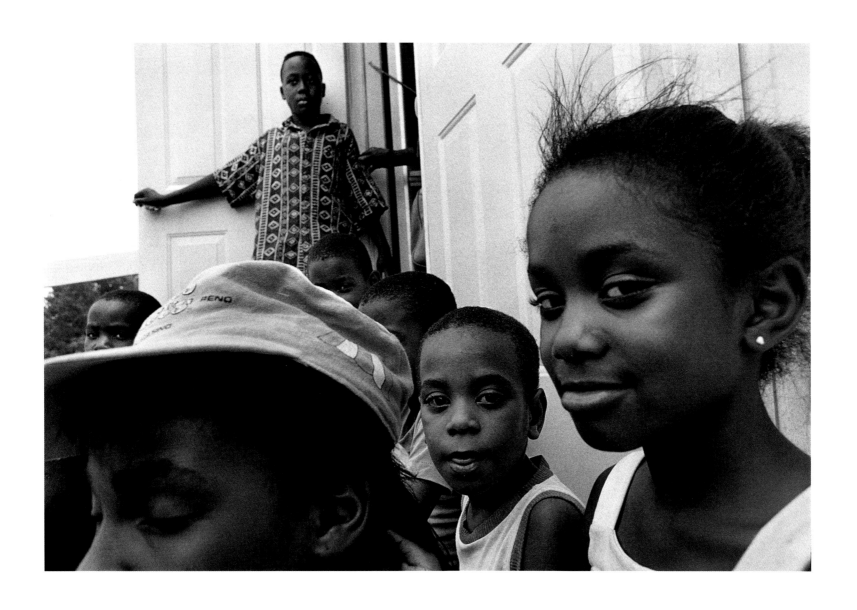

MISSISSIPPI DELTA TRAVELING COMMUNITY CENTER, MISSISSIPPI, 1991

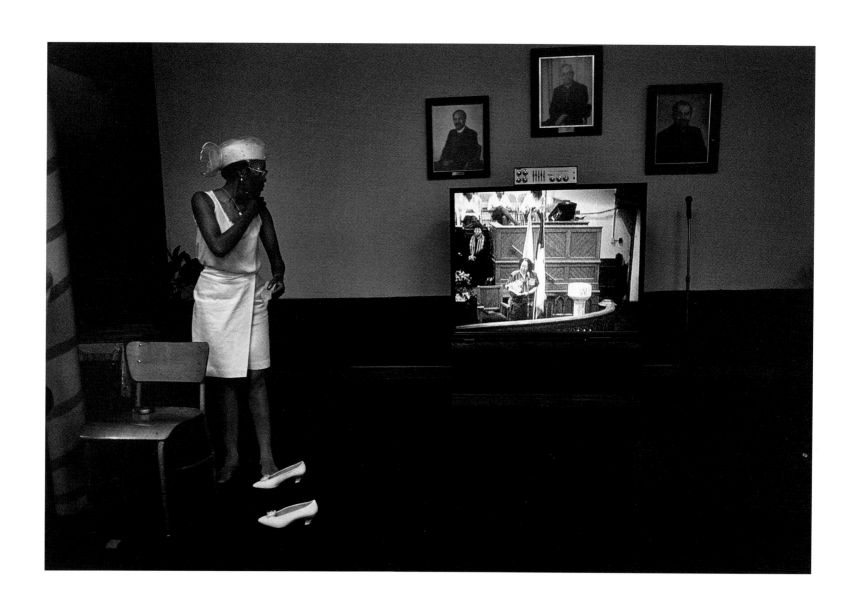

CHURCH BASEMENT, WASHINGTON, D.C., 1994

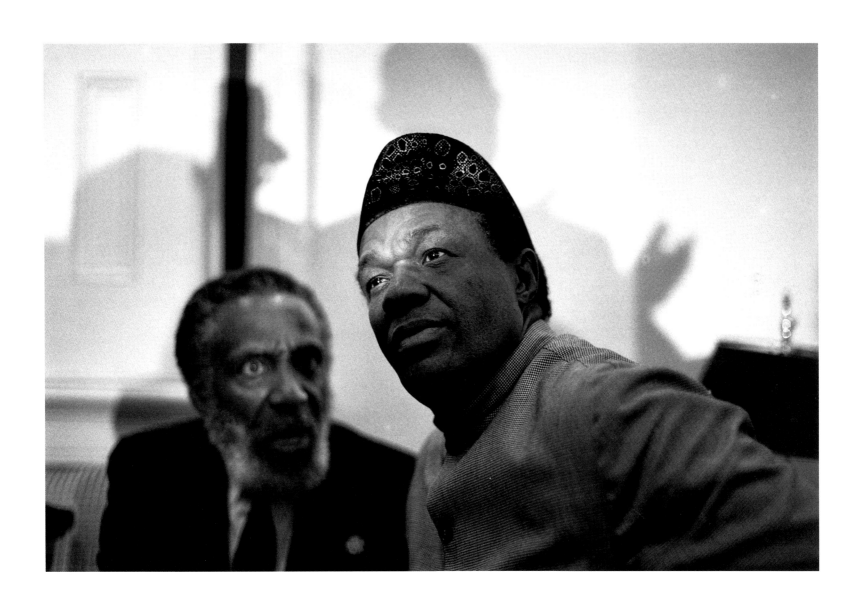

ACTIVIST DICK GREGORY AND MARION BARRY, WASHINGTON, D.C., 1993

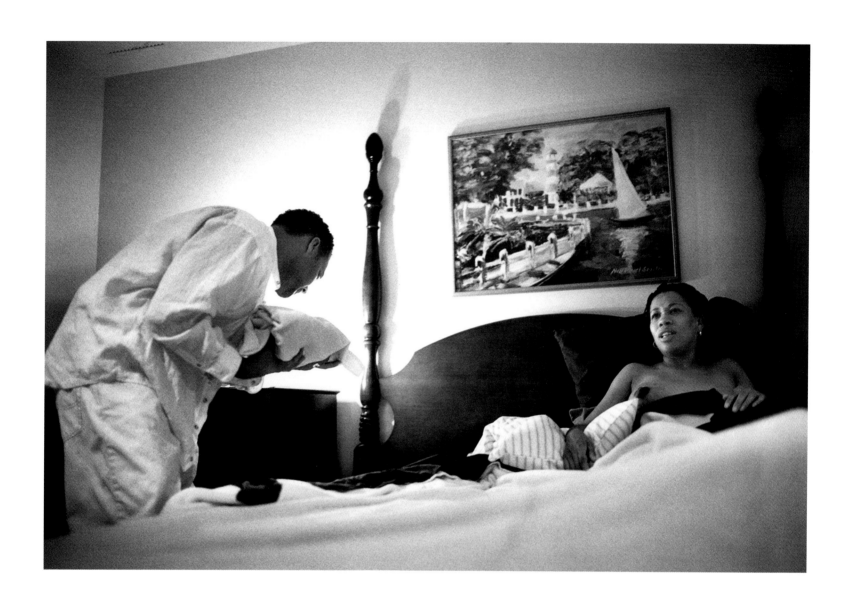

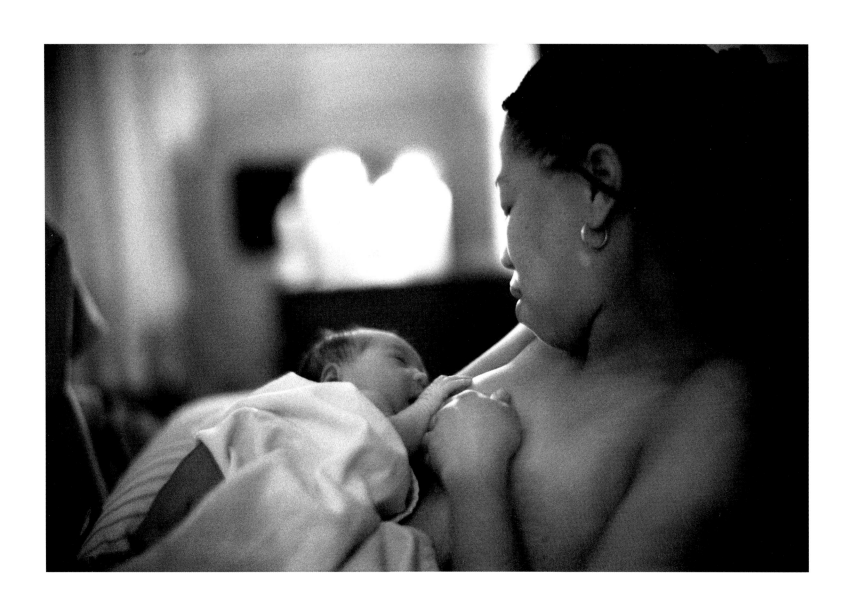

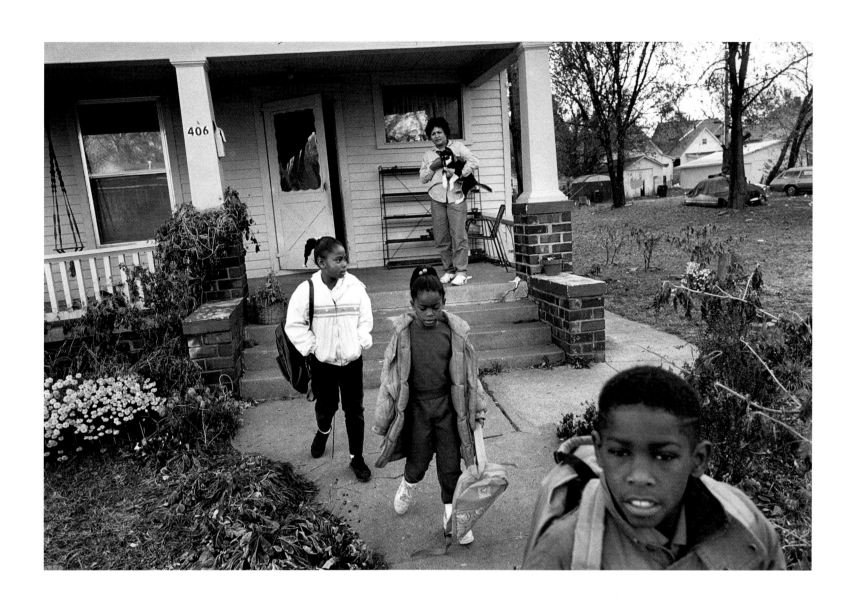

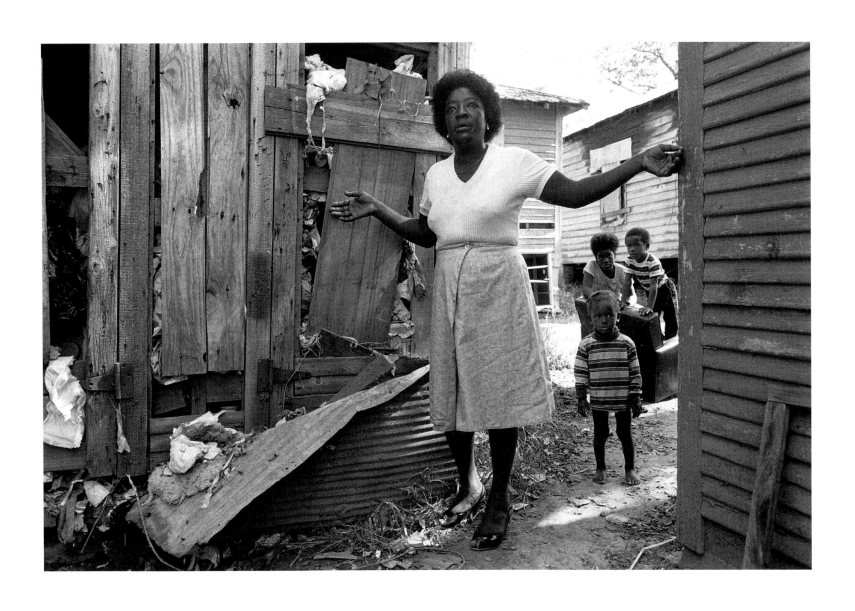

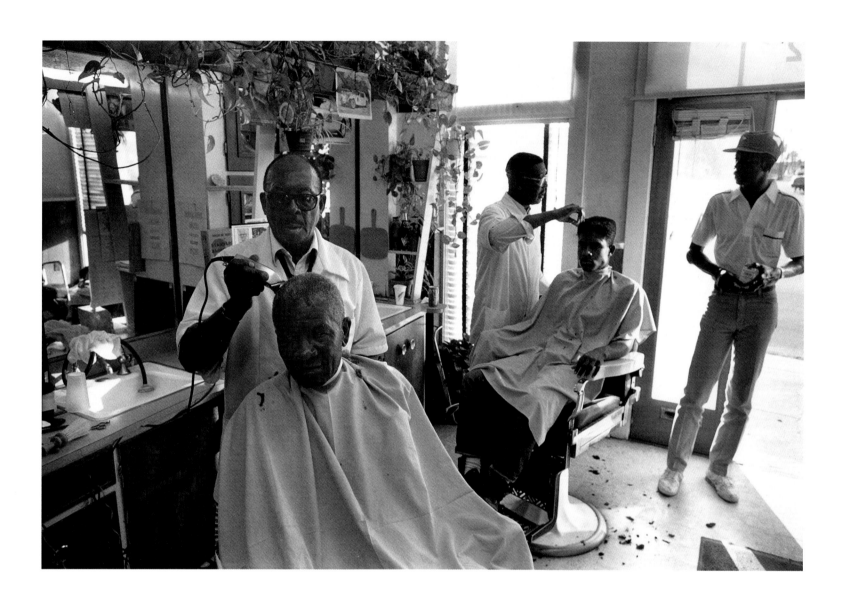

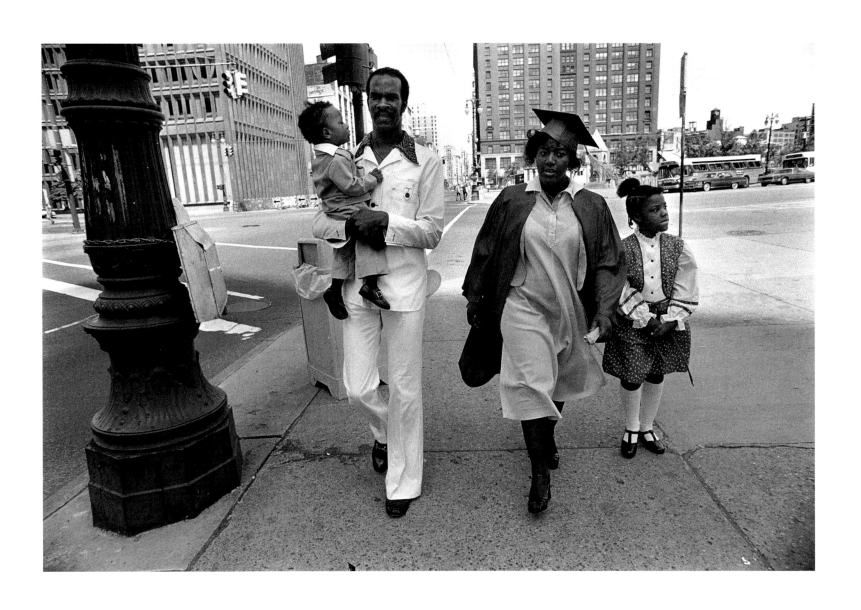

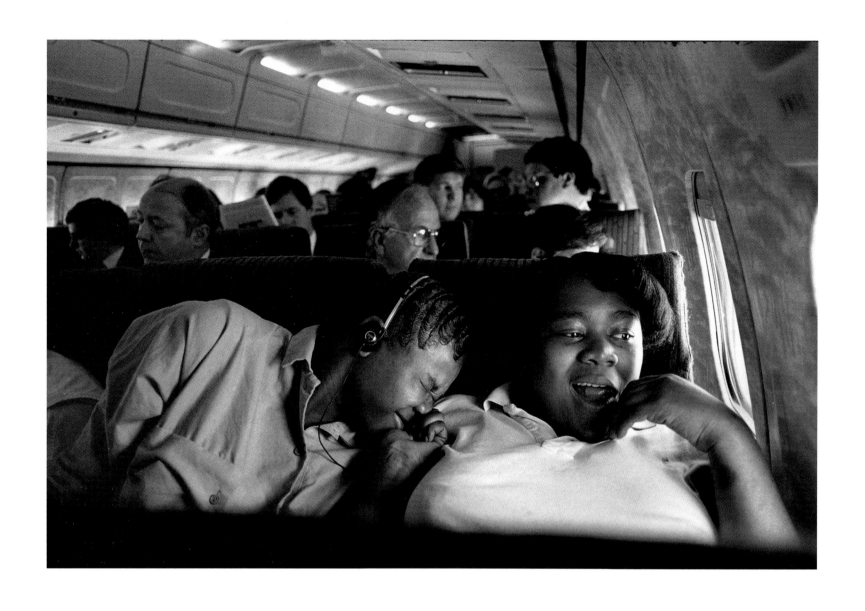

TEEN MOTHERS ON THEIR WAY TO A CONFERENCE ON TEEN PREGNANCY IN WASHINGTON, D.C., 1985

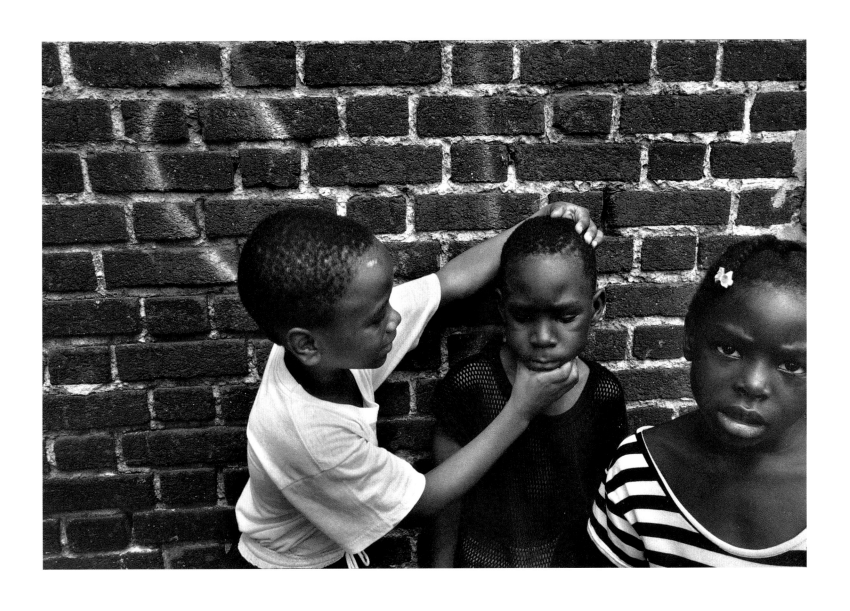

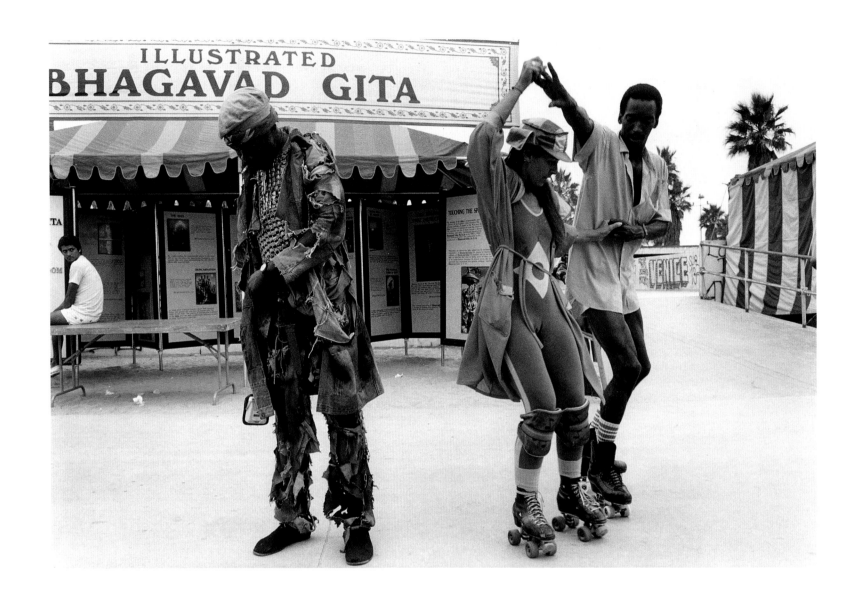

VENICE BEACH, CALIFORNIA, 1986

112

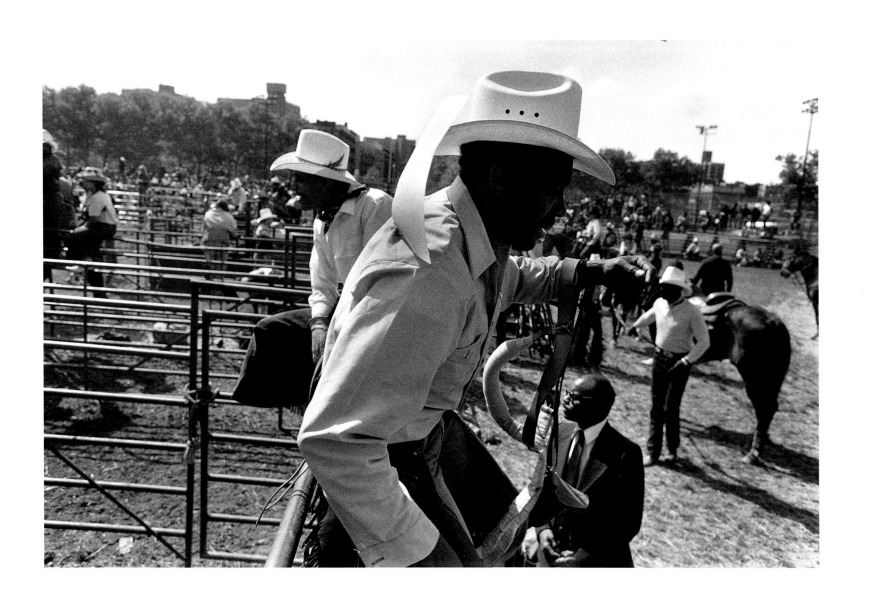

HARLEM RODEO, NEW YORK CITY, 1985

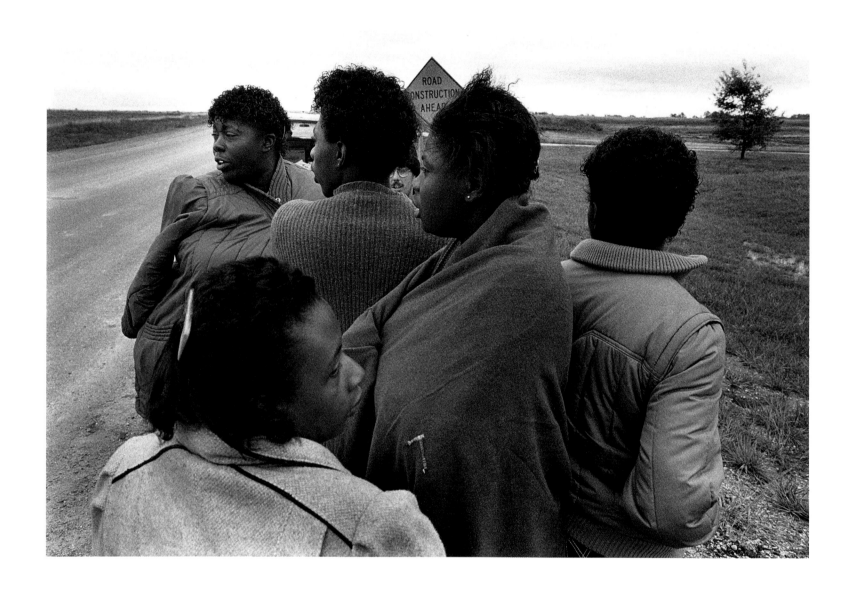

HOMELESS WOMEN, CENTRAL MISSOURI, 1986

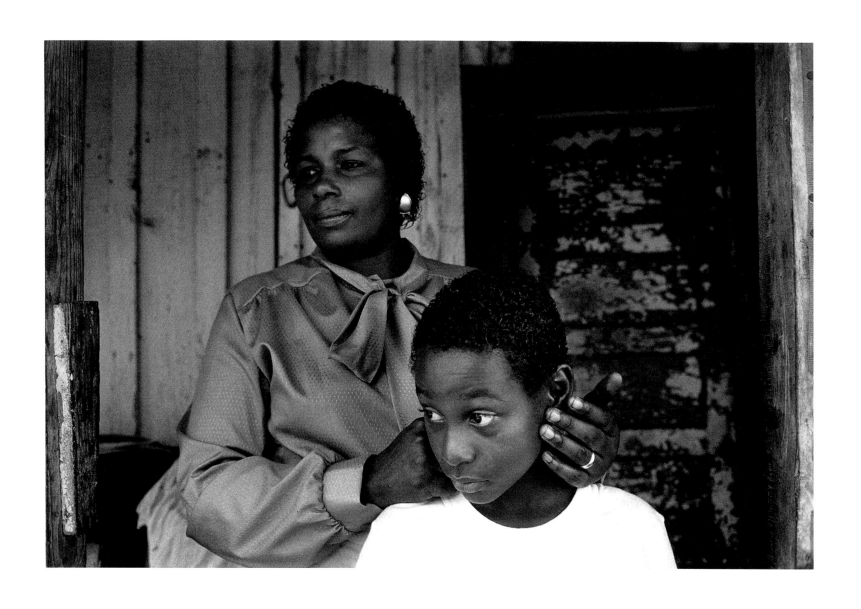

TUNICA, MISSISSIPPI, 1985

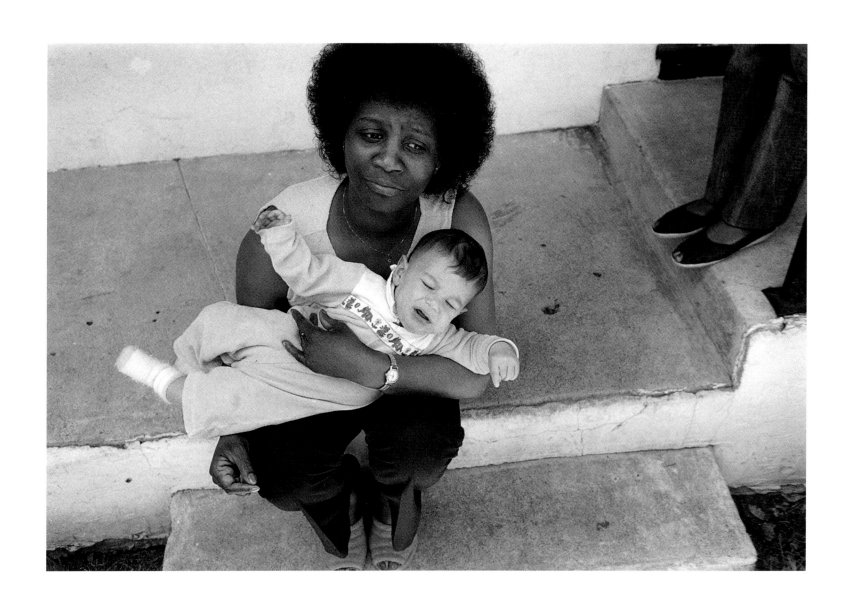

RICHMOND, CALIFORNIA, 1980

116

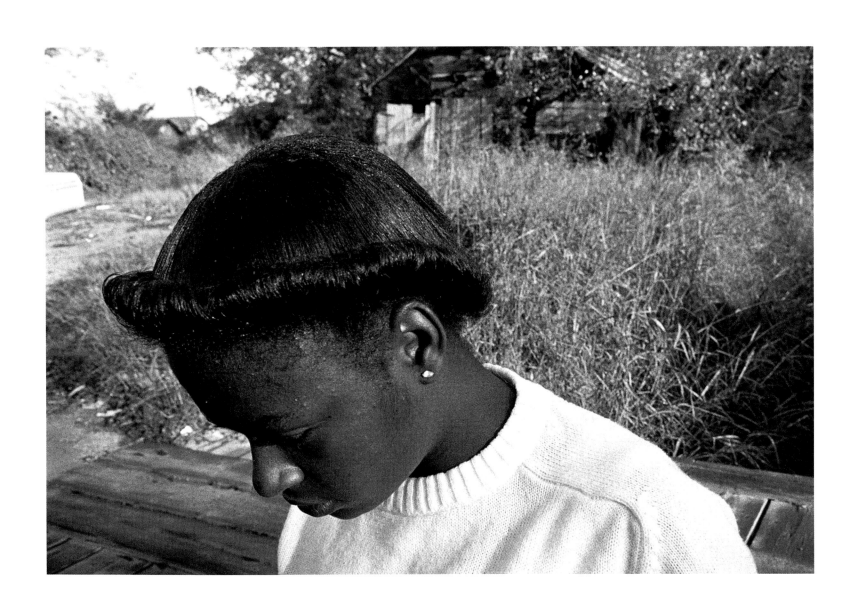

TUNICA, MISSISSIPPI, 1985

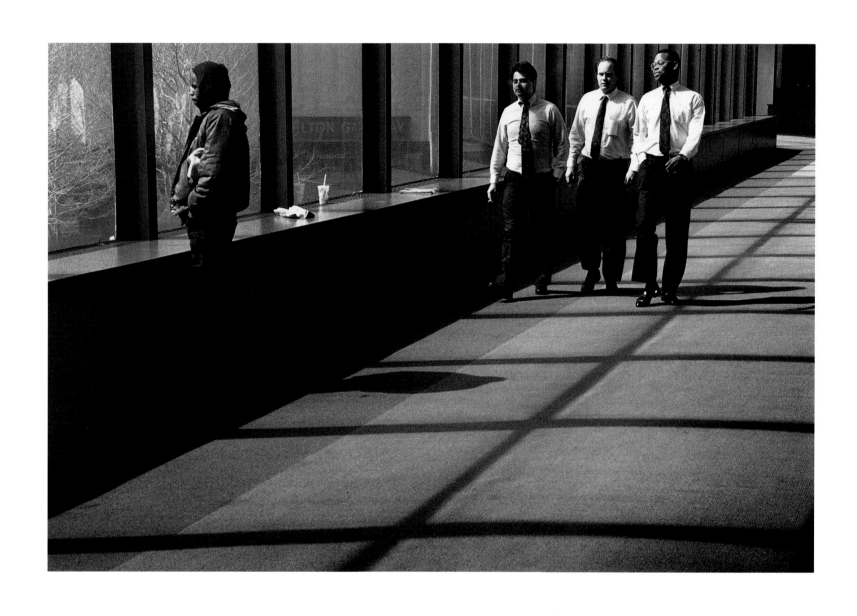

NEWARK, NEW JERSEY, 1992

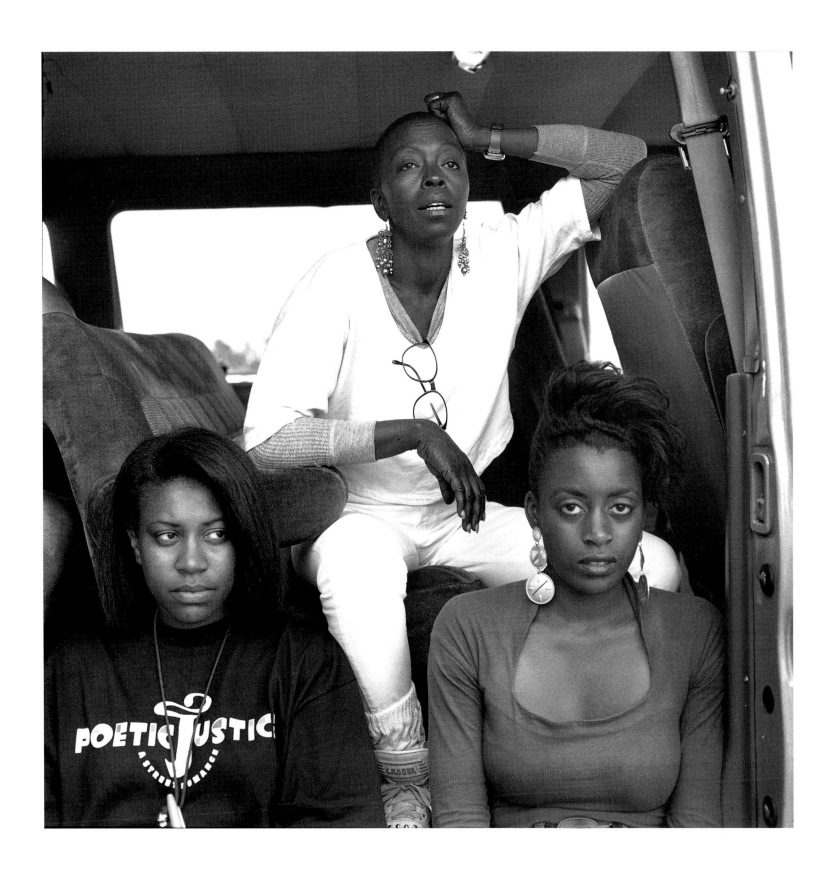

POETIC JUSTICE MOVIE CREW MEMBERS IN CALIFORNIA, 1992

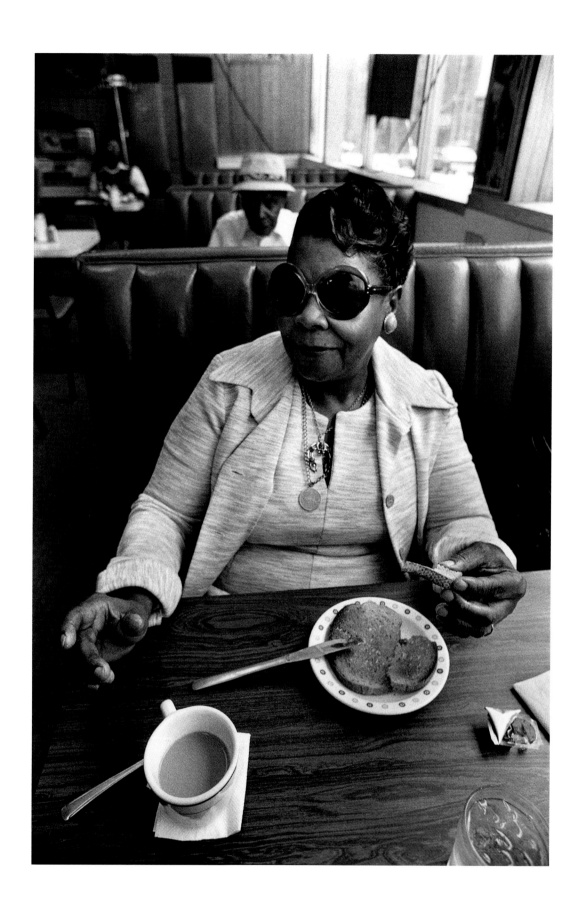

DETROIT, MICHIGAN, 1978

120

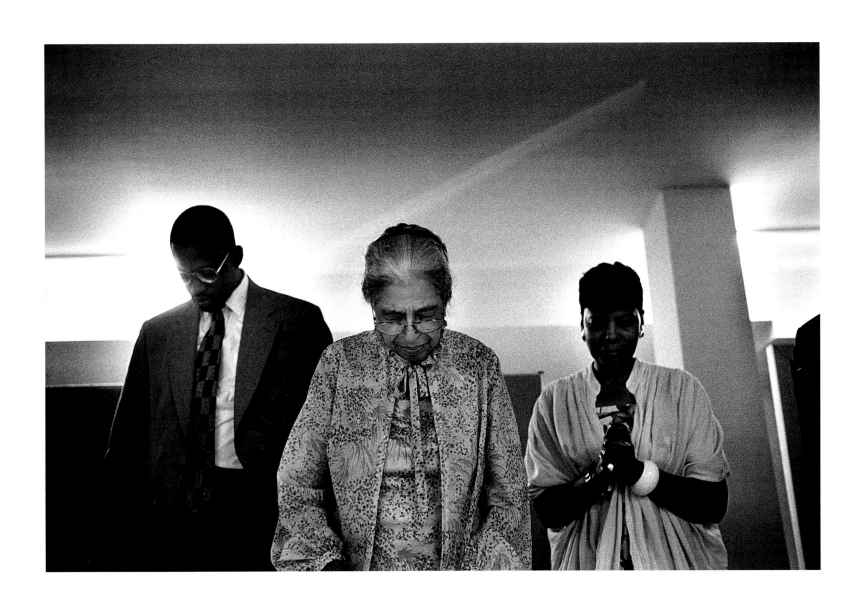

ROSA PARKS, MONTGOMERY, ALABAMA, 1995

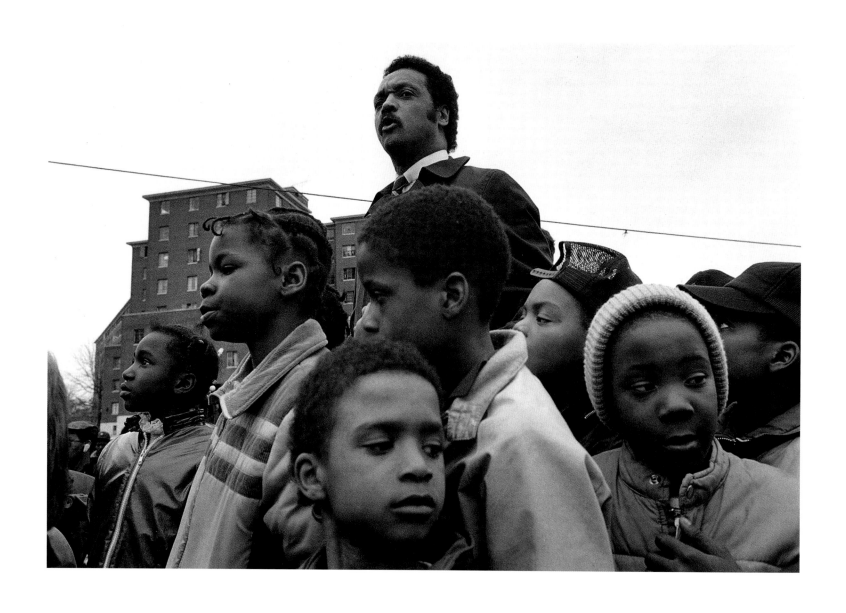

JESSE JACKSON ON THE CAMPAIGN TRAIL, HARTFORD, CONNECTICUT, 1984

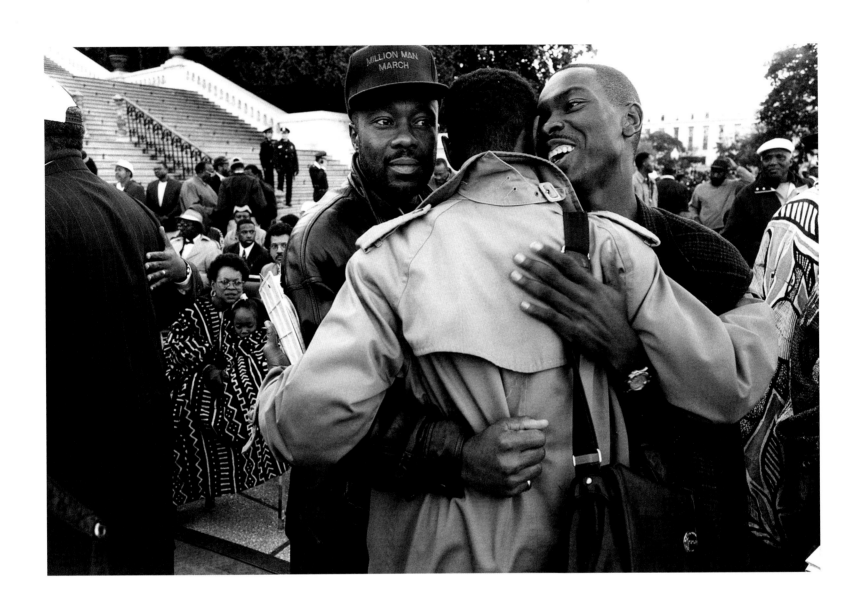

MILLION MAN MARCH, WASHINGTON, D.C., 1995

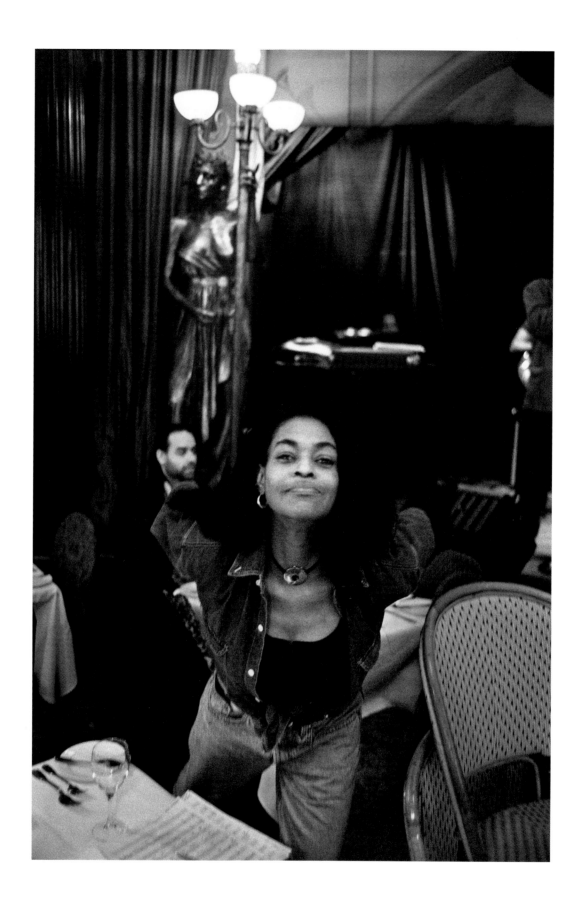

SINGER/ACTOR DEE WATKINS, NEW YORK CITY, 1996

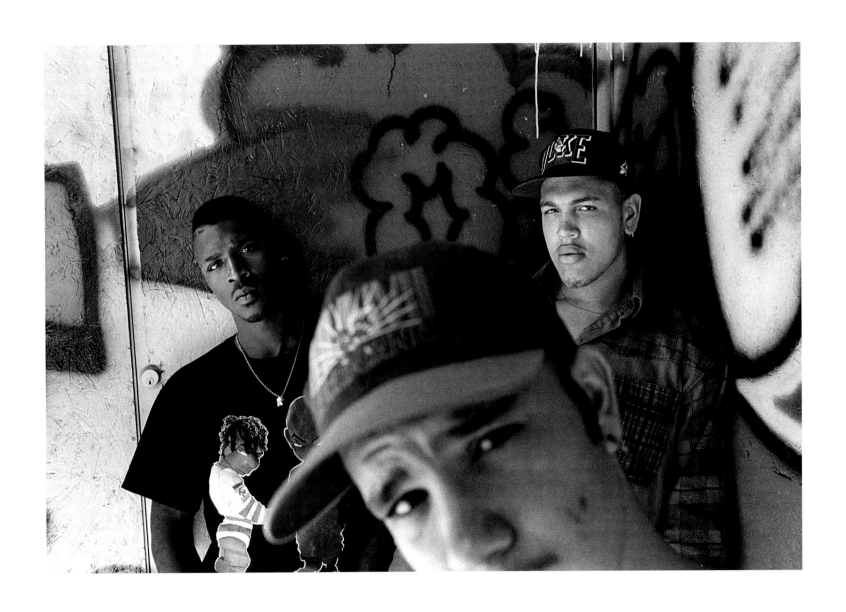

GANG MEMBERS, DETROIT, MICHIGAN, 1992

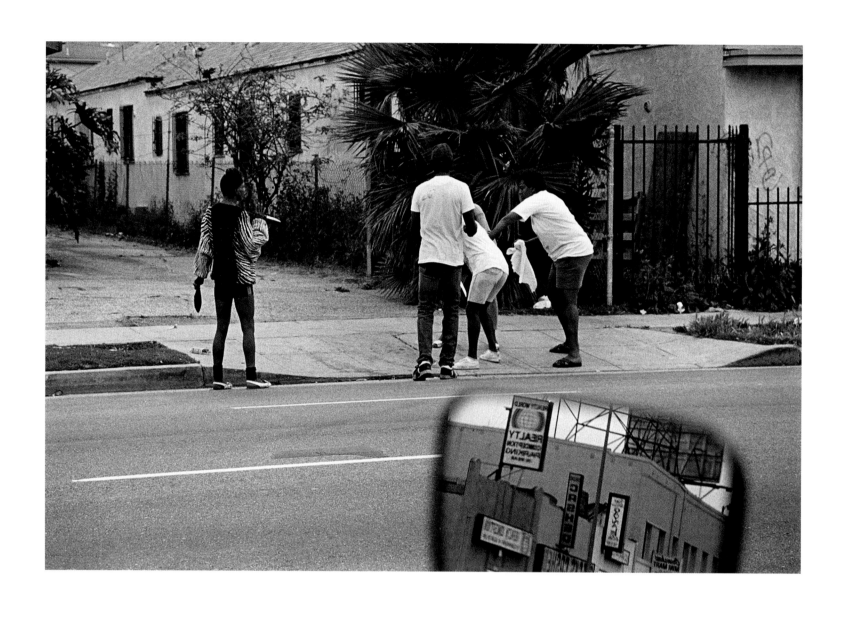

SOUTH CENTRAL LOS ANGELES, CALIFORNIA, 1992

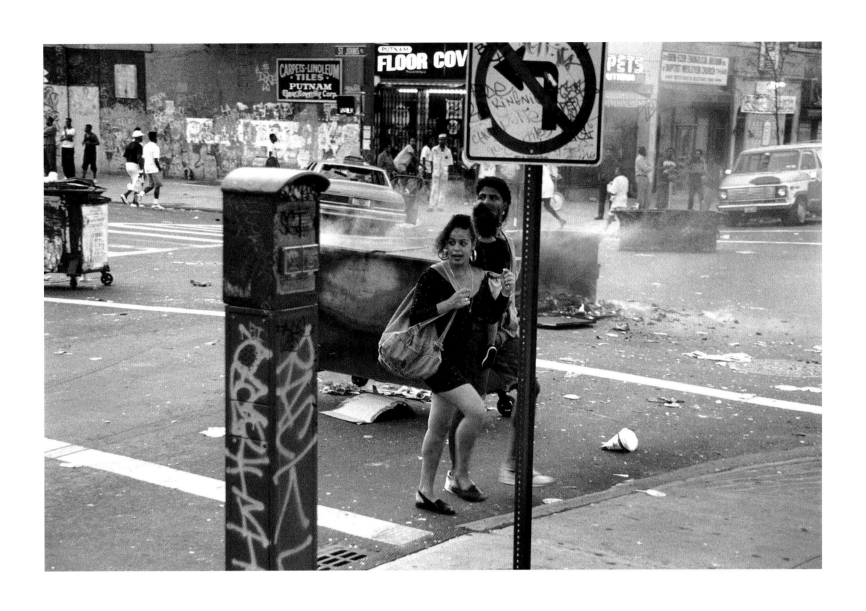

CROWN HEIGHTS RIOT, BROOKLYN, NEW YORK, 1991

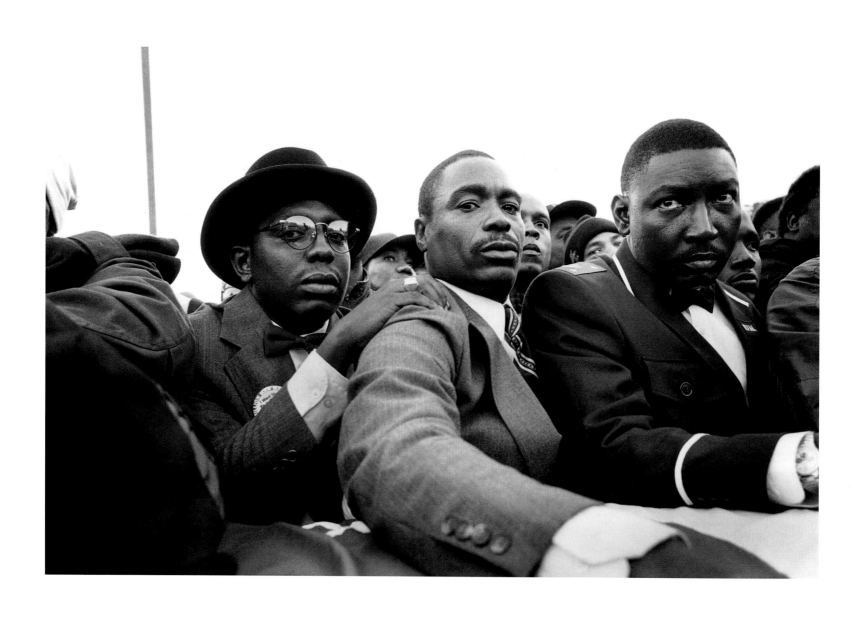

MILLION MAN MARCH, WASHINGTON, D.C., 1995

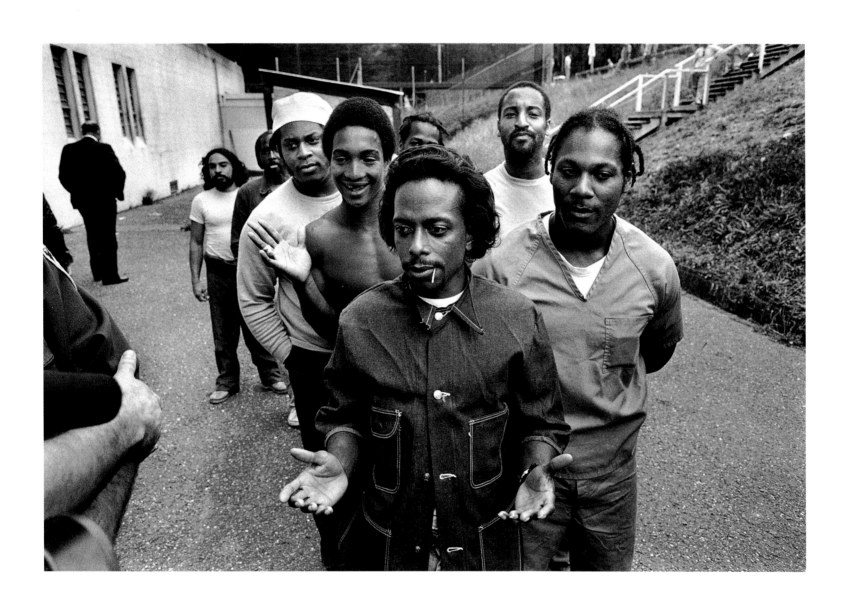

SAN BRUNO JAIL, SAN BRUNO, CALIFORNIA, 1983

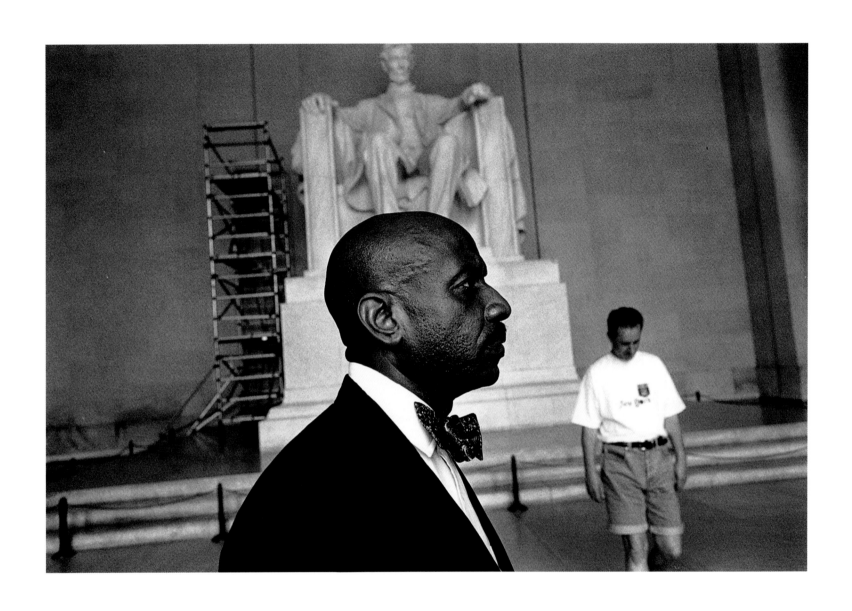

LAWYER JOHN CRUMP, WASHINGTON, D.C., 1992

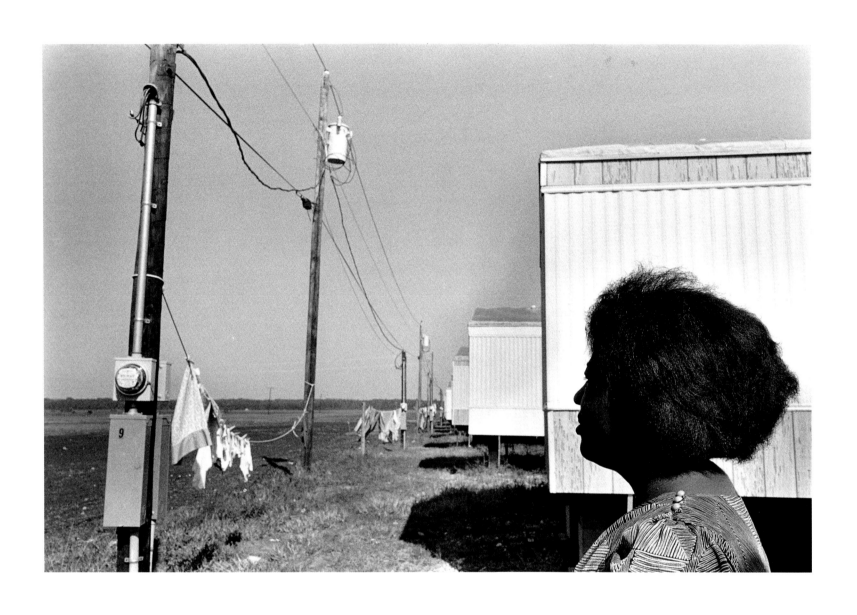

TUNICA, MISSISSIPPI, 1986

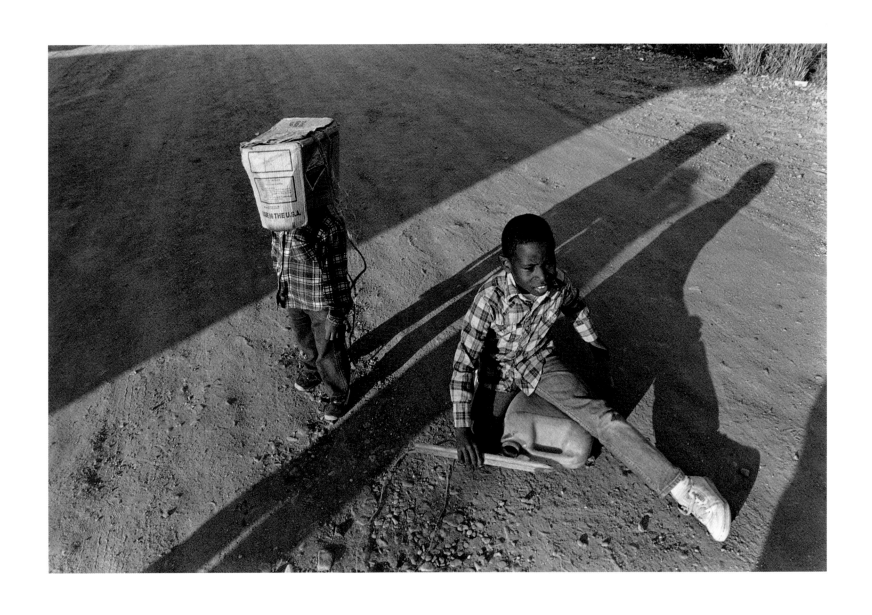

TUNICA, MISSISSIPPI, 1986

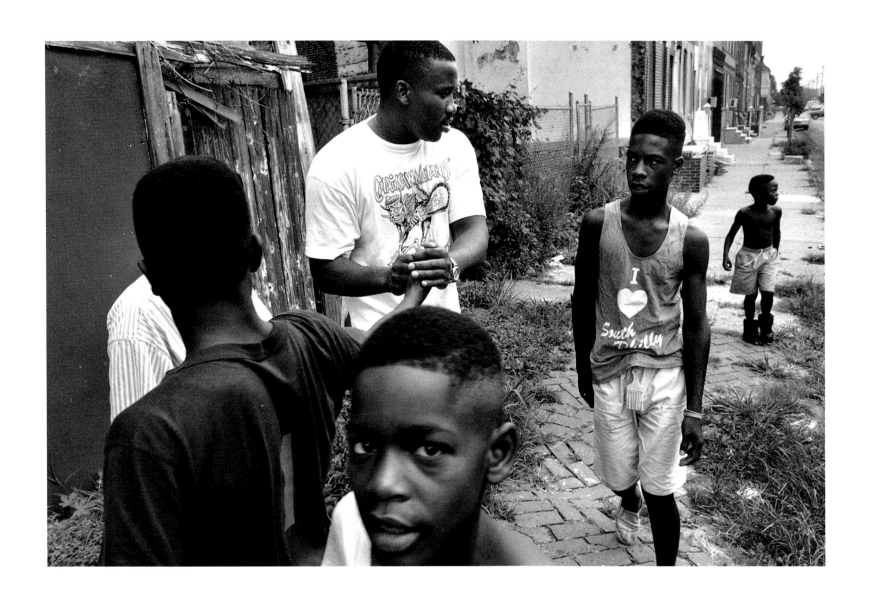

BOXER TIM WITHERSPOON, SOUTH PHILADELPHIA, PENNSYLVANIA, 1990

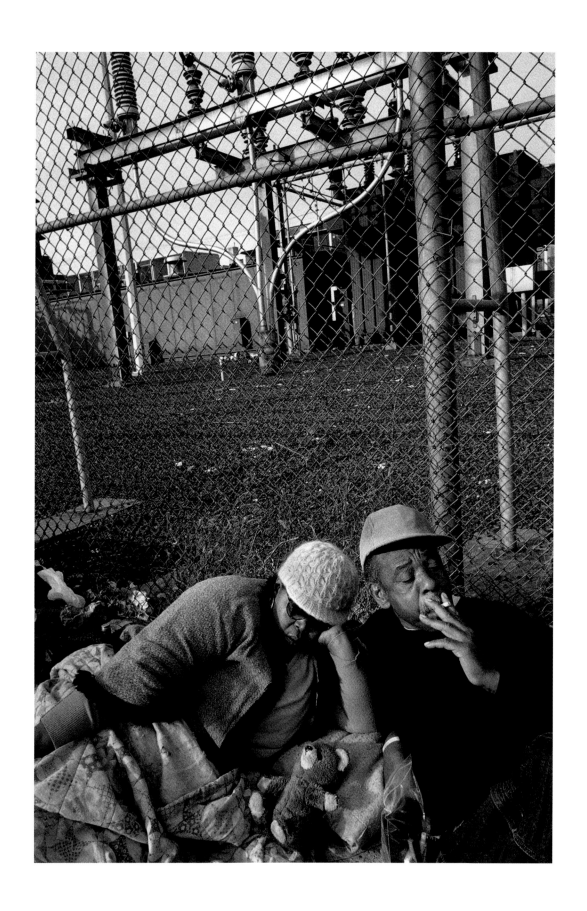

HOMELESS COUPLE, PHILADELPHIA, PENNSYLVANIA, 1989

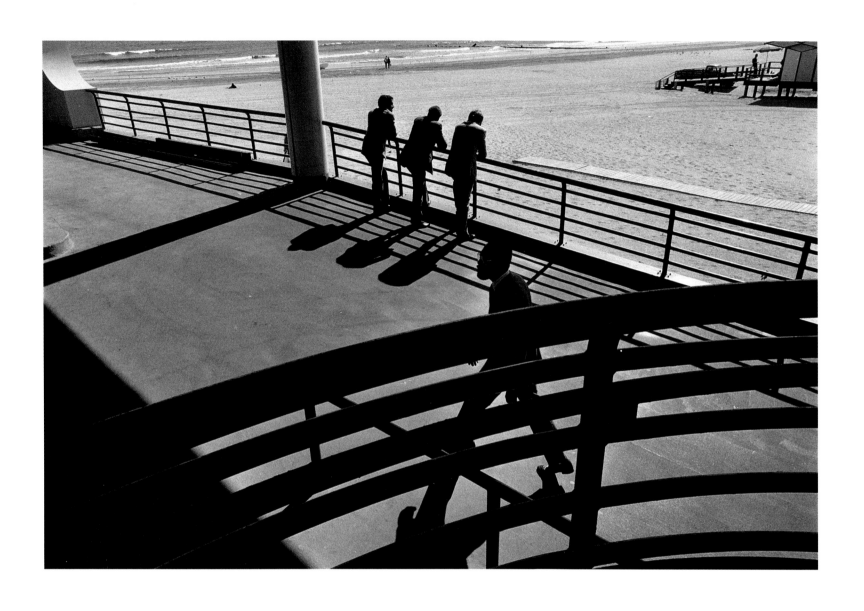

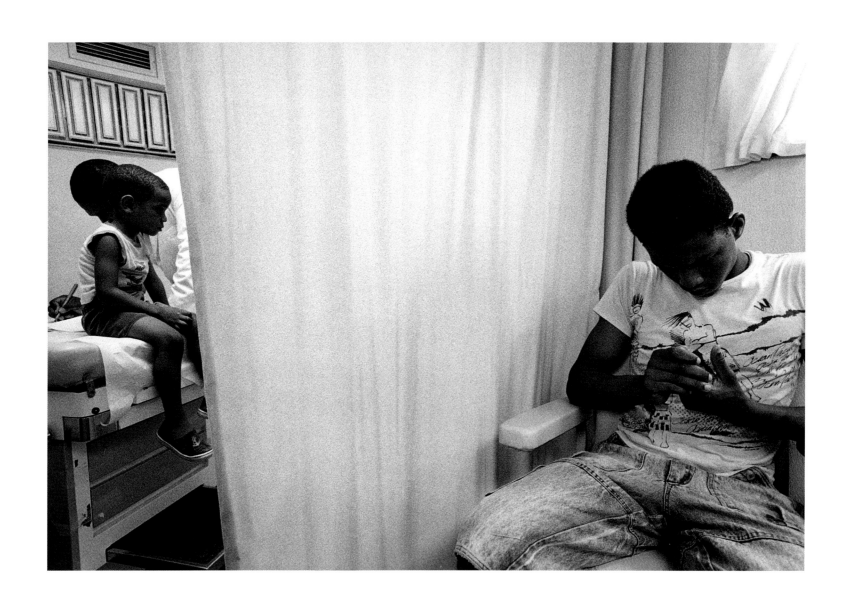

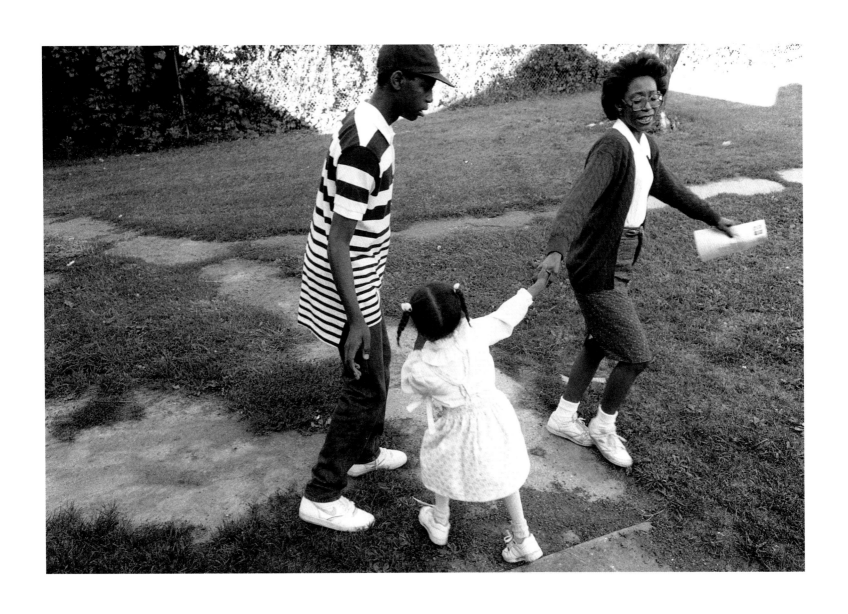

HARTFORD, CONNECTICUT, 1988

137

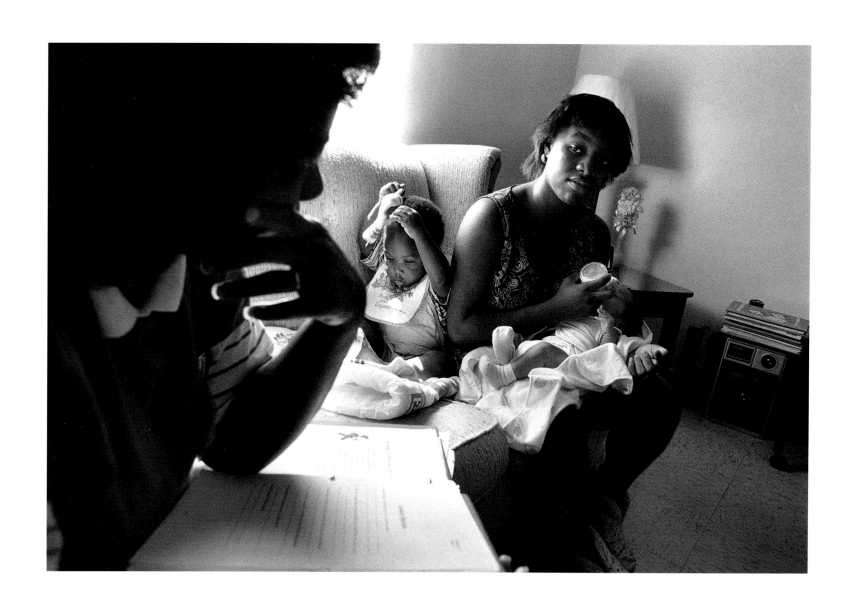

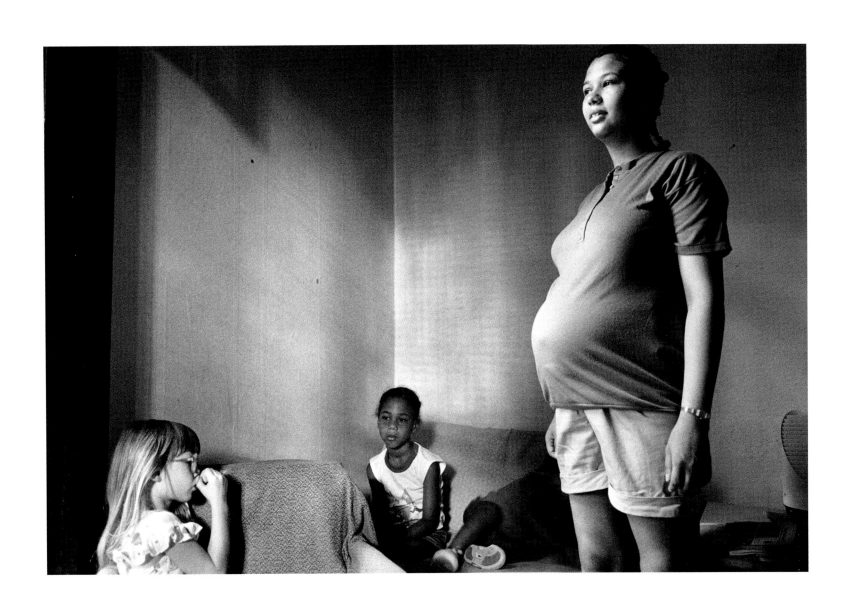

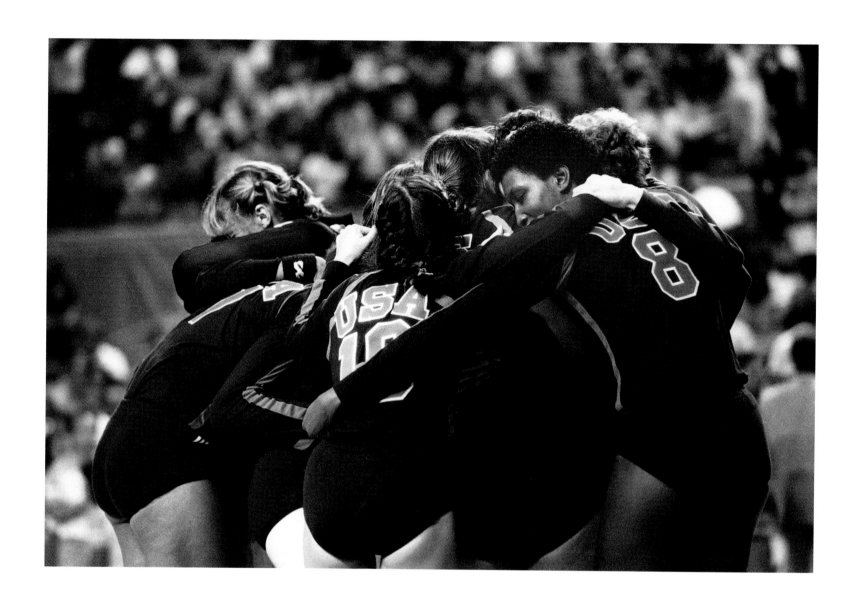

OLYMPIC VOLLEYBALL TEAM, LOS ANGELES, CALIFORNIA, 1984

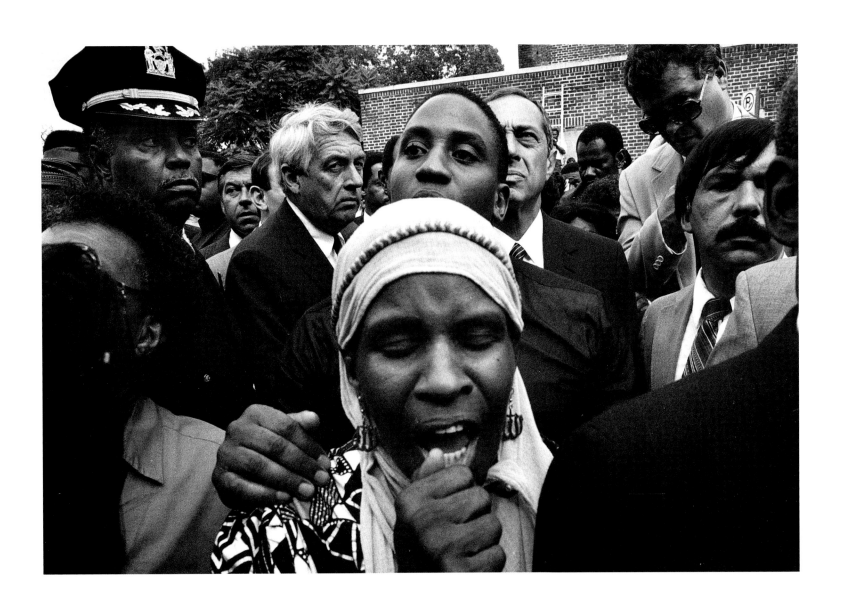

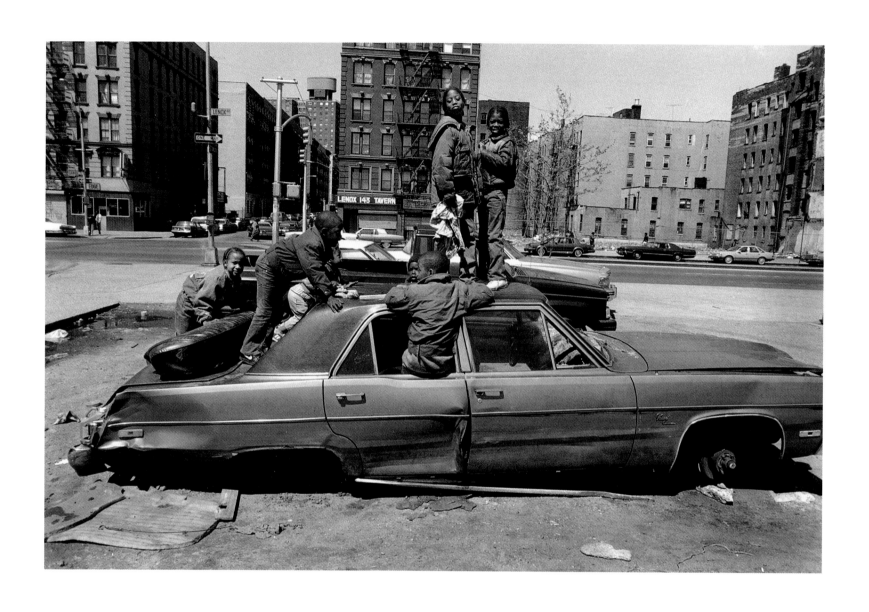

HARLEM, NEW YORK CITY, 1987

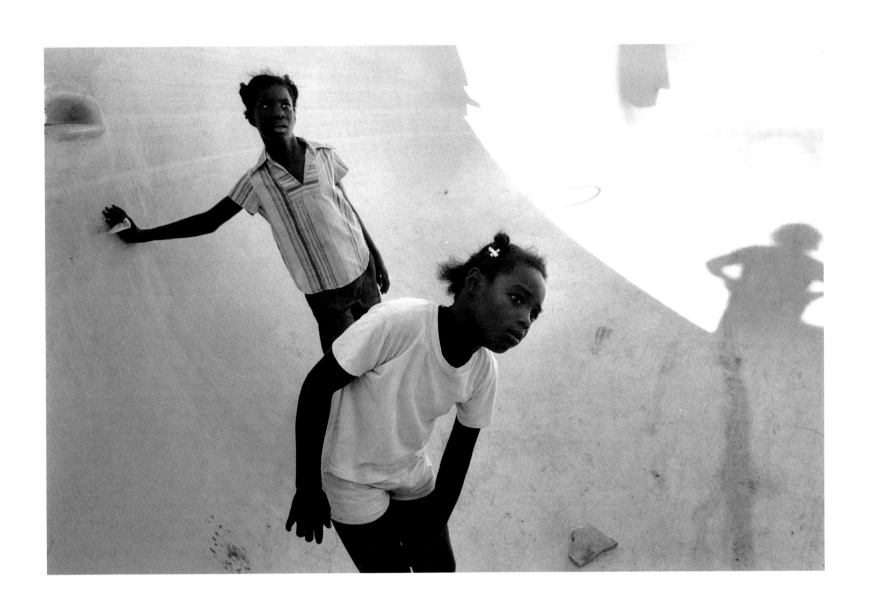

LOS ANGELES, CALIFORNIA, 1985

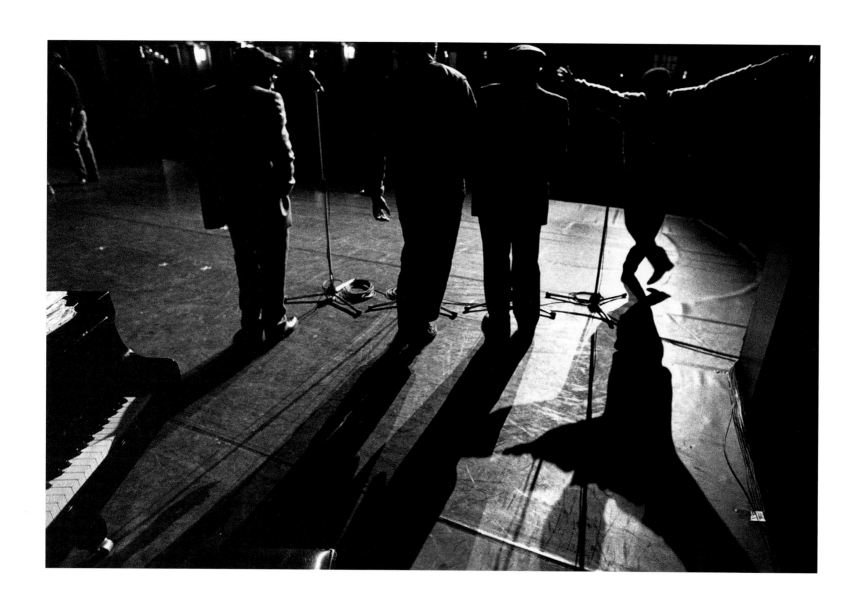

GOSPEL SINGERS THE GOLDEN GATE QUARTET, PARIS, FRANCE, 1991

144

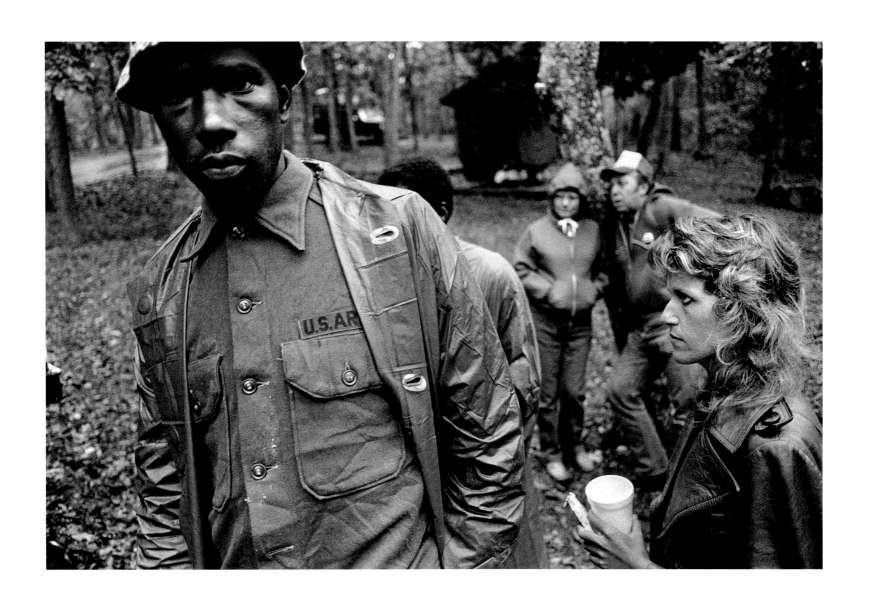

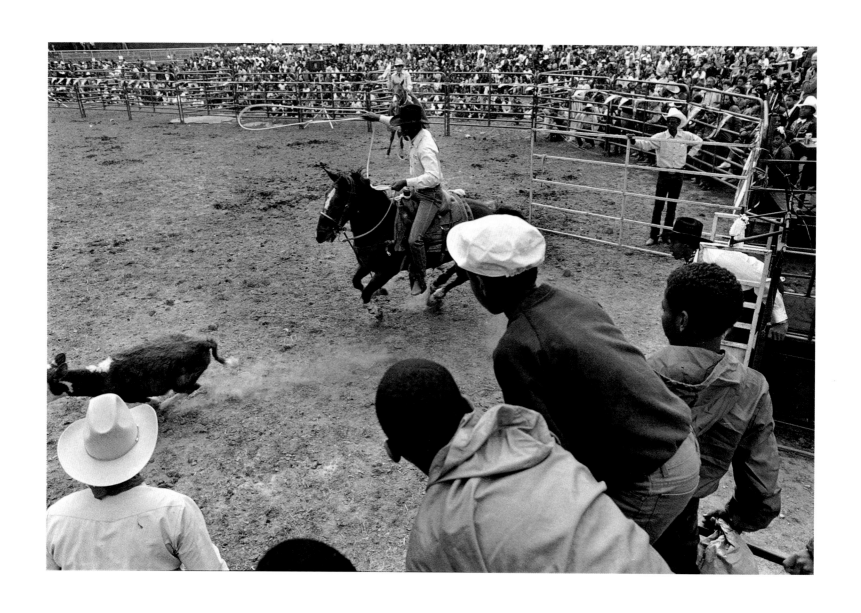

HARLEM RODEO, NEW YORK CITY, 1995

146

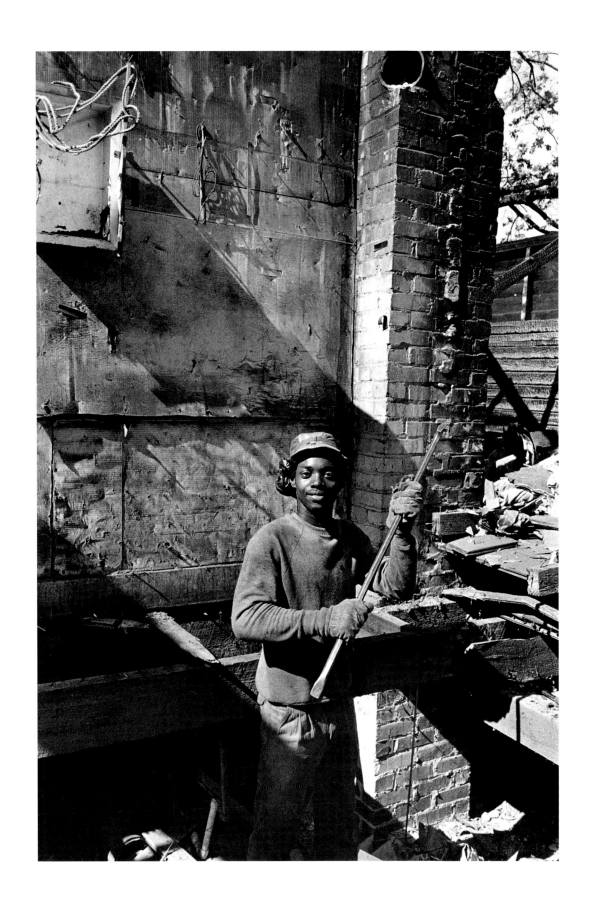

TUNICA, MISSISSIPPI, 1986

147

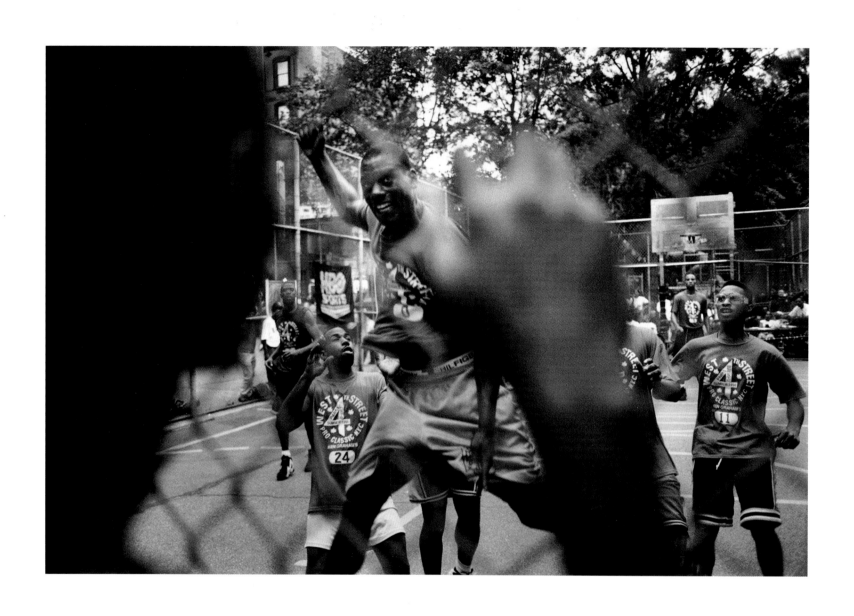

NEW YORK CITY, 1996

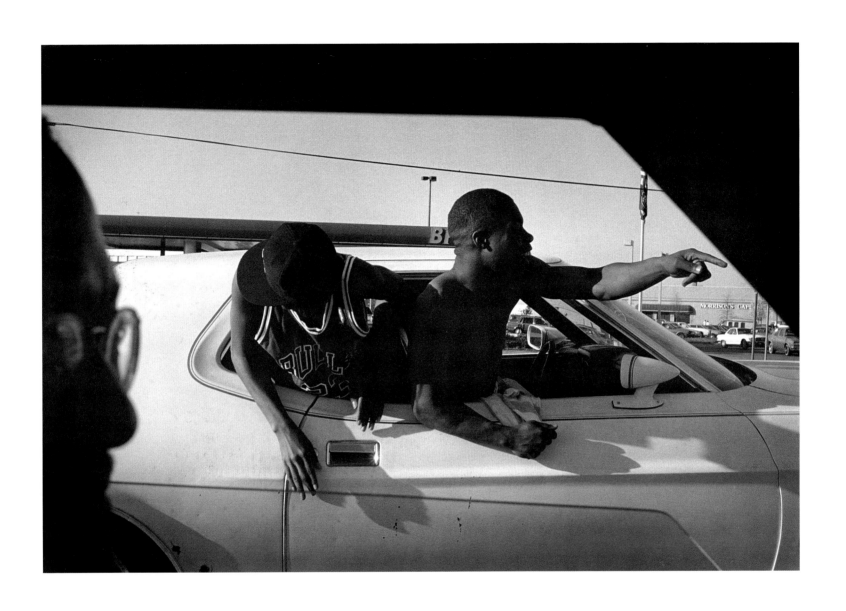

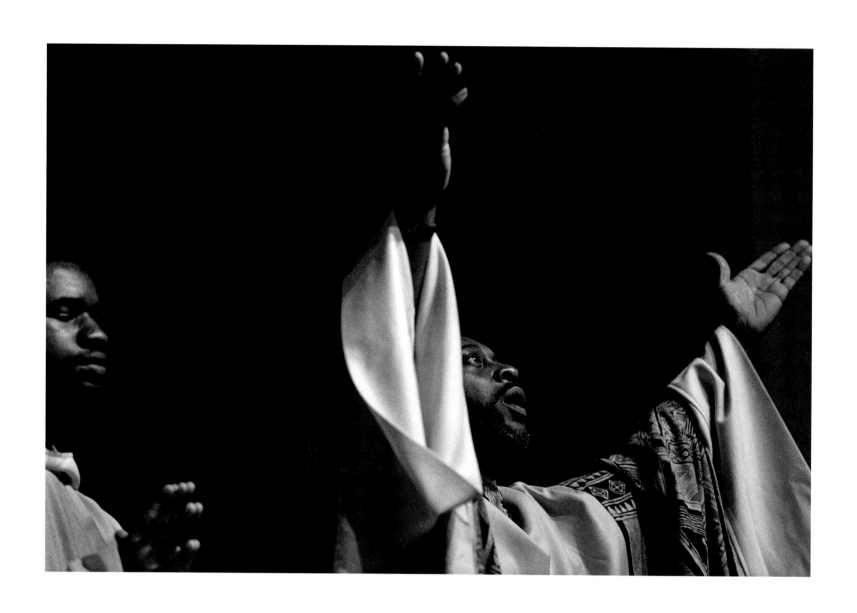

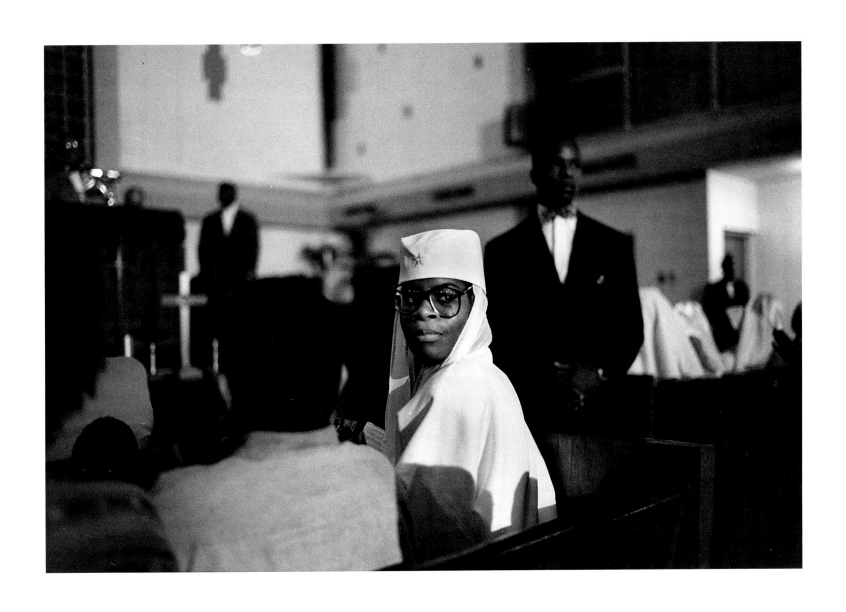

ATLANTA, GEORGIA, 1996

151

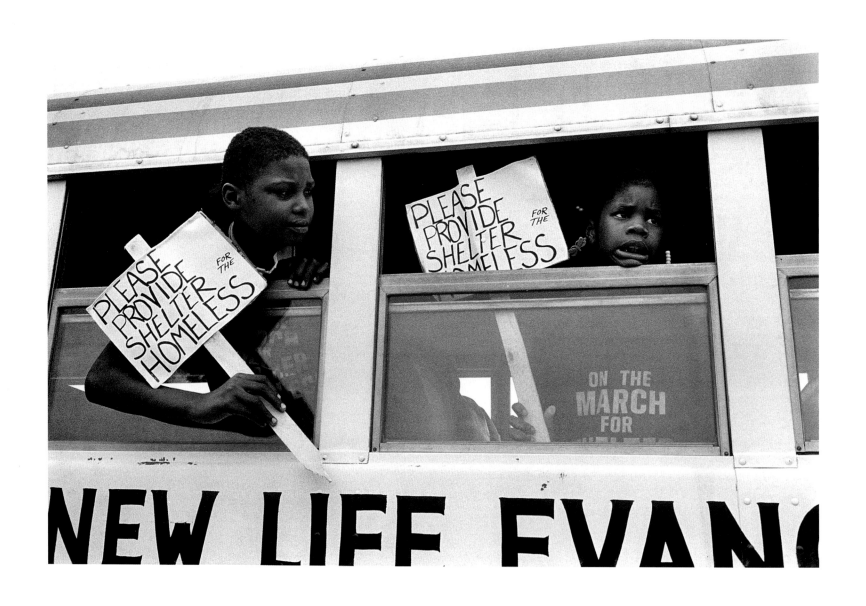

HOMELESS MARCH FOR SHELTER, CENTRAL MISSOURI, 1986

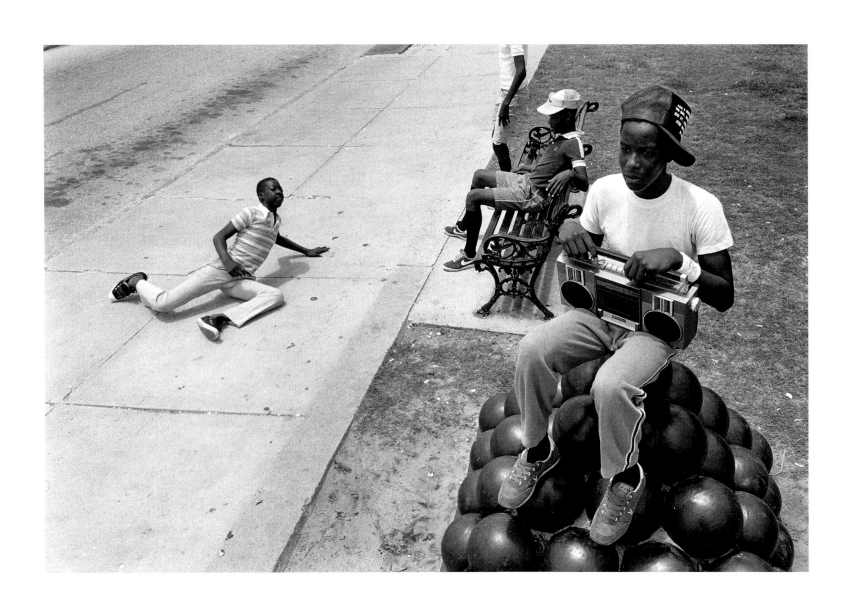

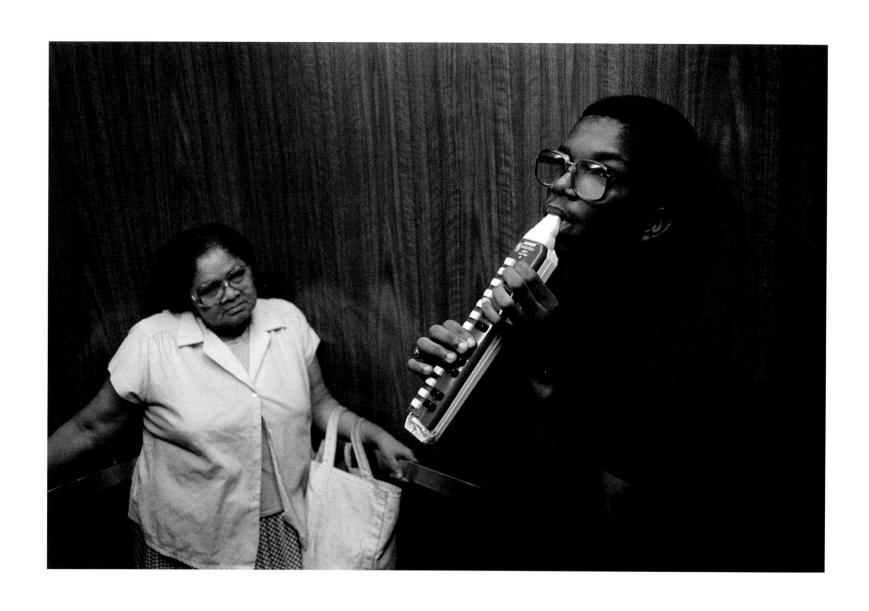

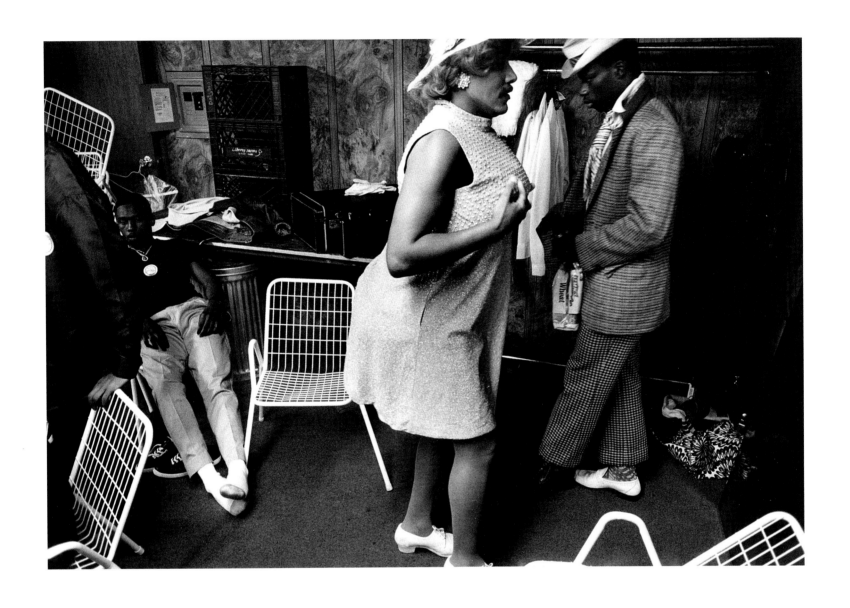

AMATEUR NIGHT AT THE APOLLO THEATER, HARLEM, NEW YORK CITY, 1985

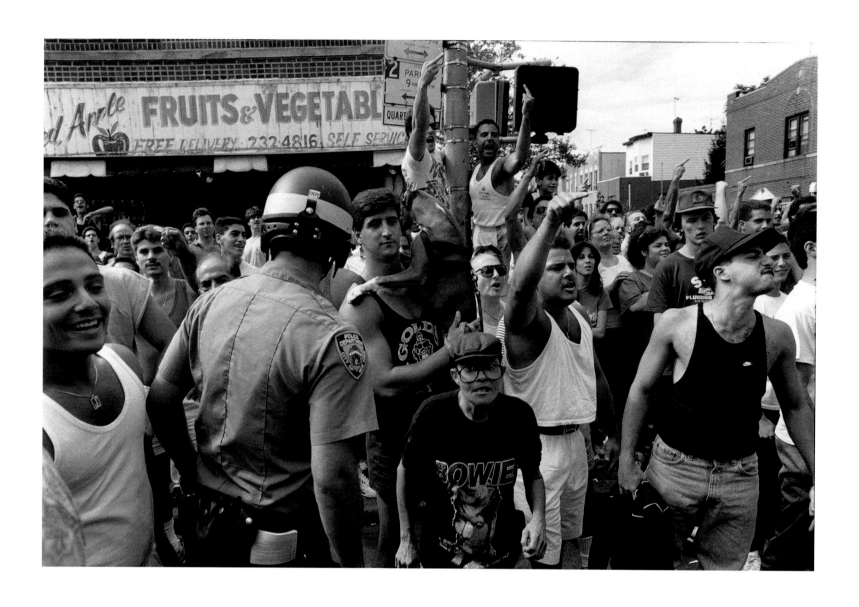

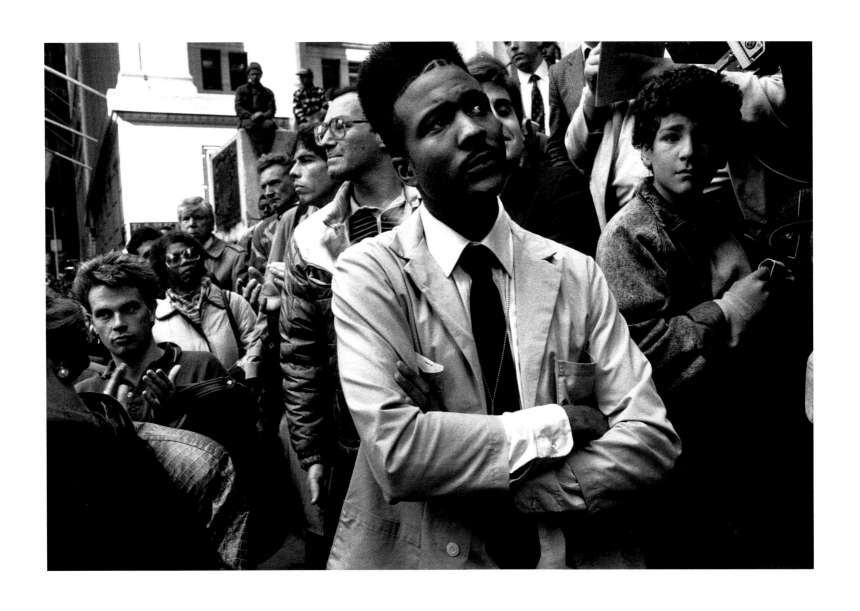

RALLY FOR DAVID DINKINS, NEW YORK CITY, 1989

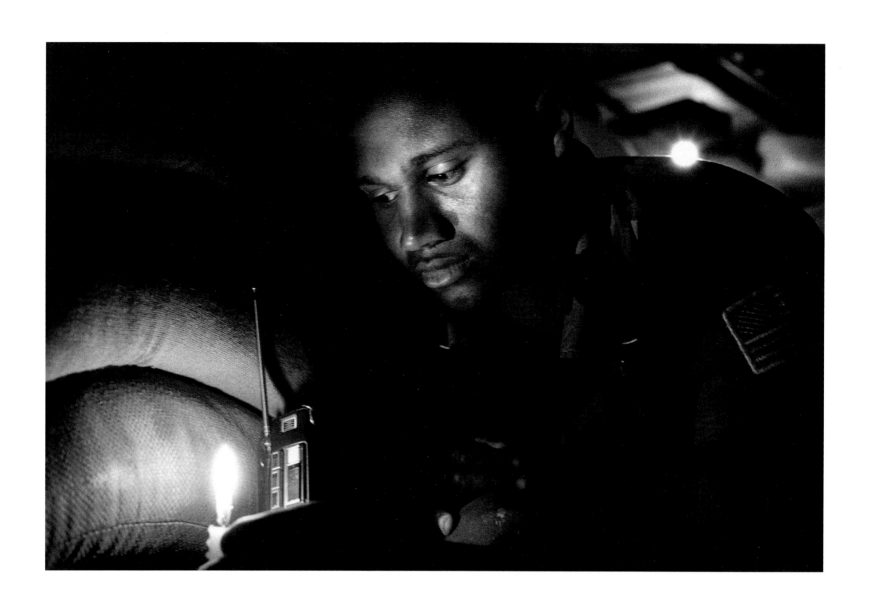

MARINE, BEIRUT, LEBANON, 1983

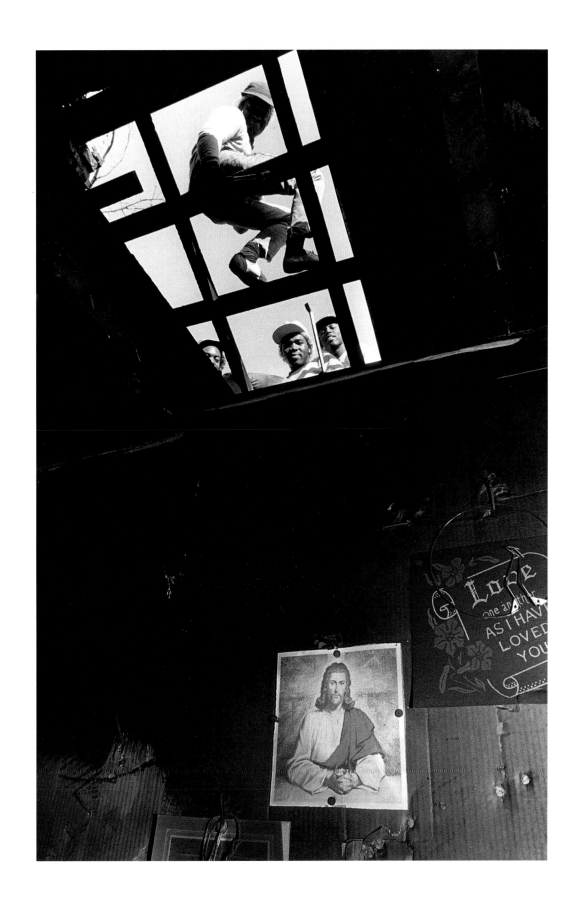

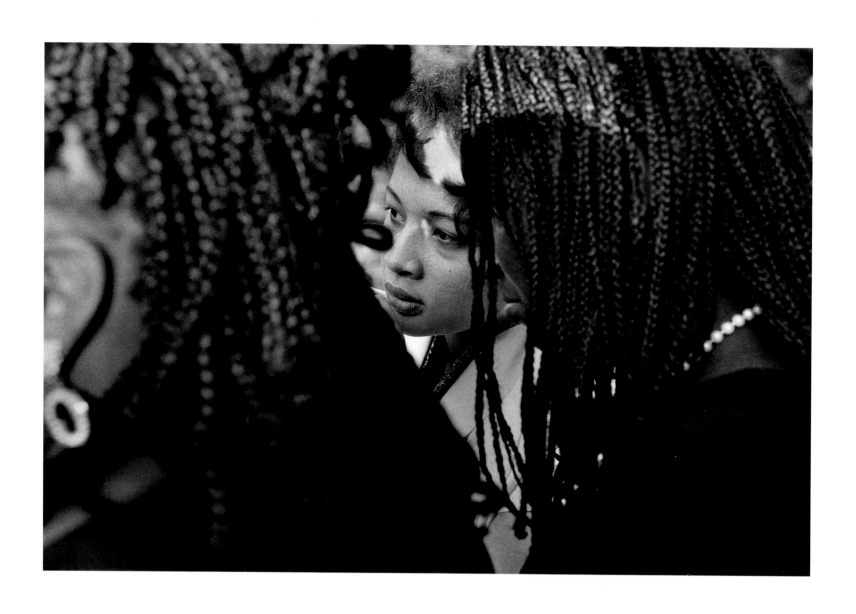

ATLANTA, GEORGIA, 1995

160

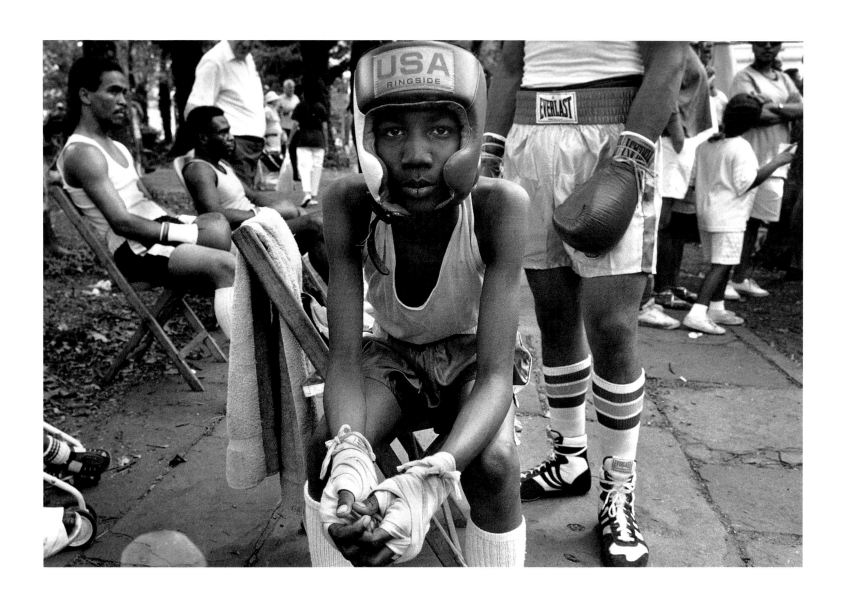

HARLEM, NEW YORK, 1990

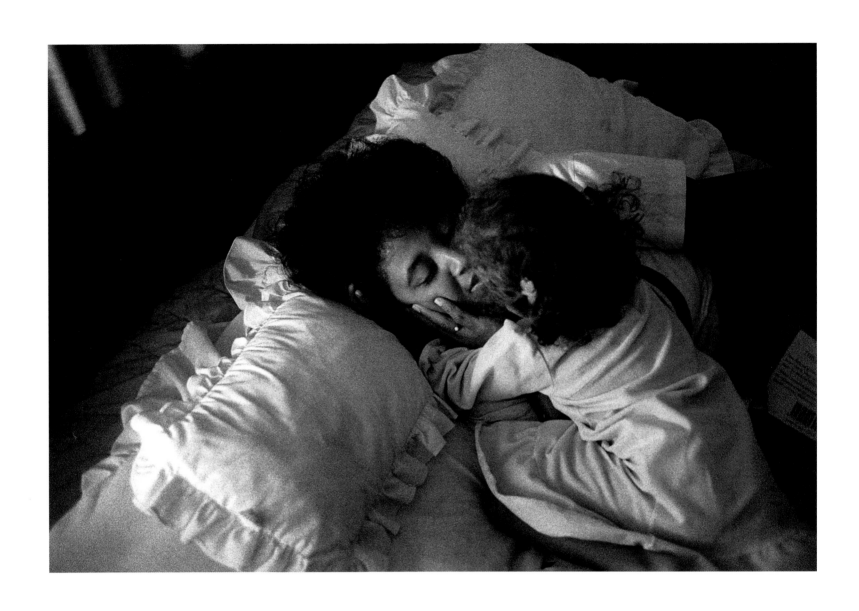

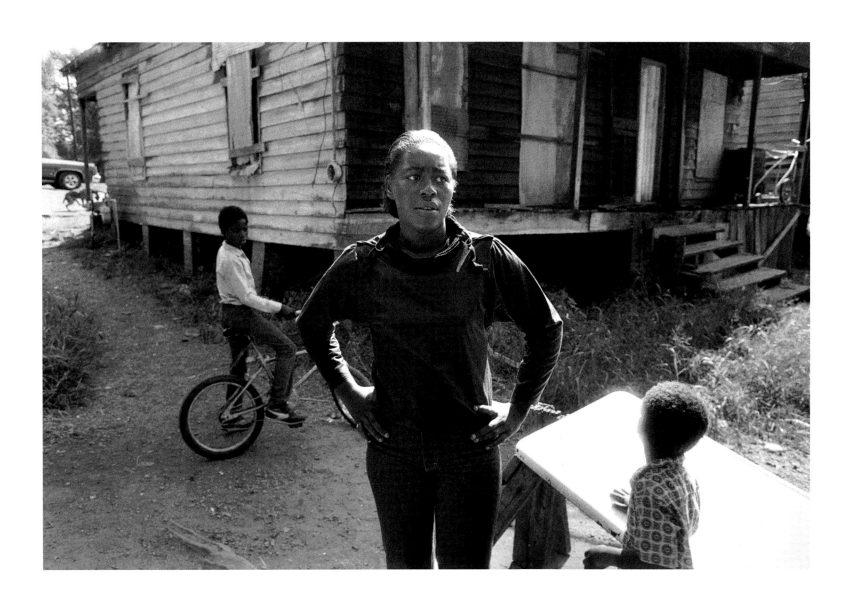

SUGAR DITCH REGION, TUNICA, MISSISSIPPI, 1986

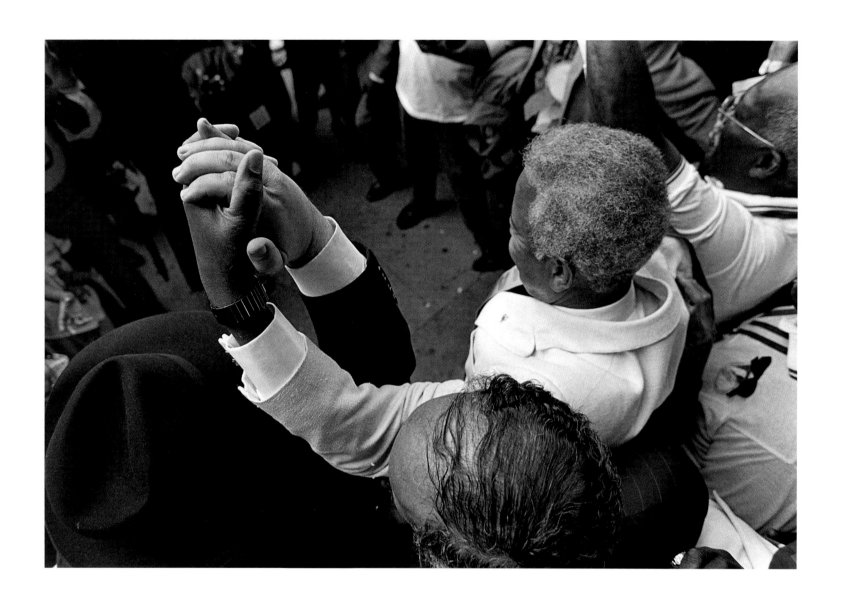

MAYOR DAVID DINKINS JOINING HANDS WITH A HASIDIC LEADER, NEW YORK CITY, 1991

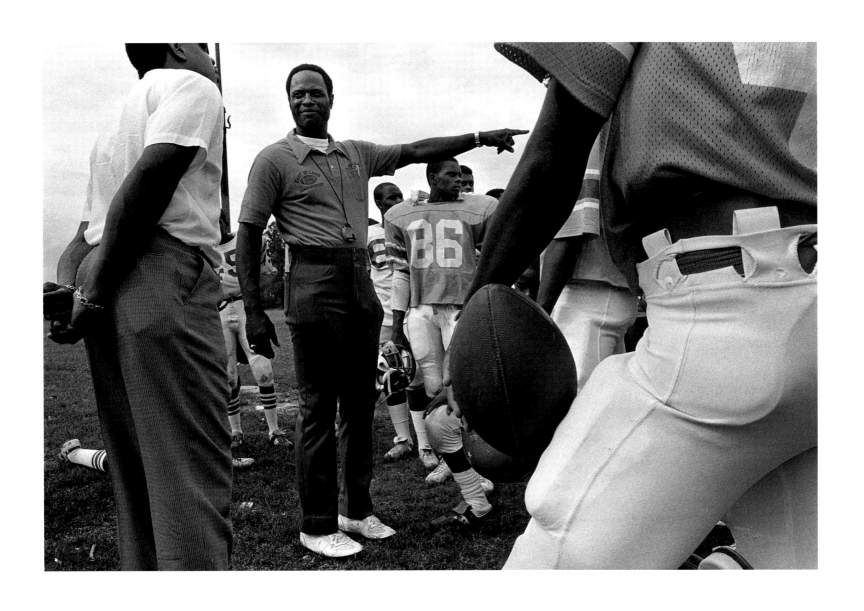

HIGH SCHOOL FOOTBALL PRACTICE, EAST ST. LOUIS, ILLINOIS, 1985

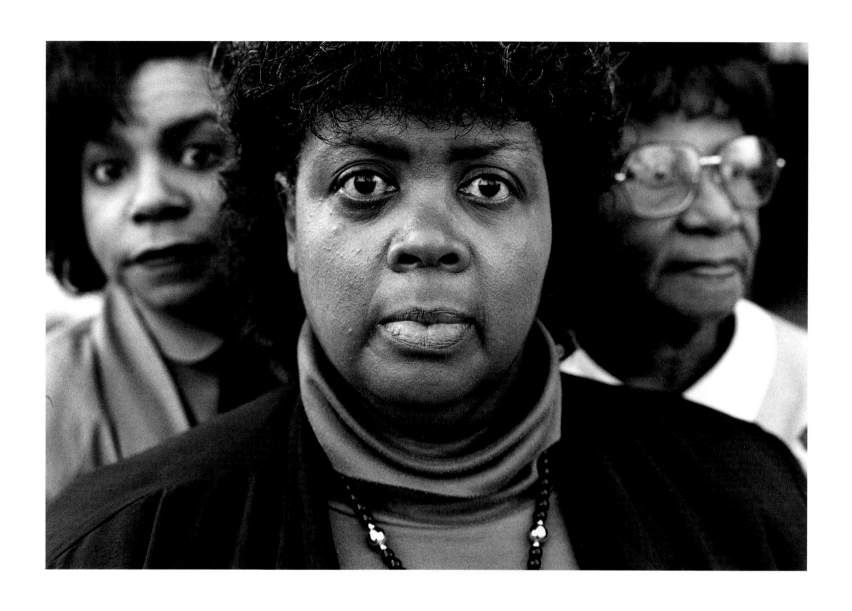

LINDA BROWN (BROWN VS. BOARD OF EDUCATION), TOPEKA, KANSAS, 1995

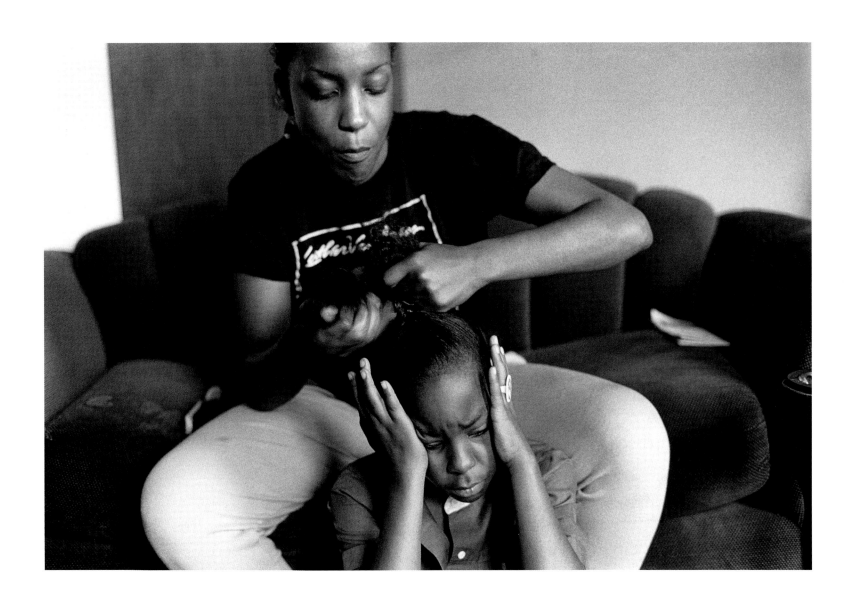

ST. LOUIS, MISSOURI, 1985

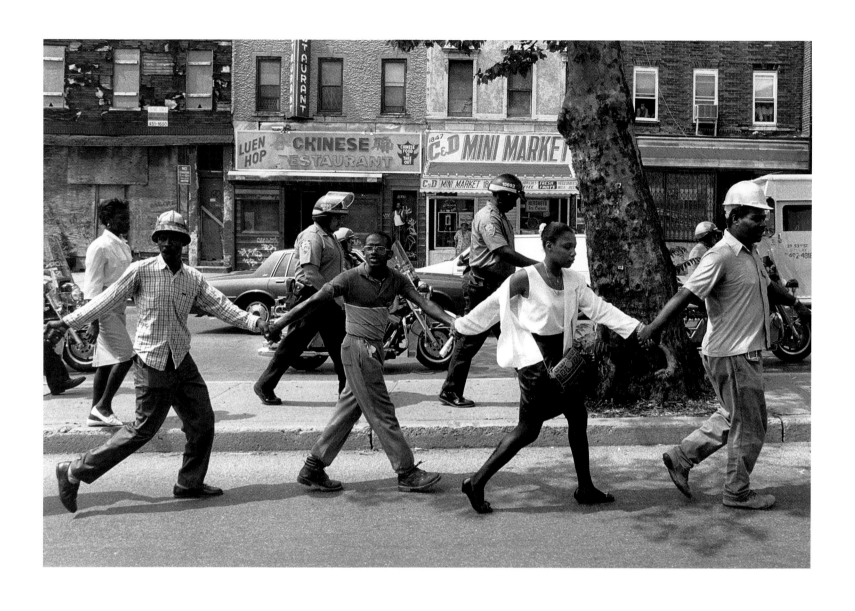

CROWN HEIGHTS RIOT, BROOKLYN, NEW YORK, 1991

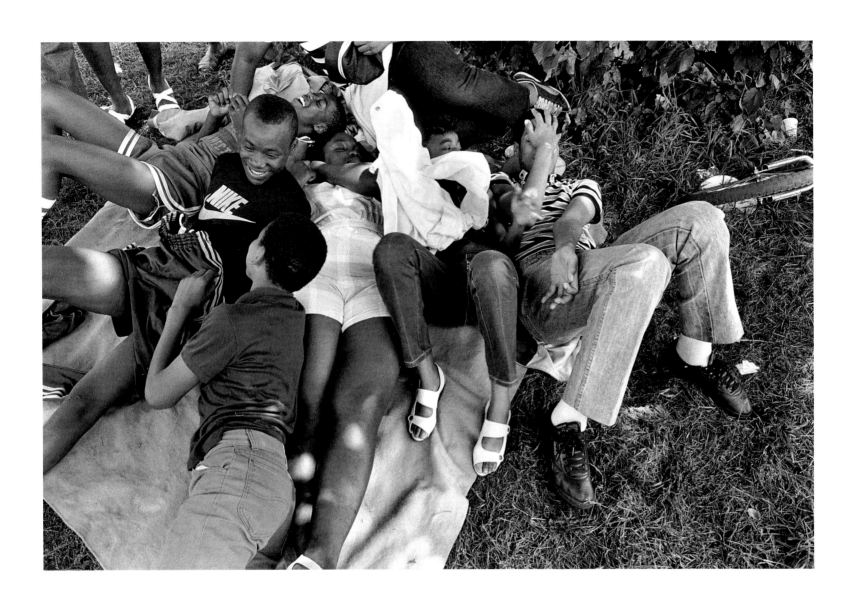

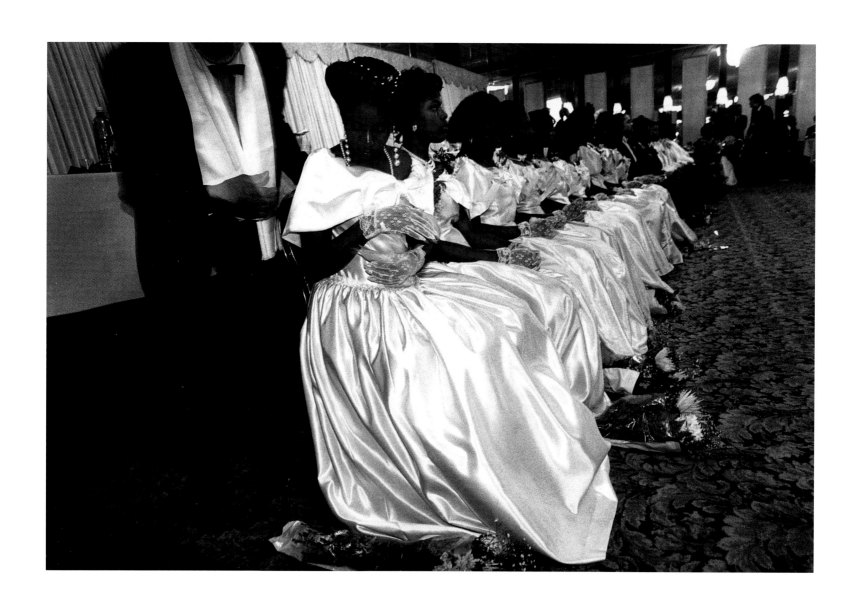

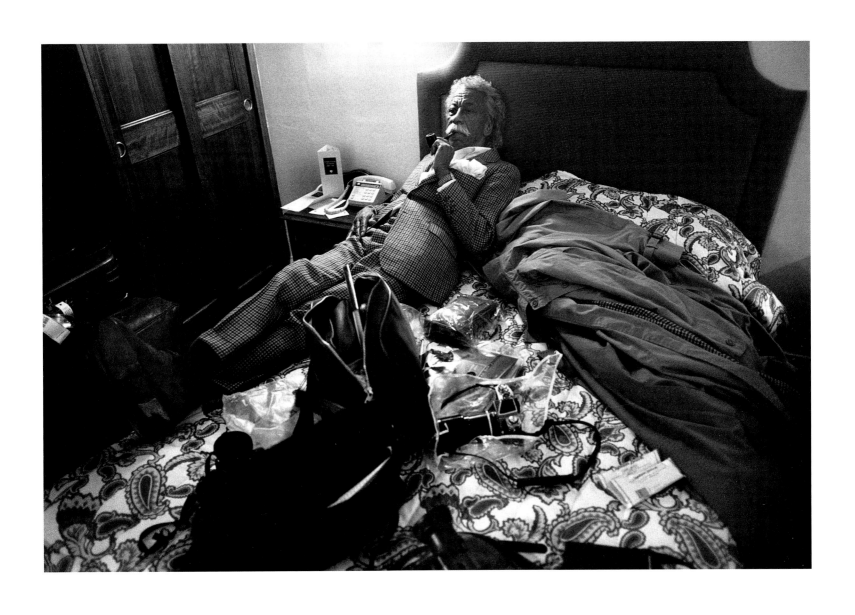

GORDON PARKS, LONDON, ENGLAND, 1994

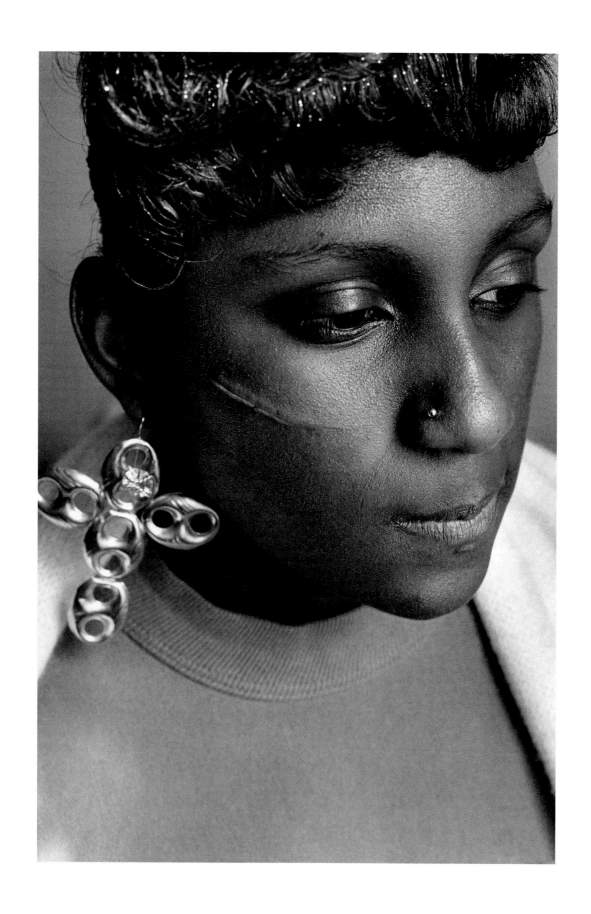

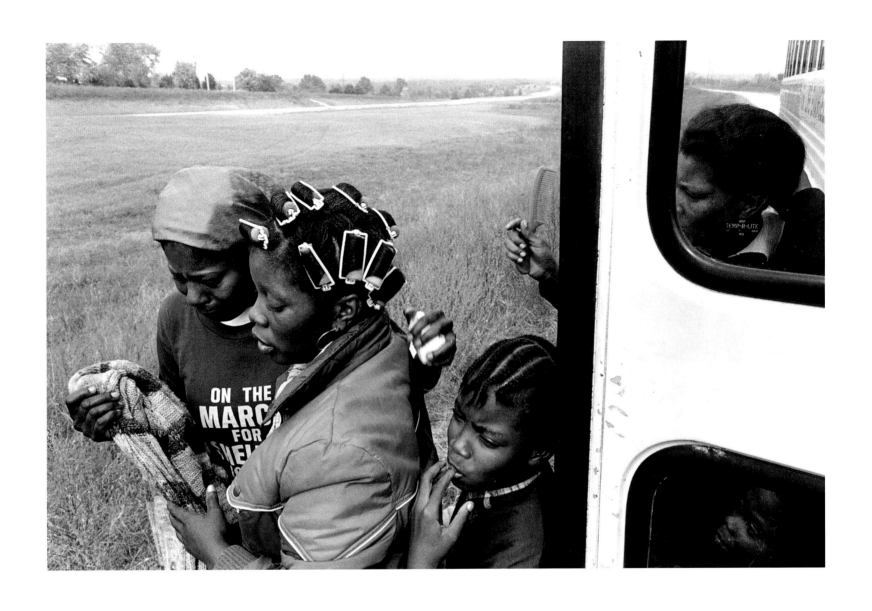

HOMELESS MARCH FOR SHELTER, CENTRAL MISSOURI, 1986

OVERLEAF: MILLION MAN MARCH, WASHINGTON, D.C., 1995

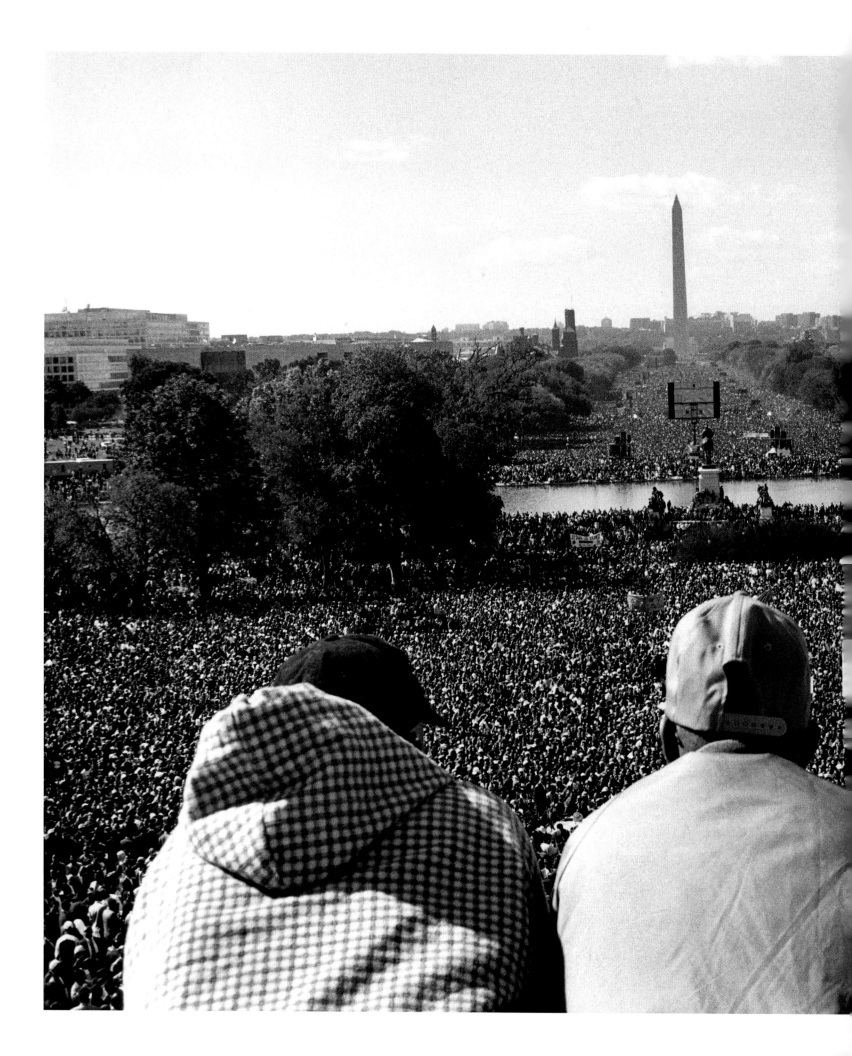

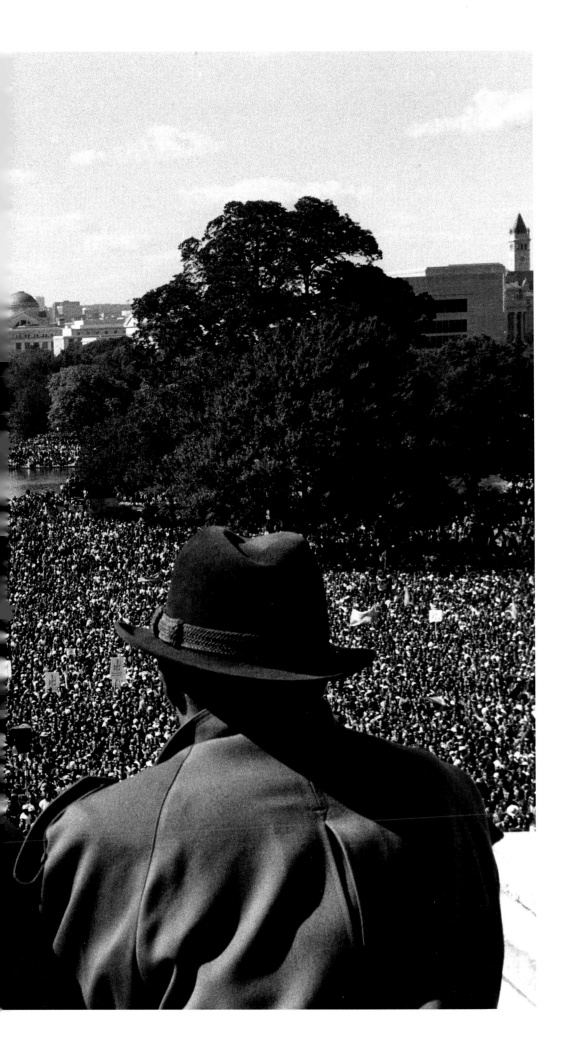

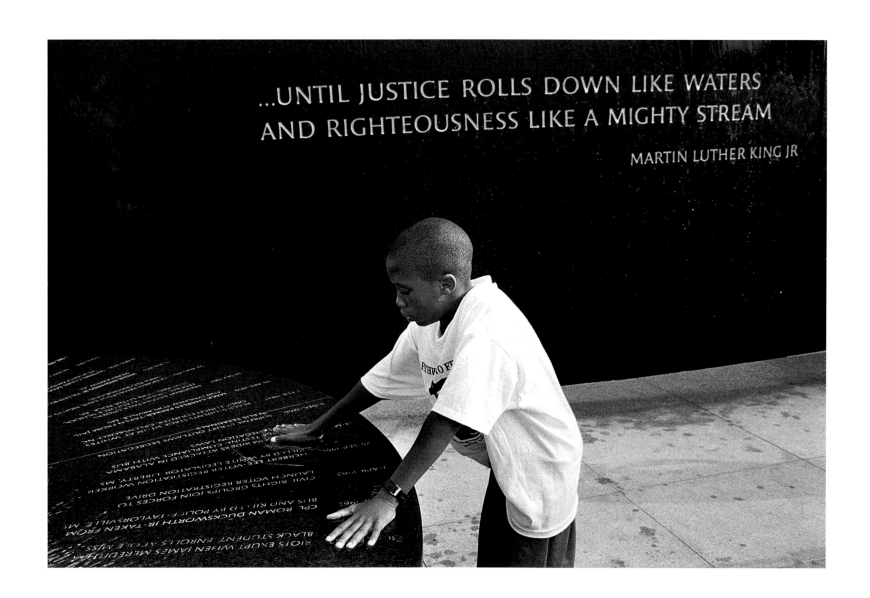